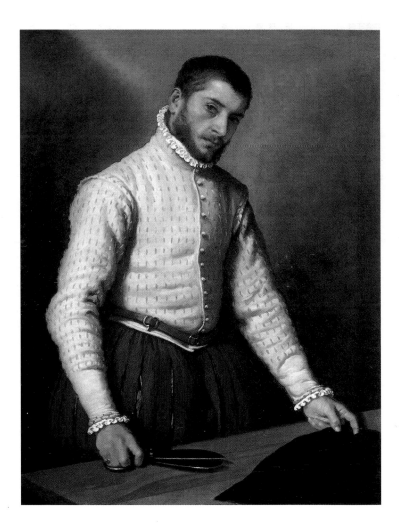

The History of Art

Volker Gebhardt

BARRON'S

Cover photos from top to bottom and left to right:
Caravaggio, *Bacchus*, ca. 1595, Uffizi Gallery, Florence, Italy (photo Scala, Florence) /
Jasper Johns, *Flag*, 1955 © The Museum of Modern Art, New York, Gift of Philip
Johnson in honor of Alfred H. Barr, Jr. / Sandro Botticelli, *The Birth of Venus*, 1485–
1486, Uffizi Gallery, Florence, Italy (photo Raffaello Bencini) / Paul Gauguin, *Nafea
Faaipoipo* (*When Are You to be Married?*), 1892, Kunstmuseum, Basel, Switzerland,
Depositum of the Rudolf Staechelin Family Endowment (photo Martin Bühler) /
Edouard Manet, *The Bar at the Follies Bergères*, 1881/1882, Courtauld Gallery,
London / Caspar David Friedrich, *The Cross in the Mountains*, 1808, Staatliche
Kunstsammlung, Gemäldegalerie Neue Meister, Dresden, Germany / Henri Matisse,
Blue Nude I, 1952, Fondation Beyeler, Basel / Jean-August-Dominique Ingres, *The
Bather*, 1808, Musée du Louvre, Paris / Albrecht Dürer, *The Four Apostles* (detail),
1956, Alte Pinakothek, Munich, Germany (photo Artothek)

Back cover photos from top to bottom:
Giovanni Bellini, *The Doge Leonardo Loredan*, 1501/1505, National Gallery, London /
Wilton Diptych (detail) ca. 1395–1399, National Gallery, London / Albrecht Dürer, *The
Four Apostles* (detail), 1526, Alte Pinakothek, Munich, Germany (photo Artothek)

Frontispiece:
Giovanni Battista Moroni, *The Tailor*, ca. 1563/1566, National Gallery, London

American text version by: Editorial Office Sulzer-Reichel, Overath, Germany
Translated by: Sally Schreiber, Friedrichshafen, Germany, and
 A. Elisabeth Anderson, Chicago, IL
Edited by: Barbara Parks, Rochester, NY

First edition for the United States and Canada
published by Barron's Educational Series, Inc., 1998.

First published in Germany in 1997 by
DuMont Buchverlag GmbH und Co. Kommanditgesellschaft, Köln, Germany.

Text copyright © 1997 DuMont Buchverlag GmbH und Co. Kommanditgesellschaft,
Köln, Germany.

Copyright © 1998 U.S. language translation, Barron's Educational Series, Inc.

All inquiries should be addressed to:
Barron's Educational Series, Inc.
250 Wireless Boulevard
Hauppauge, New York 11788

Library of Congress Catalog Card No. 97–075288

ISBN 0–7641–0435–7

Printed in Italy by Editoriale Libraria

Contents

Contents

The Crash Course *The History of Art* is chiefly an introduction and stimulus to seeing. The ability to see a painting arises from personal observation of an individual work of art. This act is the source of the joy and profit that the masterworks of painting give us. The short descriptions of pictures found in this book are meant to provide an impulse to look at the pictures. Every age has developed its own way of looking at the world, including our own visual perspective of today. One might say that the history of painting is a reflection of these various ways of seeing. The historical perspective of each age on the world around it—the way it takes visual possession of that world, nature and humankind—determines to an important extent the nature of the artistic invention of the painter. That is why this book provides a sketch of the cultural history of the given age in which the painters worked at the beginning of each chapter. The theoreticians of the Italian Renaissance placed *inventione* (pictorial inventiveness) at the center of their focus. Before the picture could actually be "made," its theme had to be thought out intellectually, and it had to be artistically translated into an "idea." This process was also what liberated the painter from the status of a mere craftsperson, and surrounded the artist with the aura of the new world of artistry. In the course of painting history, with its enormous variations of themes, constructions, color significance, surfaces, lines, and light, the artist became, by the end of the 19th century, virtually a magician of the visual image. If the compressed format of this Crash Course leads to the ability to sense the qualities of individual works, and also makes the reader aware of the artistic and cultural framework behind the paintings, then the author will have achieved his one of his major goals.

I would like to thank my teachers, Manfred Wundram, Max Imdahl, Gert Kreytenberg, Werner Busch, and Sir Ernst H. Gombrich, who taught me how to see pictures in Bochum, Florence, and London. Beat Wyss, Boris von Brauchitsch, Mario Kramer, and many others provided me with important references. I would like to thank Elisabeth Knoll for the faith to dare to embark on a Crash Course; Gitta Maczkowiak and Anita Brockmann for their understanding after long hours of work into the night; Achim Mantscheff, Nicola von Velsen, and Ingo Eilert for their competent transformation of flying pages into a book. Bernd Fechner was my patient companion, and not only during the many weeks of quarantine with the work of this book.

V. G., November 1997

The Middle Ages

Preliminary remarks

In spite of all arguments to contrary, the Middle Ages continue to be seen as a Dark Age in the history of art—a judgment dating back to the view of art history propounded by Giorgio Vasari (see p. 51), for whom light dawned in painting only around 1300 with Giotto and the advent of the Renaissance. However, a "modern" approach tends to overlook the essence of medieval art. The history of medieval painting cannot, in fact, revolve around the names of great artists, and an exclusive concentration on painting in a post-medieval sense, namely on book illustration and wall-painting, limits the focus to only a part of the medieval oeuvre.

The Middle Ages had not yet divided art into painting, sculpture, and crafts (which is, incidentally, a 19th-century concept). Neither did aesthetic norms and guidelines exist for the various genres. Furthermore, the identity of the artist, his social position, and his working place are difficult to determine. Even when individual artists began to sign their work after 1150, they remained, essentially, professional craftsmen. The age did not view the creativity, or ingenium, of the artist as personal talent, a concept that arose only after 1500. Instead, art originated in a larger, usually religious context—highly skilled service ostensibly carried out for the patron, but in reality done in the service of God. The medieval artist remained humbly in thrall to longstanding tradition. Only in the late gothic period, and more significantly in the Italian Renaissance, did the individual artist move into the limelight of history.

The heritage of antiquity

In ancient Greece and Rome, artists had already dealt with the same themes and problems of representation that would be worked through once more step-by-step from the Middle Ages to the 16th century

Renaissance. The ancients had already achieved pictorial depth through perspective—although in a form different from that which has been common since the Renaissance. Not only had the antique world arived at an astonishing realism in the rendering of their subjects, it was already working in all forms of modern painting (portrait, genre pictures, still lifes, and pictures of historical events).

If we can to believe an anecdote of Pliny the Elder (24–79 AD) in his *Historia Naturalis*, artists enjoyed quite an exalted reputation. The perfect imitation of nature and reality, or mimesis, was the highest ideal of art for Pliny, who describes one painting containing a water basin on which live doves alighted and attempted to drink. The realism of the painting was so great that the birds flew into the surface without recognizing the artificiality of the basin or water. Pliny remained an authority throughout the Middle Ages and into the Renaissance, even though for many centuries people had no concrete idea of the actual paintings he was describing. His valuation of a work of art in terms of its imitation of reality remains to this day an effective element in all polemic against nonrepresentational art.

[1]
Tomb of the Diver, (wall painting, detail), 5th century BC, Museo Archeologico, Paestum.

Today, through modern archeology, we have access to actual examples of ancient painting, but we must in turn ask whether, and to what extent, such works were familiar to the Medieval artist. Conversely, what might the medievals have had available to them that has been irretrievably lost to us? We possess only scattered and fragmented examples of original ancient Greek painting [1]—aside from the overwhelming quantity of painted vases, whose discovery dates from the first excavations of Etruscan graves during the Renaissance. However, Roman mosaics and murals, often clearly deriving from Greek models, convey a good idea of Greek painting [3]. The discovery of the the ancient frescoes in Nero's *Domus Aurea* in Rome around 1500

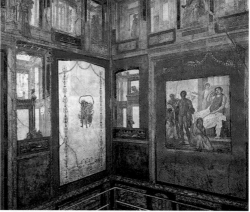

[2]
Dome Mosaic, (detail), ca. 450/460, Orthodox Baptistry (San Giovanni in Fonte), Ravenna.

[3]
Room with *Scenes from the Life of Ixion*, 63–79 AD, wall painting, House of the Vettii, Pompeii. The ancient master-pieces of wallpainting found in Rome, Pompeii, and Herculaneum, as well as the early Christian painting in the catacombs, were unknown to the people of the Middle Ages.

immediately inspired the so-called "grotesque" wall decorations by the Renaissance painters of Raphael's circle (see p. 59). Medieval wall painting and, especially, book illustration contain antique elements reflecting a cultural memory that kept the antique world alive through the centuries. Mosaics dating from the 4th to 6th centuries in upper Italian basilicas, in Ravenna [2], and especially in the early Roman churches are important not only to the history of religion, but also as vehicles of the ancient classical inheritance. Another possible bridge between the ancient and medieval world were the remains of ancient and early Christian paintings, mosaics, and ivory carvings [4] that were still extant in the northern provinces of the Roman empire, in Cologne and Trier, for example.

Also critically important in conveying the uninter-rupted tradition of ancient themes and images were the writing chambers, or *scriptoria*, of the monasteries. Here, the monks not only copied ancient texts, thereby passing them on from generation to genera-tion, but also preserved antique motifs, which the scribes adapted and developed over the years in illuminated books and manuscripts.

A discussion of painting from 800 to 1300 AD must therefore concentrate chiefly on book illumination,

church murals, and, after 1100, the newly invented art of stained glass.

The iconographic controversy—
From the icon to the panel

The historical development of religious painted panels, meant to inspire prayer and devotion, is more complicated than one might suppose. Initially, in an attempt to eliminate pagan idol-worship, the Christian Church rejected all images of Christ as devotional aids.

In the early 5th century, the Councils of Ephesus and Chalcedon had a lasting influence on the question of religious pictures, or icons (*ikone* = picture), when they defined the dual nature of Christ as both God and man. Meanwhile, between 450 and 550, the introduction of supposedly miraculous icons of Christ in Asia Minor also caused a loosening of the ban to some extent. Believers claimed that these icons had not been made by human hand, but were, so to speak, the actual reproduction of the physical and divine image of Christ. The icons soon came to be venerated and carried in processions through the Eastern Roman Empire, a ritual heretofore reserved only for images of the emperor, to emphasize his presence and authority even in the far reaches of his domain.

Conflict between Church and Emperor was inevitable, in part because the icons, with their "miraculous" origins, became relics whose touch imparted holiness and healing [6]. The growing popularity of the religious icons undermined the authority of the Eastern Roman emperor, who united worldly and divine power in his own person. In the 8th century, this tension led to a bloody controversy over image-worship, which, after several victories by the iconoclasts, or those opposed to images, finally ended in the 9th century with the formal acceptance of religious pictures and a precise recognition of their function. In Byzantium, the icon was in fact officially established as the only possible form of religious panel

[4]
Priestess, ca. 400 AD, ivory, 11.8 x 5.5 in., Victoria & Albert Museum, London. Late antique reliefs, collected by the monasteries, convey ancient classical motifs to later ages.

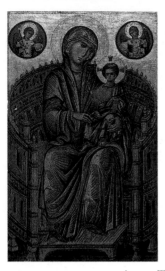

[5]
Enthroned Virgin and Child, Byzantium, late 12th century, mixed technique on wood, 32 x 19 in., Andrew Carnegie Collection, National Gallery of Art, Washington, D.C.

[6]
Virgin and Child with Angels and Saints, early 7th century, wax painting (encaustic) on wood, 27 x 27.5 in., Monastery of St. Catherine, Mt. Sinai. Since the 6th century, legends have claimed that the earliest pictures of Mary were painted by St. Luke— thus granting the "Lucas Madonnas" the highest authority in Rome and Byzantium.

picture. Through the centuries, these icons remained remarkably constant in form, content, and even details of gesture.

This conservative attitude toward the visual image may be based in the use of a supposedly authentic picture of a saint or holy figure as a relic: any change would bring about a reduction of its power. In the West, throughout the Middle Ages, icons were also mounted as altarpieces in France and Italy, unlike Byzantium, where they were chiefly were used to beautify the *iconostasis*, or separating screen between the altar and the nave of the church.

In the course of the Middle Ages, the new role of the altarpiece, combined increasingly with subjectivity of thought, and the influence of a new, mystical current in religious life (*devotio moderna*), culminated around 1300 in the development of new pictorial media. The transition from the icon to panel painting as it developed in western Europe was completed only in the late Middle Ages and early Renaissance.

The beginnings of painting in the Middle Ages

After the disintegration of the western Roman Empire at the end of the 5th century, graphic art almost came

to a halt. With time, however, a new culture began to install itself amid the ruins of the once-blossoming Roman cities. The various princely courts strove toward a higher standard, with the monasteries playing a perhaps even more important role in cultural development. Surprisingly, the legacy of the ancient world survived in its clearest form at the borders of the former Roman Empire, especially in what is today Great Britain. There, the traditions of the antique world mingled with Celtic and Germanic influences, particularly in the complex calligraphic designs on the decorated pages of illuminated manuscripts. The highly developed form of book illumination best displays its mixed heritage in works such as *The Willibrord Gospels* [8], the *Lindisfarne Gospels* [7], with their almost overgrown Celtic ornamentation, and the magnificent *Book of Kells*, which presumably originated on the Scottish island of Iona at the end of the 8th century (now in the Trinity College Library, Dublin). Also dating from the 6th and 7th centuries, the earliest surviving Roman frescoes, such as those in Santa Maria Antiqua, clearly show early Byzantine traits. Otherwise, examples of painting from this period are rare. In the Merovingian empire (present-day France), as well as the Germanic territories, the term "cultural vacuum" (to quote the cultural historian Erwin Panofsky) is an appropriate description.

The Carolingian Renaissance

In this vacuum Charlemagne built his empire. His renewal of the Roman Empire embraced all aspects of public life, and economically, administratively, and culturally, he oriented himself on ancient models. With Charlemagne's imperial coronation in 800, he forged a bond with the Roman pope, whose influence and contacts had been equally oriented toward Byzantium and the West until that time. In one of the most momentous events in European history, the coronation served not only to establish ties between the Roman church and Charlemage's empire, but also

[7]
Ornamental page from the beginning of the Gospel of St Matthew, *Lindisfarne Gospels*, Lindisfarne, ca. 700, paint on parchment, 13.4 x 9.5 in., British Library, London.

[8]
Ornamental page from the Gospel of St. Mark, with the symbol of St. Mark, *Gospels of St Willibrord*, Echternach, ca. 690, paint on parchment, 12.8 x 10.4 in., National Library, Paris.

to weaken the connection between Rome and Byzantium. In turn, the role of antiquity as a model for the West can be seen in Charlemagne's establishment of a "court school" with the aim of centrally organizing the culture, and disseminating its influence into the provinces either in the form of artistic artifacts, or court-trained artists. The greatest testament to the Carolingian Renaissance are its architectural remains, especially Charlemagne's Chapel in Aachen, a variation on the late antique church of San Vitale in Ravenna, with its mixture of Byzantine and classical elements.

Illuminated books and manuscripts provided the most important link to antiquity. The vellum-bound codex, developed in the fourth century, replaced the scroll, which had been in use since classical Greece. In the great volumes, the illustrated pages possessed no intrinsic artistic worth, but were meant only to illustrate the biblical text. The initials, or first letters, of the Gospels are particularly magnificent. In addition, a book would usually contain illuminated dedictory pages, pictures of the evangelists [9], a stately and beautiful page with the figure of the enthroned Christ—and, somewhat less often, a portrait of the illuminator himself. Furthermore, scenic backgrounds and architectural works came into a new "golden age" under Charlemagne's patronage. The conscious preservation of the literary heritage of the ancient world is also evident in the Carolingian reconstruction of the antique miniscule script, which became a pattern for modern handwriting.

Unfortunately, with the exception of the wall paintings in the church of Müstair in Graubünden, Switzerland, hardly any large murals from the 8th and 9th centuries have survived. Roman mosaics from the same period (Chapel of St. Zeno, Santa Prassede) borrow strongly from Byzantine pictorial formulas.

[9]
The Four Evangelists (detail), *The Aachen Gospels*, Aachen, ca. 810, 12 x 9.5 in., Cathedral Treasury, Aachen.
Carolingian book-painting and the highly developed art of ivory relief carving are full of antique motifs. These figures are wrapped in Roman robes, and move with surprising freedom through a three-dimensional space.

From the 10th to the 12th centuries—
The Romanesque Period

The death of Charlemagne led to a cultural standstill. The confusions over the subdivision of his realm and the wars that ensued were only temporarily relieved by the Peace of Verdun in 843, which broke the empire into three parts. Not until the 10th century was there a cultural resurgence in central Europe, incited by stimulating influences from Byzantium, after the marriage of Otto II (973–983) with Theophanu, the niece of the Byzantine emperor. The most important surviving works of the period are the gospels and *psalters*, or collections of psalms, the most splendid examples of which were commissioned by the emperor. In such works, architecture was reduced to stylized set pieces, lacking any spatially unifying power. In contrast to Carolingian art, an impulse toward abstraction outweighs the naturalistic realism found in antique art [10]. Major schools of book illumination were located along the Rhine, the Meuse, and on the island of Reichenau in Lake Constance. Of similar formal austerity are the church interiors from the time of Emperor Otto I (936–963) and his successors, above all the church in Oberzell, also located on Reichenau, where the individual paintings are decorated with painted frames in an effectively antique-looking serpentine pattern.

Romanesque church murals, whether painted in fresco or mixed technique, must be seen as an element in a complex scheme of church design. The sculptured portal, the stone capital decorated with biblical scenes, and the murals on the walls of the nave and chancel work together to provide a comprehensive theological vision for the faithful. The dark interiors of the churches were lightened by the colorful in-

[10]
Christ and the Captain of Capernaum, Codex Egberti, Reichenau, ca. 980, paint on parchment, 10.6 x 8.3 in., Stadtbibliothek, Trier. Gestures, glances, and the hierarchical order determined by the narrative dominate the complex miniatures. The figures are immovably fixed onto the rectangular surface and at the same time strong and expressive.

[11]
Apse fresco from San Clement de Taüll (removed), ca. 1120, Museu de Arte Catalunya, Barcelona.

terworking of all the elements, and effect which was further enriched by the use of sparkling enamel and gold work, especially in the opulent reliquary shrines (decorated receptacles for the sacred remains of the saints), which begin to appear in the 11th century in south-central France and in the Rhine-Meuse area. In the course of the century, an increased internationalization in painting styles becomes more evident. Church frescoes in San Angelo a Formis (near Capua, north of Naples), and the Catalan St. Clement de Taüll [11] reveal only slight differences from German, English, or French work of the age. In Romanesque art—the first universal European style—similarities are stronger than regional differences.

This unity was based on the dominance of the Holy Roman Empire, which stretched from the North Sea to Provence to Rome, and encouraged the migration of artists (for example, the Langobards who were active in Saxony). In addition, the age saw the rise of the great medieval commercial cities, such as Cologne, Milan, and Venice, which became coordinating points for cultural exchange. The influence of the first crusades and the development of the great pilgrimage routes which traversed Europe must not be underestimated. The clearest expression of this mobility are

Erwin Panofsky (1892–1968): *Renaissance and Renascences in Western Art.* Erwin Panofsky was one of the most influential art historians of the 20th century. After emigrating from Germany in 1933, he taught at Princeton University, and, along with Aby Warburg, was one of the founders of the discipline of iconology, the analysis of content and significance of images based on comparison with texts from literature, history, and the sciences.
In his influential study *Renaissance and Renascences in Western Art* (1960), Panofsky argues that revivals of the antique tradition occurred repeatedly throughout the Middle Ages. Thus the famous Italian Renaissance between approximately 1300 to 1500 did not signify a radical break with Medieval tradition, for the classical world remained present throughout the Middle Ages in art, philosophy, and the natural science.

the Norman campaigns in lower Italy, Sicily, and England. These conquests spread Byzantine forms and other motifs—now arising chiefly from the Arabic cultural sphere—across Europe largely by means of such easily transportable artwork as textiles, ivory, and jewelry.

Spain and the Arabs

With the founding of the Emirate (later Caliphate) of Cordoba in 756 began the long Islamic rule of the Iberian peninsula. The period between 800 and 1000 can be seen as one of the great epochs in European culture. Broad tolerance characterized the Islamic state made up of Christians, Jews and Muslims, and through Spain, both Mozarabic culture (court art of the Christianized Arabs) as well as ancient knowledge found their way to Europe. After the fall of the Omayyad dynasty in 1028, tensions increased, culminating in the Christian *Reconquista* of the areas of Spain that had been in the hands of the north African Islamic dynasties. Finally in 1492, the conquest of Granada was completed by Spain's king and queen, Ferdinand and Isabella. Culturally, the Arab influence remained alive through the influnce of Moorish artists, who had a strong influence on the Christian art of northern Spain, as well as on Sicilian mosaics and architecture. The Moorish influence is most clearly evident in the strong Arabic tendencies of the Mudéjar style of architecture. In painting, the influence appears primarily in decorative details, in the flat backgrounds filled with interlaced patterns, as well as in the oriental representations of animals (gryphons, peacocks, predatory animals). Highlights of Mozarabic illumination are the *Commentaries on St. John's Apocalypse* of Beatus de Liebana, created between 975 and 1200, several copies of which still survive [12].

[12]
The Four Horsemen of the Apocalypse, in Beatus Liebana, *Commentaries on the Apocalypse*, North Spain, ca. 1050, paint on parchment, 14.4 x 11 in., Bibliothèque Nationale, Paris.
The glaring colors and stylization of men and animals are a synthesis of Roman-Christian and Islamic art. The narrative richness, literally bursting with fantasy, explains why Umberto Eco borrowed many descriptions of manuscripts from the *Commentaries* of Beatus for his novel *The Name of the Rose.*

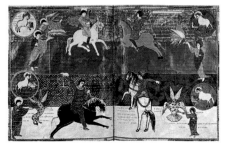

The 13th century—The High Gothic period

The Hohenstaufen empire, which had slowly been eaten away in the struggles against an overly-powerful papacy and individual princes, finally dissolved in 1268 with the execution of Conradin in Naples. At the same time, England and France were increasing their influence. The political problems of the last Hohenstuafen kings had proved particularly beneficial to France, with the conquest of Naples and Sicily by the French House of Anjou. In the western Mediterranean, the Spanish House of Aragon became the dominant political power.

The most splendid artistic creation of the time is the Gothic cathedral, whose "invention" was closely linked to the rising power of the French kingdom. Already before 1150, Abbot Suger of St. Denis in Paris, drawing on early scholastic philosophy, described the spiritual symbolism of the cathedral as the light of God made visible. For the first time in the history of art theory and artistic practice worked together in the creation of a new style. As a "heavenly Jerusalem" made of stone and light, the cathedral united architecture, sculpture, and the goldsmith work of the glittering reliquary shrines into a Gesamtkunstwerk (see p. 162). In the course of time, as stone walls increasingly gave way to windows and narrower bearing architectural members, actual wall space was further and further reduced and the importance of wall paintings declined in favor of stained glass. Mainly in Italy, where fewer windows interrupted the church walls, were large wall areas still painted with fresco cycles.

The earliest surviving examples of stained glass stem from the 11th century, with the first connected series of stained glass pictures appearing in the cathedrals between about 1160 to 1180. In stained glass work, colored and painted pieces of glass are joined together by lead piping in a technique that favored a more detailed compostion than allowed by Romanesque wall painting. The stained glass pictures, composed as they were of many small pieces and mounted high in

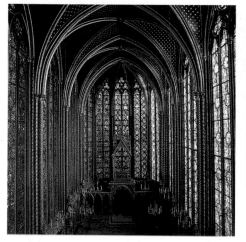

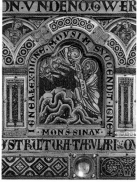

[13]
Sainte-Chapelle, interior of the upper church, 1241–1248, Paris.

the cathedral, are not in fact "legible" as pictures. Thus, an abstract theological comprehensiveness replaced the didactic Romanesque pictorial utilitarianism by means of a calculatedly overwhelming effect on the faithful within the light-flooded and impressive interior of the church [13]. The central themes of the stained glass cycles were legends of saints and the life of Christ, presented in typological contrast to scenes from the Old Testament.

Profane pictorial themes in the Middle Ages

Medieval artists also depicted, on various levels, profane (i. e., non-religious) objects, events, and narratives. On the one hand, a series of biblical scenes offered a good opportunity to introduce details of domestic or public life into the picture; on the other hand, the craftsmanship of the artist itself became an appropriate subject

[14]
Nicolas of Verdun, *Moses on Mt. Sinai*, Altar of Klosterneuburg, (detail), ca. 1181, gold and enamel on wooden base, 5.5 x 3.9 in., Monastery of Klosterneuburg near Vienna. The renewal of cathedral sculpture took place alongside developments of painting, goldsmithing, and book painting.

Georges Duby (1919–1996): The Age of the Cathedrals. Scarcely any historian has influenced our image of the Middle Ages and its art as strongly as Georges Duby. His numerous books describe the mentality of the medieval person, and interpret the art of the age in terms of the intellectual, historical, and sociological conditions of the time. In his lively and fluid language, he expanded important standard works on Medieval Christian symbolism in art history. Since the 1980's, Duby's writings have played an essential role in the growing public interest in the age of the great cathedrals.

[15]
God Father as architect, *Bible moralisée*, Champagne (Reims?), mid 13th century, paint on parchment, 13.5 x 10.2 in., Österreichische Nationalbibliothek, Vienna.
Biblical illustrations demonstrate the Medieval interest in questions about the natural sciences.

[16]
The Ammonite Mabash mistreating the Jews of Yabesh, *Psalter of St. Louis*, ca. 1263–1270, paint on parchment, 8.3 x 5.7 in., Bibliothèque Nationale, Paris.
The miniature refers to the pogroms against the Jews beginning in 1200. The Jews can be recognized by the pointed caps that they were forced to wear.

matter. For example, the construction of the Tower of Babel could provide an excuse for a meticulously detailed description of the construction site of a medieval cathedral with its surrounding workshops and quarters. By the late 12th century, courtly feudal culture had become heavily ritualized, revolving around the ideas of honor and courtly love. Lyrics, verse epics and romances—such as the songs of Walther von der Vogelweide (active ca. 1190–1230), the *Lais* of Marie de France (first half of the 12th century), the courtly romances of Chrétien de Troyes (ca. 1135–1190), Arthurian romances, the *Parzival* by Wolfram von Eschenbach, and *Tristan and Isolde* by Gottfried von Strassburg (both around 1210)—are poetic expressions of the age. Manuscripts of these popular works presented various narratives of life at court in idealized form. Even in religious art, whereas the biblical characters of the early and high Romanesque had been clothed in a broadly antique style, the 13th century gave its figures an altogether different look: contemporary knights now peopled the biblical scenes, bringing the narrative into the present-day world [16]. Important media of visual representation were also maps and atlases of the world, and, even more importantly, manuscripts dealing with the natural sciences (medicine, botany, and zoology), as well as astrology. The illustrators of antique or scholastic texts of the age frequently had to invent pictures for texts, for which there were no prior examples [15]. These illustrations, therefore, offer valuable insight into the contemporary understading of pictorial art. Without the inventions and traditions developed by these nameless illustrators, the Italian Renaissance would be unimaginable.

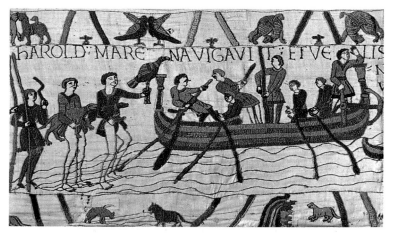

Work habits and position of the artist

The construction sites of the cathedrals were large, well-organized undertakings, employing architects, stone masons, and stained glass makers. Building plans were contained in architects' drawings. Painters worked with pattern books in which they recorded their creative ideas for new pictures, but also copied and passed on other patterns for later use. A famous example of such a book is the *Pattern Book* of Villard de Honnecourt, which presents the whole span of Gothic painting, from the illustration of animals to architectural details. The book painter, usually confined to a monastery, expressed his individuality in *marginalia*, small draw-

ings in the margins of manuscripts. Apart from the main religious subjects, these drawings allowed him free artistic expression of his fantasies. Increasingly, the artists began to immortalize themselves in their own work, whether in the form of a written sigature, or in a small self-portrait [18].

[17]
Harold's Embarcation for England, *Bayeux Tapestry*, ca. 1080, wool needlework on linen, 1.7 x 226.4 ft., Musee de la Tapisserie de la Reine Mathilde, Bayeux.
This unique historical picture depicts the Norman conquest of England in 1066 in the finest detail.

[18]
Self-portrait of the Stained Glass Worker Gerlachus, ca. 1150, stained glass, 20.7 x 19.9 in., Westfälisches Landesmuseum für Kunst- und Kulturgeschichte, Münster.
This self-portrait does not allow one to draw conclusions about the emancipation of the artist, who remained bound as a craftsman to his workshop and guild.

Late Middle Ages and Early Renaissance

1275
Marco Polo reaches China
1309
Removal of the Pope to Avignon; start of the "Babylonian Captivity"; papacy dependent on French king
1309–1343
Robert the Wise, from the House of Anjou, rules the Kingdom of Naples
1311–1321
Dante Alighieri writes *The Divine Comedy*
1313–1375
Giovanni Boccaccio
1328–1498
Rule of the House of Valois in France after the extinction of the Capetians
1339
Beginning of the Hundred Years's War under King Edward III of England

Late Medieval or Renaissance?

In the 14th century, Italy underwent tremendous economic growth. After the decline of imperial Hohenstaufen power, the city-states, principalities, and dukedoms—republics and tyrannies alike—were drawn into constant military, economic, and cultural competition with and against each other. Nonetheless, the urban trade-based bourgeoisie shared a pragmatic approach toward both the world and religion, as well as a new, more self-conscious individualism than been possible during the Middle Ages. These attitudes provided the ground for the flowering of art during the Italian Renaissance.

In an attempt to raise their standing above their own non-aristocratic origins, the newly rising Italian families were eager to surround themselves with courtly, late chivalric art from northern Europe. As a result, several artistic developments blossomed parallel to each other until the end of the 15th century in Italy—a situation that contradicts the one-sided image of Italian culture totally engaged in the Renaissance. In northern Europe (England, France, Burgundy, Bohemia), the post-scholastic philosophy of Roger Bacon (1214–1294) and the Nominalism of William of Ockham (ca. 1285–1349) opened new directions for art. Experience, the observation of nature, and experimentation yielded a new image of the human being. On top of this came the influence of the

The term Renaissance was used for the first time by Vasari in 1550 to describe the "Rinascimento," the renewal of painting after the (to him) barbaric darkness of Gothic art. In 1855, the French historian Jules Michelet (1798–1874) reintroduced the term into historical scholarship, and Jacob Burckhardt brought the word to public attention in his *Culture of the Renaissance in Italy* (1860), in which the Renaissance means the rebirth of the antique world in all areas of culture—that is, literature, historical writing, and painting. Burckhardt's definition reflects his interest in the Renaissance of 15th century Italy, where the attitudes of the strong tyrannical and autocratic rulers determined the prevailing culture. Challenged today in many of its details, Burckhardt's work nonetheless presents a broadly conceived panorama of the age and, along with its high literary quality, remains a standard work on the history of art.

mystical texts of Meister Eckhart (d. 1327), and St. Birgitta of Sweden (ca. 1303–1373), who argued for a personal submersion into the incarnation of Christ (*devotio moderna*) and the incorporation of religion into the private life.

Around 1450, this combination of contemplative and analytic impulses led to the late Medieval painting of the Netherlands by way of the so-called International Gothic style, in which narrative richness and realism of detail flowed together in a process comparable to what was occurring in the Italian Renaissance. It is significant that from Florence to Sicily and Spain— that is, throughout southern Europe— active import trade developed, centered on Early Netherlandish paintings and tapestries, which were purchased by the southerners not as exotica, but as the logical extension of their own artistic activity.

An analysis based only on social history cannot explain the great regional differences in artistic developments of the time, for the social structures of the great Flemish trading cities like Ghent or Bruges were in fact very similar to those of the Italian cities, and yet the regions followed very different courses of cultural development. On the other hand, the courtly art and culture of the Burgundian heartland, Bohemia, France, and England, is more comprehensible because in these areas, the Medieval feudal system underwent its last great flowering.

In the following discussion, the terms "Late Medieval," "Early Renaissance," and "Renaissance" are used as technical historical terms of reference, and describe in any case two equally valuable sides of a single coin.

Giotto—The "Father of Painting"

Giotto de Bondone (ca. 1266–1337) opened the door to a whole new world of painting, as Vasari was the first to recognize in his *Lives* of 1550, when he designated the artist as the "Father of Painting" (see p. 51). Under Giotto, Italian painting became the leading European style until well into the 17th century.

see p. 51

1346–1378
Rule of the Luxemburg Emperor Charles IV; golden age of Bohemian court culture
1356
Golden Bull: the German king is simultaneouly the elected Holy Roman emperor
1358
Hanseatic cities unite in a league for the support of their mutual interests
1363–1477
Golden age of the intermediary kingdom of Burgundy; Maximilian I inherits kingdom on the death of Charles the Bold
1378–1417
Great Schism of the Church
1378
Geoffrey Chaucer: *The Canterbury Tales*; beginning of English poetic tradition

Terms commonly used in discussion of Italian Renaissance art:

Duecento	= 13th c.
Trecento	= 14th c.
Quattrocento	= 15th c.
Cinquecento	= 16th c.
Seicento	= 17th c.
Settecento	= 18th c.

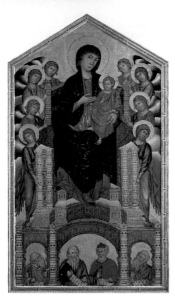

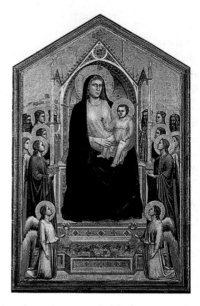

[19]
Cimabue, *Maestà*, ca. 1280–1285, tempera on wood, 12.6 x 7.3 ft., Galleria degli Uffizi, Florence.

[20]
Giotto, *Madonna Enthroned*, ca. 1310, tempera on wood, 10.7 x 6.7 ft., Galleria degli Uffizi, Florence.

A student of Cimabue, Giotto probably first painted in the Upper Church of San Francesco in Assisi, and between 1304 and 1310, he created the comprehensive *Cycle of the Cappella degli Scrovegni* in Padua (Arena Chapel). After 1311, aside from longer stays in Milan and Naples, his traces can be discerned in Florence. Further major works have been to some extent preserved in the Frescos of the Bardi and Peruzzi Chapels (after 1320) in the Franciscan church Santa Croce in Florence. In addition, Giotto was active as a painter of altar pieces, and as an architect (campanile of the Florence Cathedral)—in total, a compact oeuvre, especially because many of his frescos have been destroyed.

Giotto's contemporaries, the poets Dante and Petrarch, had already noted that Giotto was the first painter to introduce reality into painting. He filled a comprehensible pictorial space with persons who could be imagined in real life, and who generate spatial corporality, in contrast to the flatly conceived and linearly decorated icons of a Byzantine madonna [5], or even a madonna image of his teacher Cimbue [19].

Giotto does away with the remote immateriality of Medieval religious images [20] and enables viewers to identify themselves with the woman on the throne—an experience that shook religious painting to its foundations.

Simultaneously depicting a succession of moments in time, Giotto redefined pictorial narration. He arranged in a single pictorial frame scenes which actually occurred sequentially in the biblical text [21]. Thus, in the *Raising of Lazarus from the Dead*, Christ, with an expansive gesture, orders the helpers to open the tomb. While the women are in the process of beseeching Christ for the decisive action, Lazarus is already awaking back to life, and at the same moment the helpers are in the process of lifting the stone from the tomb. The movement of Christ's arm is continued upward and to the right (that is, in the direction of reading) by the line of hills, and thus strengthened; in its upward direction, the gesture already anticipates the resurrection of Lazarus. In Giotto, both the before and after of the story is experienced simultaneously in the present moment of the picture. Giotto compensates for the painting's loss of spirituality by its nearness to reality and requires from the viewer an intensive involvement with the biblical story and its structure. This approach corresponded to the mystical texts of the time (for example, to those of the Pseudo-Bonaventure), which humanized the incarnation of Christ.

Giotto was the first painter to distinguish between interior and exterior space in painting. From this point onward, the separating wall between the scene of the painting and the viewer is often absent from pictures, opening the possibility for the communication among the persons in the picture through doors and windows on the pictorial stage. The volume, or bodily

[21]
Giotto, *Raising of Lazarus from the Dead*, 1304–1310, fresco, Arena Chapel, Padua.

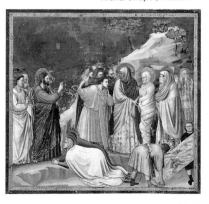

presence, of Giotto's figures actively control the surrounding space, but the narrative is acted out on a plane parallel to the surface of the picture, not yet in the front and rear of the pictorial room.

Modern art history has taken up Giotto's art with great enthusiasm because his complex surface and room structures correspond to modern visual experiences. The painters who followed his tradition enriched the compositions of the master with narrative details, but distanced themselved increasingly from his rigor. His most important students are Maso di Banco (active around 1330–1350), who developed a special sense for abstract surface effects (Bar-di-Vernio Chapel, Santa Croce, Florence, ca. 1330/1340) and Taddeo Gaddi (ca. 1300–1366) who introduced experimental illumination effects into fresco painting.

The alternative in Sienna—
Duccio and the Lorenzetti Brothers

In Sienna, it took longer for religious painting to move away from the Byzantine tradition—a development that Giotto had accomplished in one leap. As a result, for many years, early 13th century Siennese painting unjustly stood in the shadow of Giotto and his school. Where Giotto employed block-like volumes, line remained determinant for Duccio de Buoninsegna (1250/60–1318). In both beauty of line and graphic development, as well as in the richness of his materials

In fresco painting (from Italian *fresco*, fresh), the wall is first coated with wet lime, and mineral colors are immediately applied to the fresh plaster. When dried, the calcium, water, and colors combine to make a resistant layer. A new area of the wall is prepared on a daily basis, because the plaster dries out (daywork). The preliminary sketch (sinopy) is worked with charcoal or bronze earth tones. Since the Quattrocento, a 1:1 sketch is prepared and the outline of the contours are pricked directly into the fresh plaster from the sketch. Details were often added after the plaster had dried (al secco), but these passages have not held up to time so well. Fresco painting could only be used where walls remained dry—in the cooler north of Europe, painted canvases were used for ceiling paintings, and walls were decorated with tapestries rather than frescoes. In the sixteenth century, the fresco technique spread hesitatingly across France (School of Fontainebleau) and to the north, where it underwent a final blossoming in Austria and southern Germany during the Baroque and Rococo.

and colors, Duccio is in no way inferior to Giotto, and in fact his imaginative narration, his sensitive gradations of color, and surprisingly deep pictorial and landscape spaces, even surpass those of the Florentine artist, as seen in Duccio's *Scenes from the Life of Christ* [22] on the reverse side of the Maestà, the gigantic former main altar painting of the Cathedral of Sienna. On the front, Mary sits amid a circle of saints, in an early rendition of the *sacra conversazione* or "holy conversation"—a painting theme that later became popular in the Florentine Quattrocento.

[22]
Duccio, Entrance of Christ into Jerusalem, *Maestà* (detail, reverse side) 1308–1311, tempera on wood, 41 x 21 in., Museo del Duomo, Sienna.

Duccio's student Simone Martini (1284–1344) presents a still broader spectrum of themes and styles. He also made his start in Sienna with a *Maestà* (1315), painted as a fresco for the Palazzo Pubblico in a courtly variation on Duccio's front painting of the cathedral. Martini's further work in Italy [23] increasingly reveals influences from late French Gothic book painting, as evident in the Frescos of the Martin's Chapel in the lower church of San Francesco in Assisi, and the artist in fact became a court painter in Naples to Robert I of Anjou in 1317.

[23]
Simone Martini, *Annunciation*, ca. 1333, tempera on wood, 8.7 x 10 ft., Galleria degli Uffizi, Florence.

From Martini we learn far more about courtly life of the trecento than from Giotto, who pursued timelessly classic religious pictorial images which existed apart from daily life. Martini slowly worked his way to Avignon, although his works there are no longer extant. In all probability, the brothers Ambrogio and Pietro Lorenzetti (late 13th c.–1348 and ca. 1280–1348) were students of Duccio. Their altar paintings and frescos, revealing also the influence of Giotto, are more emotional and more lively

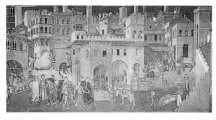

[24]
Ambrogio Lorenzetti,
Allegory of Good Government (detail, left half), ca. 1338–1340, fresco, 78.7 x 46 ft., Palazzo Pubblico, Sienna.

than those of their contemporaries [24]. Ambrogio's major work, the monumental portrayal of *The Allegory of Good Government*, is not only the first landscape and cityscape in European art, but also reveals the self-understanding of the city government of Sienna in its innumerable details.

International Gothic

Between approximately 1370 and 1430, a similar phenomenon appears throughout European painting from England, through France, Burgundy, northern and central Germany, Bohemia, Austria to Italy. Characteristics of the International Gothic style came together in the sculptures of the "Beautiful Madonnas," in the wall, panel and book painting of the age, as well as in goldsmithing. The term describes common stylistic characteristics, without the existence of a direct connection between individual works, which in fact were produced in widely distant locations. Increased mobility after the Black Death of 1348, as well as the expansion of European trade, allowed a quick exchange of ideas. Sculpture, illuminated books, and devotional pictures functioned both as a medium of diplomacy and as gifts between courts and governments. A refined courtly culture—for whose style initially the Bohemian Habsburg court of Emperor Charles IV, and later the courts of the Burgundian

The publication of *The Waning of the Middle Ages* by the Dutch historian and language scholar Johan Huizinga in 1919 caused an excitement similar to that generated earlier by Burckhardt's *Culture of the Renaissance in Italy*. In contrast to Burckhardt, who ascribes an optimistic attitude to the new age, Huizinga describes a declining culture, whose decadence tried to suffocate itself in gaudy display in Burgundy, France, and the Netherlands of the late 14th and 15th centuries. Knightly symbols and ideals became hollow shells, which meanwhile were loaded with heavy pathos. The fear of death was inescapable, and against it was set an exaggerated feeling of life in a kind of eschatological mood. In early Dutch art, Huizinga discerns not so much the realism of a van Eyck as the brilliantly painted detail and the materiality of objects—a form of materialism under which the harmony of the whole may suffer.

dukes, set European standards—celebrated itself in painting in the form of shimmering gold backgrounds, delicately changing colors, subtly moving garments, preciously refined gestures, and the ambiguously smiling faces of saints and angels. Stemming from the early years of the period, the private chapels of Emperor Charles [25] are comprehensive works of art which incorporate precious stones with panel painting, frescos, and liturgical equipment.

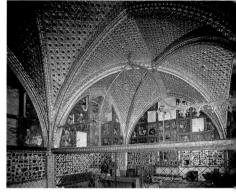

[25]
Chapel of the Holy Cross, ca. 1365, Karlstein Castle, near Prague.

The Medieval people increasingly began to see themselves as individuals, and for this reason, private religious devotion became more important, resulting in an increase of commissions for smaller household altar panels [26]. The wasteful riches of this art form may have been a counter-reaction to the misery and devastation of the Black Death in the middle of the century, which had already depopulated wide areas of Europe. In fact, images of death and the transitoriness of life, which reflect the existential experiences of the age, begin to appear in art between 1350 and 1450. In France, double grave sculptures representing the deceased as a worldly figure in the full glory of office and worldly honor, but underneath as a *transi*, or worm-eaten corpse, become typical at this time. Religious art concentrated on devotional pictures containing drastic portrayals of the suffering and patiently endured martyrdom of Christ, found in the "suffering crucifixions" (also called "plague cruc-

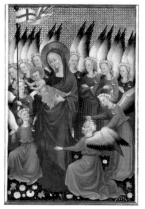

[26]
Wilton Diptych (right panel), ca. 1395–1399, 14.5 x 10.5 in., National Gallery, London. The small format enabled easier transport from place to place, and raised the intimacy of the worship. This private use of the panels did not prevent a high level of refinement in material and workmanship.

29

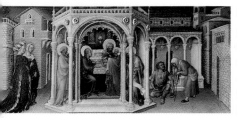

[27]
Gentile da Fabriano, *Presentation of Christ in the Temple*, predella of the altar painting Worship of the Magi, 1423, tempera on wood, 10 x 26 in., Galleria degli Uffizi, Florence.

[28]
Middle-Rhenish Master, *Garden of Paradise*, ca. 1410, tempera on wood, 10.4 x 13 in., Städelsches Kunstinstitut, Frankfurt.

ifixions"); panel paintings depicted the instruments of martyrdom and scenes of the Passion of Christ through multiple signs and symbols. At the same time, in a counter movement, pictures began to convey more strongly the dogmatic contents of faith, especially in the environment of the Dominican order which was responsible for carrying out the Inquisition.

The late *gotico internationale* period in Italy occurred at the same time as the early Renaissance, and enjoyed equal favor from contemporaries. Influences deriving from the work of Lorenzo Monaco (ca. 1370–1425) and Gentile da Fabriano [27] (ca. 1360/70–1427) are still evident after 1498 in Botticelli's late religious work. In Burgundy, Melchior Broederlam (active ca. 1381–1409) pointed the way to the art of Jan van Eyck and the Flemish Master of Flémalle, whereas in Germany, painters of the School of Cologne, in

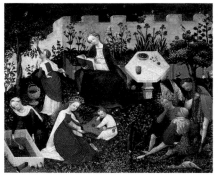

particular Stephan Lochner (ca. 1400/ 10–1451), and in the north the Masters Bertram (ca. 1340–ca. 1415) and Francke (ca. 1380–after 1430), combined the linearity of Bohemian courtly art with the richness of details found in French book painting and the early Dutch masters [28].

Tempera painting (from Italian *temperare*, to mix) remained the standard technique for wall painting until 1440 in the Netherlands and 1500 in Italy. The process had already been used in medieval wall painting. Colored pigments are mixed with water and a binder (such as egg, or oil, with additions of honey, milk, and clay) and applied to the surface in several layers. After drying, the color is no longer water-soluable; perhaps for this reason, tempera pictures are often oriented on line, and are determined by the perimeter. A transparent resin coating lends the picture a gleam, but not the depth of color attained by oil paints. Normally, tempera was applied to a wooden panel; several panels could be attached for a larger picture.

The triumph of French book painting

Avignon is, so to speak, the launching pad for the dispersal of Italian art—in particular Siennese art (Martini)—northward into Burgundy, central France, and the Netherlands. At the court of Avignon, the late Gothic observation of nature, poetry, mystical theology of the *devotio moderna*, united with Italian beauty of line. Book painting became the medium of the hour: at once luxurious and easy to pack and transport, illuminated books became collector items. They both enhanced the honor of courtiers and princes such as the Duc de Berry in Bourges (the brother of Philip II, the Bold, of Burgundy) and served in private worship.

Among the multiplicity of high quality miniatures, the work of the Limbourg Brothers (ca. 1375/85–1416) stand out. Commissioned by the Duc de Berry, they produced several parchment books of hours, including *Les belles heures* (Metropolitan Museum of Art, The Cloisters, New York) and *Les très riches heures* [29], "the most tender and finest creation of miniature art," according to historian Johan Huizinga. With their detailed illustration of the annual cycle of nature, these early 15th century books of hours represent the first series of genre pictures in the history of painting. They anticipated later religious pictorial inventiveness, and their deeply boxed interiors prepared the way for the art of Van Eyck "in miniature."

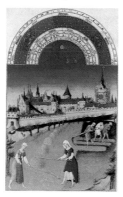

Panel and wall painting reveal at this time a correspondingly less independent profile, aside from the work of various regional schools, such as that in Provence around 1400. Jean Fouquet (ca. 1415/20–1477/81), as a miniaturist and panel painter, also forms an exception, and essentially founded French painting.

Important late-Gothic illuminated manuscripts:
Bréviaire de Belleville by Jean Pucelle, ca. 1330, Bibliothèque Nationale, Paris
Book of Hours of Jeanne d'Evreux, by Jean Pucelle, ca. 1330, Metropolitan Museum of Art, The Cloisters, New York
Book of Hours of the Boucicaut Master, ca. 1405/1410, Musée Jacquemart André, Paris
Book of Hours of the Bedford Master, 1410/1420, British Museum, London
Book of Hours of the Rohan Master, ca. 1420/1425, Bibliothèque Nationale, Paris

[29]
Limbourg brothers, calendar page for June, *Les très riches heures*, ca. 1416, paint on parchment, 11 x 8 in., Musée Condé, Chantilly, France.

The Renaissance in Florence— Beginning of a New Age

1385–1402
Giangaleazzo Visconti enlarges Milan's sphere of influence
1389
Ottoman Turks conquer the Serbs
1401–1464
Nicolas of Kues (Cusanus) lays scholasticism to rest with his *De docta ignorantia*, ("Of learned ignorance") (1440)
1404
Greatest expansion of the Teutonic Order of Prussia into the Baltic lands
1414/1418
Council of Constance; beginning of Church reform; election of the Roman Pope Martin V ends the Schism; condemnation and burning of reformer John Hus
1431
Execution of Joan of Arc in Rouen
1434–1464
Cosimo de'Medici rules Florence indirectly with republican committees and stewards
1453
Conquest of Constantinople by the Ottoman ruler Mehmed I Fatih; end of the Byzantine Empire

The Florentine Renaissance arose in an urban commercial environment which had not only developed sophisticated accounting procedures for deposit and credit banking, but which felt at home with philosophical and literary discussion. It was in Florence that the architect and sculptor Brunelleschi (1377–1446), influenced by antique models, developed his new, classically-oriented designs for palace and church architecture (San Lorenzo and San Spirito), even surpassing the Roman Pantheon with the dome of the Florence Cathedral. Meanwhile, the sculptor Donatello (ca. 1386–1466) turned his back on Gothic wall sculpture, introducing in its place free-standing figures whose proportions, postures, and clothing drew closely from antique models, and demanded a precise knowledge of human anatomy. Simultaneously with Lorenzo Ghiberti (1378–1455), Donatello invented a painting-like bas-relief sculpture in deep perspective (*rilievo schiacciato*). Looking back to ancient Roman, and later Greek models, the first generation of humanists developed distinct literary genres anew: lyric, historical description, scientific tract, and dialogue.

Of course the ground for these developments had already been laid in the early *trecento* between 1300 and 1330 by the poetry of Dante, Petrarch, and Boccaccio, the sculpture of Niccolò (ca. 1220–1278/84) and Giovanni Pisano (ca. 1250–after 1314), as well as the painting of Giotto and the Siennese masters. However, the simultaneous appearance of innovations in all areas of the Florentine cultural laboratory between 1410 and 1440 remains a remarkable phenomenon. The notion of the *uomo universale*, the universal man—the many-sided intellectual who was both a successful artist and scientist—encouraged a fertile, inter-disciplinary creativity: the sculptors Donatello and Ghiberti self-confidently designed stained-glass windows for the

Florence Cathedral, while the architects Brunelleschi and Alberti provided decisive impulse for the new theories of perspective.

Politically, however, Florence was torn by factionalism. The city defined itself as a republic (*commune*), and was in fact ruled by several family clans by means of "democratic" committees—a format hardly consonant with our present-day understanding of democracy. In a sophisticated competition to present themselves as patrons and sponsors, the great Florentine families supported church endowments and institutions, assumed important guild positions, built grand palaces, and increasingly made use of references and models drawn from antiquity to inflate their image among the populace. The artistic and literary avant-garde of the age not only conveyed the necessary cultural understanding internally to the Florentine families, but also soon began to export it beyond the boundaries of the city-state.

The motivating force behind these developments was Cosimo de'Medici (1389–1464), scion of a successful Florentine banking family. Officially, Cosimo was never more than minimally engaged in city govern-ment; unofficially, he expanded his political influence by filling offices with his clients, who were closely

1455–1485
War of the Roses between the Houses of Lancaster and York in England
1492
Death of Lorenzo de'Medici
1494
Charles VIII of France conquers Naples; collapse of the Italian city-state system
1498
Reformist preacher Savonarola executed in Florence

Leon Battista Alberti (1404–1472) was the ideal *uomo universale*, or universal man. He was not only a pioneer in architecture, and active as both a sculptor and painter, but he compiled the Renaissance knowledge of art in his tracts on painting, sculpture, and architecture.

The effect of his treatment of art in *De pictura* (1435) on his contemporaries cannot be overestimated. Philosophical discussions of architecture by Brunelleschi flow together with his own work. Alberti's tracts distinguish themselves from all previous treatments of painting in their theoretic approach and in their elevation of painting from a craft to the ranks of intellectual knowledge. In his first section, Alberti describes the principles of linear perspective, as first employed by Masaccio. He develops the famous image of an open window through which one looks into the visual pyramid of the pictorial space, organized by a central perspective. In the second section, he concerns himself with the *disegno* of drawing—a term he used for both the outline drawing as well as for all aspects of pictorial composition, including the choice and use of the right colors. This section is particularly important for art scholarship, for Alberti makes the contemporaty 15th century art terms available to later ages. In the last section he describes the correct education of the artist.

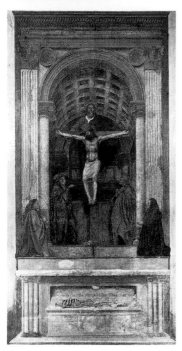

[30]
Masaccio, *Trinity*, ca. 1427, fresco, 22 x 10.5 ft. Santa Maria Novella, Florence.
The expansion of the pictorial space not only in depth, but also foreward toward the viewer, draws the faithful into the religious event depicted.

bound to him through blood or debt. His gradual gutting of the republican system soon brought him into conflict with the influential Albizzi family, who effected Cosimo's banishment in 1433. Within one year, however, he reentered the city in triumph and proceeded to consolidate his position beyond challenge.

Masaccio—
The second revolution in painting

In the 14th century, Giotto had begun a new age in painting with the introduction of realism; a century later, in an equally revolutionary development, Masaccio (1401–ca.1428) reorganized pictorial space by means of perspective. His fresco *Trinity* [30] marks a turning point in Western art. The viewer gazes into a barrel-arched room whose depth is suggested with mathematical precision. By means of linear perspective (*costruzione legittima*), a relatively simple geometrical process, the various planes and layers of the three-dimensional space are projected onto the surface of the painting. Lines of vision direct the viewer's eye into the depths of the (re-)constructed pictorial room, and both real and virtual lines of perspective culminate in a vanishing point. In classical central perspective, this point is always exactly at the center of the picture; so-called two-point perspective, however, allows for a second vanishing point.

In his *Trinity* fresco, Masaccio utilized perspective with a single vanishing point. In contrast to the pictorial space the Dutch painters created by means of empirical painterly experience, Masaccio faced the problem of arranging figures in a mathematically defined space without making the picture appear to be artificially constructed, and thus isolating them from the composition, or even sacrificing them to the ideal propor-

tions of the room. Masaccio solved the problem by placing the traditional portraits of his patrons, the figures of Mary and John next to the cross in different spatial planes, whereas the postion of God the Father remains unclear, thus softening to some extent the rigors of the mathematical perspective: the Father stands on a kind of raised platform at the far end of the chapel room, and lifts up the cross, whose base rests on the front edge of the step—in fact on the same level as Mary and John.

The enrichment of mathematical perspective by such irrational impulses reveals both the painter's artistic freedom and masterful virtuosity. Naturally, appreciation of such intellectual play presupposes a critically discerning observer.

Masaccio was the first artist to unite Giotto's principles of composition with the possibilities offered by perspective, a combination particularly clear in the predella panels at the base of the altar pictures. His masterpiece in the Brancacci Chapel of Santa Maria del Carmine (after 1424/1425) far surpasses even Giotto's depiction of both narrative and human figures. Masaccio not only distributes large numbers of figures across a wide pictorial field, but also depicts human beings in their individuality [31]—a revolutionary break with the Medieval past, which had conceived of human figures only as types.

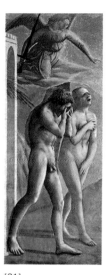

[31]
Masaccio, *The Expulsion of Adam and Eve from Paradise*, ca. 1425–1427, fresco, 6.7 x 3 ft., Santa Maria del Carmine, Brancacci Chapel, Florence. The painting portrays the reaction of Adam and Eve to their banishment humanly, not abstractly.

Florence from 1420 to 1450— The creation of the avant-garde

The successors of Brunelleschi, Donatello, and Masaccio are similar in their eager play with all the various forms becoming available in the Renaissance, and in their development of their own individual styles.

The plastic forms in the frescos of Andrea del Castagno (ca. 1421/23–1457) appear to be a translation of Donatello's sculptures into painting. There is almost a violence in the cool perspective of Castagno's *Last Supper* [32], which is perhaps the boldest of the

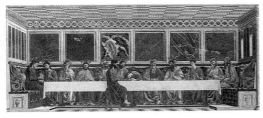

[32]
Andrea del Castagno, *Last Supper*, ca. 1445–1450, fresco, Refectorium of the Santa Apollina Monastery (Castagno Museum), Florence.
In spite of their strong gesture and action, the apostles and Christ take on an abstract character derived from the cool marble splendor of the room. The painting illustrates the diffculty of grouping figures within a mathematically conceived space.

[33]
Domenico Veneziano, *Madonna and Child with Saints* (part of the Santa Lucia Altarpiece) ca. 1445, tempera on wood, 6.8 x 7 ft. Galleria degli Uffizi, Florence.

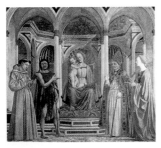

numerous treatments of the theme until that of Leonardo. Recognizing the problem presented by too obviously mathematical perspective, Domenico Veneziano (ca. 1400/10–1461) responded by muting the color of his paintings, and thus his few surviving predelle and altar paintings achieve an atmospheric density unknown in painting up to that time. In his *Santa Lucia Altarpiece* [33], probably one of the most exciting paintings of its age, Veneziano's subtle gradations of color fill the room with air, light, and shadows for the first time in the Italian Renaissance. When viewed from above, the façade of the Arcadian architecture runs parallel to the surface of the painting, and appears to be the front, or first, plane of the picture. Viewed from below, however, the columnar architecture seems to be in a second plane, in front of which the saints are standing on the boldly foreshortened floor tiles. Like Masaccio, Veneziano developed a pictorial room as an outgrowth of the space of the viewer. The enthroned Mary is not clearly to be located on a single pictorial plane, for the necessary points of reference are lacking. To faithful believers praying before the picture, she moves closer, or remains distant— the choice is left up to the viewer, who thus actively participates in the process.

The Dominican Fra Angelico (ca. 1387–1455) is often denigrated as an artist of sweet Madonnas; his frescos commissioned by Cosimo de'Medici for the monastery of San Marco, together with other works contained in the cloister museum, remain very popular with the public. The colorful world of the saints in all their rich anecdotal detail, however, distorts appreciation of this thoroughly intellectual painter, whose works in fact represent extremely sophisticated experiments in the

development of painting. Fra Angelico enriched the standard figure of the Madonna within the circle of saints, the *sacra conversazione*, with spatial and boldly conceived figural variants, in which the narrative wealth co-exists with almost abstract detail. Particularly in the predella panels of his altar paintings, the artist worked out new narrative forms within his seemingly naive play with pictorial space, surface, and depth [34].

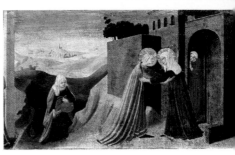

[34]
Fra Angelico, *Visitation* (detail), panel from the altar picture of the *Annunciation*, ca. 1449, tempera on wood, 8 x 11 in., Museo Diocesano, Cortona.

Vasari's *Lives* assigned Paolo Uccello (1397–1475; see p. 42) the role of the eternal eccentric of the Florentine Renaissance. In fact, there is almost no painter whose works are more strongly rooted in perspective construction than Uccello. However, the artist was also aware of the shortcomings of this approach, and, like Masaccio, strove in his composition to integrate his figures into the pictorial surface of his paintings. Under the patronage of the Medicis, he became one of the busiest and most sucessful artists of Florence, working on both the Cathedral and urban cloisters. In spite of its eschatological theme, his fa mous fresco of the *The Great Flood* [35] paradoxically celebrates the rapprochement of Eastern and Western Christianity in 1439—ironically, shortly before the fall of Constantinople. The remarkable presentation of two arks in a single picture symbolizes the union of the two churches, pulled together by the extreme visual foreshortening of what Alberti would have called the visual "pyramid."

[35]
Paolo Uccello, *The Great Flood*, ca. 1444– 1447, fresco, 7 x 16.7 ft., Santa Maria Novella, Chiostro Verde, Florence. Cosimo de'Medici is present as a full figure, right, and is "baptized" by Noah, as Christ was baptized by John. Blessing the new world, he rises above all threats from his political enemies, and stands for the beginning of a "Golden Age" under the patronage of the Medici.

Campin and van Eyck—The triumph of oil painting

While the ideal of antiquity and experiments with perspective increasingly absorbed Italian painting, a

[36]
Roger Campin, *Mérode Altar*, ca. 1425–1430, oil on wood, 21.5 x 10.8 in., Metropolitan Museum of Art, The Cloisters, New York.

[37]
Jan van Eyck, *The Arnolfini Marriage*, 1434, oil on wood, 33 x 22.4 in., National Gallery, London.

different kind of revolution was taking place in the Netherlands. Here, too, realism made its way into painting, not in idealized form as in Italy, but in the concrete reality of everyday objects, domestic interiors, and the people to whom they belonged. The work of the Master of Flémalle presents this reality as a *fait accompli*. In a style that is the antithesis of the contemporary book painting, with its emphasis on beauty of line, he presents saints, a painfully distorted sufferer on the cross, and an annunciation to Mary which emerge with almost sculptured dimensionality from the gilded background of the lovingly composed room [36]. Today, most of the works of the Flémalle Master are ascribed to Roger Campin (ca. 1375–1444), who realistically portrayed the joy and pain of the biblical story by means of expressive postures and gestures, and an exactitude of observation carried down to the finest wrinkles of skin. The heavy symbolic atmosphere of Medieval painting is entirely absent. With such a painting, the question again arises as to its suitability as a spur to religious worship, for all religious signs and symbols are "painted out" in such detail as objects that they are no longer symbols. Erwin Panofsky (see p. 16) supplies an answer, discerning what he terms a "disguised symbolism" behind the realism. During the same period, Jan van Eyck (ca. 1390–1441) was creating both miniatures and, especially, oil paintings which cast "a gleaming light far beyond his own century" (Jacob Burckhardt). Inevitably, the viewer of a van Eyck painting moves closer to the canvas, and always discovers something new. But however close the eye approaches the surface, it never reaches that border

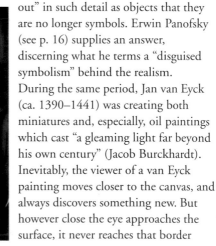

where the painted object dissolves into points of color. In both his miniatures and panel paintings, van Eyck offers a brilliant technical display of the possibilities of oil. Two and a half centuries later, Vermeer will consciously pick up the technical tradition (see page 106).

In his major works, van Eyck succeeded in creating a deep pictorial space whose depth derives from painterly experience rather than from mathematics. The viewing eye is always higher in van Eyck than in Renaissance Italian paintings. This raised observation point remains characteristic of Netherlandish painting, and allows the depiction of many objects in a room, only a section of which is normally presented. This combination draws viewers into the picture, and enables them to look into the depth of the room. The observer is thus made into a witness of the events of the picture. In the convex mirror on the rear wall of *The Arnolfini Marriage* [37], two persons can be seen, one of them possibly the painter himself. In order to be so reflected, the figures must be entering the room at exactly the point at which the viewer of the picture presently stands. The daring intellectual game of *Las Meninas* by the Spanish painter Diego Velázquez (see p. 90) is thus anticipated by two hundred years.

In contrast to Medieval painting, whose symbols were always primarily references to religious themes, van Eyck bequeaths the character of worship to the process of seeing, making it equal in value to the subject of the painting itself.

To what extent the miniatures of the *Turin Book of Hours* (Biblioteca Civica, Turin), as well as several panels, are to be ascribed to Jan van Eyck's elder brother Hubert van Eyck remains a problem for specialists.

[38]
Jan van Eyck, *Adoration of the Lamb, Ghent Altar* (detail), completed 1432. Oil on wood, 4.4 x 7.7 ft., (altar in toto 11 x 14.4 ft., St. Bavo, Ghent.
Van Eyck's monumetal masterwork of painting is full of details that must have seemed even more mysterious in the colored light of the medieval church windows.

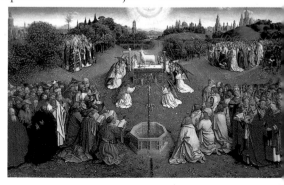

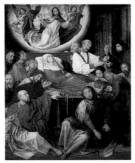

[39]
Hugo van der Goes, *The Death of Mary*, ca. 1478–1482, oil on wood, 4.8 x 4 ft., Stedelijk Museum voor Schoone Kunsten (Groeningemuseum), Bruges.

From van der Weyden to Memling

Rogier van der Weyden (1399/1400–1464) succeeded in balancing the monumental and expressive formal language of his teacher Robert Campin with van Eyck's realism of detail. With his comprehensive oeuvre, van der Weyden's clearly formulated compositional schemes remained influential for decades, both north and south of the Alps. He developed monumental designs for the large format altar painting [41], and his innovative smaller works present a complicated series of interior scenes which opened new possibilities in linking narrative trains of action within a single picture.

In van der Weyden, clear basic values of red, blue, and green prevail, creating a calmer effect than the abundance of color in van Eyck. As a result, the panoramic "Weltlandschaften—world landscapes" become quiet pictorial backgrounds in van der Weyden's work. The creative environment of the early 15th century Netherlands fostered the development of many individual styles of painting. Dirk Bouts (ca. 1410/20–1475) effected a stronger rationalization of interior space (*Last Supper*, 1464–1467, Peter's Church, Leuwen). Petrus Christus (ca. 1410/20–1472/73) approached, as it were, an elegant abstraction of the style of van Eyck.

Portrait: In the Middle Ages, a portrait meant presenting the subject in his social function, but did not necessarily imply the recognizability of the person. The portraiture of Roger Campin and Jan van Eyck changed these assumptions. By reducing the focus of the portrait to the head or upper body, the model moved nearer to the observer. Skin, physiognomy, and cloth were worked out to the last detail. For the first time, not only the social role of the subjects, but also their characters were found worthy of depiction—a development whose prerequisite was the newly won self-consciousness of the portrayed person as an individual [37]. Inscriptions in the painting, describing attributes, or writing on the frame (in Jan van Eyck's works, often preserved in the original), either expand on or make a riddle of the picture. Early Netherlandish portraits formed the necessary groundwork not only for portraiture in the time of Dürer, but also radiated influence as far as Italy and Spain. The portraits of Filippo Lippi, Botticelli, Ghirlandaio, and Antonello da Messina are hardly imaginable without the work of van Eyck and Campin.

However, the most interesting personality of the second half of the 15th century is without question Hugo van der Goes (ca. 1440–1482), whose altar paintings [39] formally drew the work of van der Weyden and van Eyck to their logical conclusion, and carried it psychologically even further. His major work, the *Portinari Altar*, erected in 1485 in Florence, aroused the greatest admiration in Italy, and parts of it were actually copied by Florentine painters into their own works (Domenico Ghirlandaio, *Adoration of the Magi*, after 1485, Foundling Hospital and *Adoration of the Shepherds*, Santa Trinità, Florence).

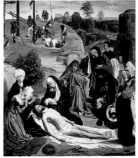

[40]
Geertgen tot Sint Jans, *The Lamentation*, ca. 1485, oil on wood, 5.7 x 4.6 ft., Kunsthistorisches Museum, Vienna.

With Hans Memling (1433/40–1494) and his student Gerard David (1463–1523), the tide of Dutch painting begins to ebb. Their peaceful composition, balanced color, and schematized gestures and actions reveal a diminution of artistic impulse.

In contrast to the the above-named painters, who worked in the triangle formed by Bruges, Ghent, and Brussels, Geertgen tot Sint Jans (active ca. 1460/65; died 1495), the sole significant painter in the northern Netherlands, was active in Leiden and Haarlem. His few surviving pieces offer a fascinating mixture of landscapes and lathe-turned figures, whose carved faces peer melancholically out of the painting [40].

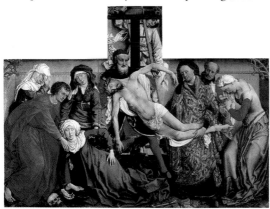

[41]
Rogier van der Weyden, *Descent from the Cross*, ca. 1435/36, oil on wood, 7.2 x 8.6 ft., Museo del Prado, Madrid.

Piero and Lorenzo de'Medici—
Florentine court art

In the middle of the 15th century, around the time of the construction of the Palazzo Medici, Florentine art began to follow a new direction, inspired by the decoration and interior design of the palace which was completed in 1456. The rise of the Medici in the first half of the quattrocento had gone hand in hand with the beginnings of Renaissance art; now, during the era of Cosimo's son Piero (1416–1469), the impetus moved more to decorative concepts. The important trading operations of the Medici in Bruges invited the purchase of Netherlandish art, and the artistic imports included the purchases of large-format altar pieces like the *Portinari Altar* by Hugo van der Goes, and the *Last Judgement* by Hans Memling (which was seized by ships of the Hanseatic League and carried off to Gdansk, Poland, where it remains to this day). Side by side with Florentine art works, series of Flemish tapestries decorated the walls of the Medici palace with profane themes from the world of chivalry. In 1459, Benozzo Gozzoli (1420–1497) paid homage to the new trend in art with his brilliantly colorful frescos, glimmering with gold, in the palace chapel [42].

The brothers Antonio and Piero del Pollaiuolo (1432–1498 and 1443–1496) created a *Hercules Cycle* for the main hall, while Paolo Uccello's (see p. 37) cycle of the *Battle of San Romano* (begun in 1444; completed for the Palazzo Medici ca. 1455; today, National Gallery, London; Uffizi Gallery, Florence; Louvre, Paris) glorified an insignificant dispute between Florence and Sienna in 1432 in three large panels. Crucial for the choice of theme was the coincidence of the battle with an important moment in the Medici rise to power. Uccello reflected the changing taste of the age by his flat, tapestry-like treatment of the background landscape. As with Gozzoli's frescoes, Uccello's panels also contain applications of gilt gesso that lend a shimmering glow

[42]
Benozzo Gozzoli, *The Procession of the Magi* (detail), 1459, fresco, Palazzo Medici-Riccardi, Chapel, Florence.
The painting melds joy in surface decoration with realistic portraiture of the Medici—in this case the young Lorenzo de'Medici, who participates in the procession as one of the three Magi.

to clothing and armor. In his late, and perhaps most beautiful work, *Hunt* [43], Uccello succeeds in creating a balance between the atmospherically dense forest landscape, and a forcefully presented depth of perspective.

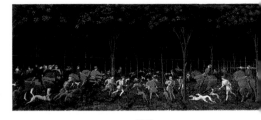

[43]
Paolo Uccello, *The Hunt* (detail), ca. 1470–1475, tempera with oil on wood, 30 x 70 in., Ashmolean Museum, Oxford.

The intellectual heart of the palace—and, next to the chapel, its most private room, entered by only the most selected guests—was the *studiolo*: a small chamber, at the end of the row of palatial rooms, which served for the study and safe-keeping of humanistic writings, ancient coins, jewels, and glass vessels. Subsequently, almost every larger Italian *palazzo* contained such a chamber.

A wide swath of the wealthy bourgeoisie also began to enrich their houses with humanistic themes by commissioning *cassoni*, or painted marriage chests. On the front, artists, such as Apollonio di Giovanni (ca. 1415–1465), depicted scenes from the ancient fables, or tales from Ovid, Livy, or even Petrarch. The figures, however, wore Renaissance, rather than ancient, clothing.

Under the influence of the Neo-Platonic philosophers Cristoforo Landino (1424–1498), Marsilio Ficino (1433–1499), and Pico della Mirandola (1463–1494) of the Platonic Academy, Piero's son Lorenzo de' Medici (1449–1492), termed *Il Magnifico*, "the Magnificent," completed the turn to a truly antiquarian artistic interpretation. Works as different as Michelangelo's early sculptures and the great allegorical paintings of Sandro Botticelli (ca. 1415–1510) reflect the change. Drawing from the quattrocento "beauty of line" tradition conveyed through

[44]
Sandro Botticelli, *Primavera* ("Spring") (detail), ca. 1482, tempera on wood, 6.6 x 10.3 ft., Galleria degli Uffizi, Florence. This painting presents a masterly combination of philosophical content, Renaissance human forms, and northern European richness of detail.

[45]
Domenico Ghirlandaio, *Pope Honorius III approving the Rule of St. Francis*, ca. 1482–1486, fresco, Santa Trinità, Sassetti Chapel, Florence.

For his contemporaries, Ghirlandaio was the guarantor of evenly balanced composition, and of excellent portraits of Florentine society, which he integrated into his wall paintings; he was also known for the restrained synchronization of his colors.

[46]
Sandro Botticelli, *Lamentation over the Dead Christ*, ca. 1490, Tempera on wood, 4.6 x 6.8 ft., Alte Pinakothek, Munich.

his teacher Filippo Lippi (ca. 1406–1469), Botticelli soon achieved success with his numerous Madonna paintings. Within the Medici circle, he built up a reputation as an illustrator of complicated humanistic themes, as reflected in his painting *Primavera* ("Spring") [44], whose symbolism even yet has not been satisfactorily interpreted. Botticelli was equally successful as a painter of illuminated books (illustration of Dante's *Divine Comedy*, Kupferstichkabinett, Berlin), and as a portrait artist. His *Birth of Venus* remains an icon for all tourists to Italy (see book cover). Botticelli's student Filippino Lippi (ca. 1457–1504) soon carried Botticelli's style into a detail-laden Mannerism.

The fresco cycles of Domenico Ghirlandaio (1449–1494) evince a more solid, but less poetically inspired effect than the work of Botticelli. This said, however, the *Frescos of the Sassetti Chapel* [45] are among the best of their time in their masterful presentation of a ripe and complex theological and humanistic theme. The comprehensive study of these frescos by the cultural historian Aby Warburg (1866–1929) stands as one of the cornerstones of modern art scholarship (see p. 166).

Ghirlandaio, as Michelangelo's teacher, and Andrea del Verrocchio (1435–1488) as Leonardo da Vinci's, stand at the threshhold of the High Renaissance, whose arrival was accompanied by two political events in Florence which marked the end of the early Renaissance. After the death of Lorenzo in 1492, the Medici palace was plundered, and a democratic city government banished the family from the city two years later. In a counterreaction to the Medici's "court of the Muses," the monk Savonarola established a theocratic

[47]
Pisanello, *Portrait Medal of Lionello d'Este* (front and reverse sides), 1441–1442, bronze, diameter 4 in., National Gallery of Art, Washington.

regime. Paintings and other signs of earthly vanity were incinerated. Both the spiritualized rigor of Savonarola's rule, and especially his execution in 1498, exerted a traumatic effect on Botticelli's late work [46], whose formal and religious rigidity never again recaptured the spring-like allegories of the Medici era.

Art of the Italian courts— Pisanello and Mantegna

Most artists of the quattrocento were active in several cities. For example, the Florentine Donatello also worked in Padua, Andrea del Castagno in Venice, Filippo Lippi in Spoleto, and Paolo Uccello in Urbino. The artist's mobility balances out the otherwise heavy concentration of art history in Florence. In addition, many artists migrated from court to court, led by the promise of artistic freedom and life at court. Such painters addressed the wishes of their patrons, and their job was always to further princely glory with their work. Portraits, in particular, played an important role as gifts in normal diplomatic work. Pisanello (ca. 1395–ca. 1455) was an ideal court artist in this sense, with his precisely detailed portrait medals [47], for unlike panel painting, the medals could be replicated. On the reverse of the

[48]
Andrea Mantegna, *Ceiling of the Camera degli Sposi* (detail), 1465–1474, fresco, Palazzo Ducale, Mantua.
In one of the most beautiful rooms of the Quattrocento, Mantegna opens the ceiling for the first time with a view into heaven.

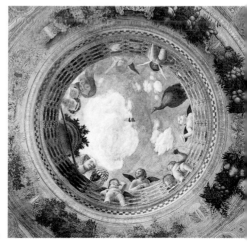

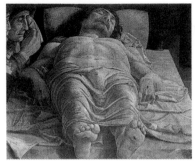

[49]
Andrea Mantegna,
Dead Christ, ca. 1480,
tempera on canvas,
26 x 32 in., Pinacoteca
di Brera, Milan.
The exaggerated fore-
shortening of the dead
Christ can be seen as a
work of art in its own
right, as well as an
endpoint in the develop-
ment of the devotional
worship picture.

medals, Pisanello translated the emblem, an encoded motto of the male or female ruler, into an intellectually allegoric image. Sovereign sublimity thus took material form in an easy-to-send bronze disc. Pisanello was also a successful painter of frescos depicting chivalric and religious themes, and his detailed drawing of plants, animals, and human figures document the awakened interest of the Renaissance in the intensive study of nature.

Andrea Mantegna (1431–1506) was the court painter to the Gonzaga family in Mantua from 1459. Not only did he take his motifs from antiquity, but also the crystalline outlines of his figures are reminiscent of ancient reliefs. The logical outgrowth of this direction was his series of paintings in *grisaille*, monocolor painting in gradations of gray. Further, his experimentation with various forms of composition developed new techniques, as in his *Ceiling of the Camera degli Sposi* [48], which is the foundation of modern *trompe l'œil* art. Mantegna's work was particularly influential in Venice, where his son-in-law Giovanni Bellini carried the older painter's pictorial types into the 16th century.

The most homogeneous image of courtly art arose in Urbino under Federico da Montefeltro (1422–1482). Having acquired wealth as a *condottiere*, or mercenary soldier selling his services to the highest bidder, he gathered philosophers, writers, mathematicians, and visual artists to his "court of the Muses." He

Allegory implies the presentation of concepts or mental understandings which are in themselves not able to be concretely represented. The image is given a meaning, and this invisible meaning is in turn illustrated through the image. Since the Renaissance, allegories have been a favorite means of exalting the ruler through borrowings from themes of ancient mythology. A favorite motif is the Golden Age, which goes back literarily to the Roman poet Ovid. In the Golden Age, humanity finds itself on the highest level of happiness, because the world is ruled by the wisest of all rulers.

commissioned illuminated books and invited the Netherlandish painter Joos van Wassenhoove (also called Justus van Ghent; ca. 1435–after 1480), the Spanish painter Pedro Berruguete (ca. 1450–1503/04), Paolo Uccello from Florence, and, in particular, Piero della Francesca, to Urbino, where he also had the most magnificent *studiolo* of the age.

Piero della Francesca

Piero della Francesca (1415/20–1492) is one of the most mysterious figures of the Italian quattrocento. There are only a few fixed dates that provide even a vague idea of the creative life of the painter as he moved between Sansepolcro, Florence, Rimini, Arezzo, and Urbino. Like Uccello, he was almost forgotten, until Roberto Longhi in the early 20th century insisted on a revaluation of his surprising qualities. Piero bequeathed the world of painting works which art critics considered unapproachable, even arrogant, "but which was in reality nothing else than the poetry of a perfect, crystalline world" (Roberto Longhi).

The world of Piero's painting seems hermetically sealed in stillness, and does not yield the impression that the pictorial space is separated from the observer merely by Alberti's "open window." Piero's art does not attempt an expansion of the space of the viewer, but rather creates its own world, which, although designed according to the laws of perspective, varies them to such an extent that a separate artificial and artistic world comes into existence. His treatment of color, surface, and space increase the impression of artificiality. On the one hand, his figures fill plastic volumes, defined by simplified outlines; but at the same time, they contain a high level of colored surface value. In this way, the various planes of depth in the room are forced together into a two-dimensional network of colored surfaces. The distribution of the

[50]
Piero della Francesca, *The Dream of Constantine*, ca. 1460(?), fresco, San Francesco, Main Choir Chapel, Arezzo.
The angel floats foreward from the upper left, and signifies to the sleeping emperor that he will be victorious in the next morning's battle against his rival Macentius through the sign of the cross. For Piero, this was reason enough to bathe the scene in light streaming from the angel.

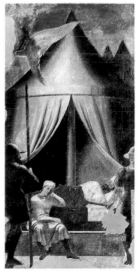

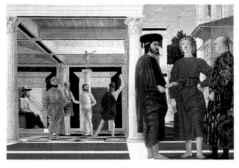

[51]
Piero della Francesca, *The Flagellation*, ca. 1458– 1460(?), tempera on wood, 23 x 32 in., Galleria Nazionale delle Marche, Urbino.
The overcast glances of Piero's figures at once seek direct contact with the viewer, but at the same time refuse it, lost in their eternal melancholy.

colors plays an important role, as is clear in the *Madonna del Parto*, where not only the the angels are arranged as mirror images of each other, but also the colors of their gowns and wings correspond with precise symmetry. The fascinating apparent hermeticism of the pictures, particularly his major work, the *Story of the True Cross*, in the Franciscan church at Arezzo [50] and the *Brera Madonna* in Milan (ca. 1470/75) has led 20th century scholarship to speculate over the content and patron of the paintings. Thus, the unknown accompanying figures at the biblical event of the *Flagellation* [51] have been variously interpreted as a call for the intervention of the West in the rescue of Constantinople, or as reference to political events of the day. More useful, perhaps, is Piero's essay *De prospectiva pingendi* ("On Perspective"), which provides insight into the artist's conception of painting.

The beginnings of oil painting in Venice—Da Messina and Bellini

[52]
Giovanni Bellini, *Madonna and Child*, ca. 1468, oil on canvas, 33.5 x 45 in., Pinacoteca de Brera, Milan.

Venetian painting of the trecento understandably looked to Byzantine models, considering the close trade relations between the cities. A Venetian specialty are the multi-panel altar pieces (*polyptyches*), framed

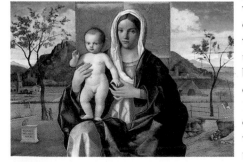

with late-Gothic richly carved frames. The tradition was not only continued by the family of the Vivarini, but also in the early work of Giovanni Bellini (ca. 1430–1516), who creatively experimented with all the variants of Renaissance art, up to his magnificent late

work, whose serenity and balance bring it close to the so-called High Renaissance (see p. 65).

External influences were important to Venetian painting. Florentine artists conveyed a knowledge of perspective, Mantegna and Bellini entered into an artistic debate which deepened the very individual styles of both artists in the process of reaching a mutual appreciation. Bellini carried the late Medieval devotional painting further, reduced the number of figures in favor of a more concentrated religious statement [52], and set his scenes in broad, atmospheric landscapes. Precisely here is he just as predictive of the future of painting as the discoveries concerning perspective in Florence were to be. In addition, northern European models were introduced by Antonello da Messina (ca. 1430–1479), who had become acquainted with Early Netherlandish Painting in Naples. Although Antonello was only a short while in Venice, his art made a powerful impression. His concentrated paintings, reduced to the most important essentials [53], united Italian physiognomy with Netherlandish realism. He was the first in Italy to make broad use of northern oil techniques in the creation of glow and depth—a development that apparently inspired Bellini, who began to let his figures merge into the atmospheric space. Leonardo's famous *sfumato*, or smudging of the outline, had already made its appearance with Bellini. Gentile Bellini (1429–1507) and Vittore Carpaccio (ca. 1460/ 65–1523/26) pursued another path: their cycles of saints' legends offer a lively picture of daily life in Venice, enriched by fantastic architecture and landscape scenes.

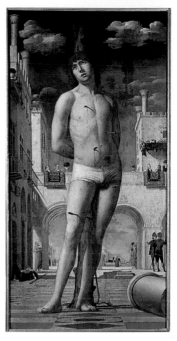

[53]
Antonello da Messina, *Martyrdom of St. Sebastian*, ca. 1476, oil on canvas stretched on wood, 5.6 x 2.8 ft., Staatliche Kunstsammlungen, Gemäldegalerie, Dresden.

High Renaissance and Mannerism

1455
Invention of the printing press with movable type by Johannes Gutenberg.
1483–1515
Charles VIII and Louis XII of France, heirs of Anjou, claim Naples and Milan.
1483–1546
Martin Luther
1489
Publication of the *Malleus maleficarum* or the *Witch's Hammer* by the Cologne Dominicans as foundation for the witch hunts.
1493–1515
Maximilian I enlarges the Habsburg territories with Burgundy and northern Italy.
1509–1547
Henry VIII of England
1511–1525
Jacob Fugger finances Charles V's election as Holy Roman Emperor.
1513–1521
Pope Leo X (a Medici) pushes for the system of indulgences; Raphael completes the painting of the Stanze in the Vatican.
1515–1547
Francis I of France
1517
Posting of the 95 Theses in Wittenberg by Martin Luther
1519–1521
Conquest of the Aztec Empire by Cortez

A world in transition

Around the year 1500, the world found itself in a transformational period which fundamentally challenged the self-understanding of humankind. Columbus's discovery of the Americas in 1492 signaled the dismissal of the notion of a flat earth. In 1512, Copernicus placed the sun in the center of the visible universe. These discoveries shook the foundations of theology and provoked the biggest crisis in church history: Luther's posting of the Theses on the palace church of Wittenberg marked the definitive departure from the established social order of the Middle Ages. While the Humanists reacted with uncertainty, the rage of the lower classes was unleashed during the German Peasant's Wars of 1524 to 1525. Irrational models of world salvation and apocalyptic visions appeared in all the nations of Europe, despite the failure of Savonarola's model for a godly state in 1498. Witch hunts and inquisitions became a part of everyday life. The philosopher Machiavelli responded to all of this with a rational conception of the world and of power, which laid the basis of modern political thought, shocking in its clean-eyed appraisal of power politics. This was especially pertinent against the backdrop of the invasion of the French king Charles VII, which caused the fragile system of Italian city-states to collapse like a house of cards. In 1492, the last Moors—as well as all the Jews—were expelled from Spain. In the east, the Ottomans were advancing westward through the Balkans, thereby threatening Venetian territories in the Aegean as well as Mediterranean trade. In Europe, the large states of England and France consolidated themselves. With the division of the Habsburg Empire between his two sons, Emperor Charles V came to accept the trend toward the development of nation-states. The sun had set over his empire. The struggle for dominance in

Europe between France and the Empire was being carried out on Italian soil, and the secular character of Renaissance papism ended abruptly in 1527 with the Sack of Rome, the bloody conquest of the city by the Catholic troops of Charles V, and the imprisonment of the Medici pope Clement VII.

Renaissance and/or Mannerism?

Artists react to political, philosophical and social turmoil in many different ways. The painters of the Italian High Renaissance ignored daily political events, and created an abstracted, self-contained, idealized art, which united classical tradition with the accomplishments of the quattrocento in a larger synthetic whole. All Italian painters after 1510

1519–1556
Emperor Charles V
1521
The Imperial Assembly of Worms; Luther is banished by imperial decree.
1524–1525
Peasant Wars in Germany
1522
Luther's first Bible translation
1571
The Turks are defeated in the naval battle of Lepanto.

Giorgio Vasari (1511–1574) is known to every visitor of Florence as the architect of the flight of rooms in the Uffizi (1559). Less well-known is the painter Vasari, who leaves an ambivalent impression with his decoration of the churches of Santa Maria Novella and Santa Croce. Of immeasurable importance is, however, his *Vite*, the collection of biographies of Italian painters through Michelangelo, that was published in 1555. This inestimable work remains a central reference for every involvement with Italian art. Many art pieces that have been lost over time are described in it. Of equal importance is the underlying historical philosophical concept of a developmental history of art, which has influenced the thought of Winckelmann and Hegel. For Vasari, art began after the dark Gothic Middle Ages, with Cimabue and Giotto. With the three masters Leonardo, Michelangelo, and Raphael, art achieved its final completion and hence had reached its actual end. After this only decay could follow; this view remained intact until the 19th century. Vasari recognized this problem and extended the second edition (1568) with critical annotations. The artist who—according to Vasari—merely copied Michelangelo would necessarily only produce sterile, unimaginative work. Hence, he should develop his own talent. In this manner, Vasari opened an escape route for the future of painting. The inherent logic and consistency of the arguments in the work, as well as the thorough research, are indeed impressive, though this does not mean that every detail remains valid today. Vasari was the first to understand artists within the framework of their respective artistic and historical contexts. He insists on the absolute nature of artistic qualitative criteria, but reminds us that Giotto, had he lived during the time of Raphael, might have been unsuccessful. With the often quoted *Disegno*, he not only cites the preparatory sketches, but also the intellectual achievement of the artist, before he transfers his *inventione*, the creation of the picture, to paper, a fresco or oil painting by following his specific personal *maniera*. The emphasis on the creative achievement places the artist above the sphere of the artisan, and creates his new social status.

distinguish themselves by their rejection of pursuing merely classical early Renaissance tendencies but reflect—to borrow Vasari's concept—a particular *maniera*, or technique, in their works. Today we understand Mannerism to be that exciting reaction by literature, painting, sculpture and architecture to a transformed framework of conditions which contradicted the harmonious tendencies of Renaissance norms and forms. While so-called High Renaissance art already contains Mannerist tendencies in the works of the great masters Leonardo, Raphael and Michelangelo, there is an explosion of Manneristic possibilities after 1520. Mannerism is therefore not a uniform European style, but rather it unites artists in their questioning, structurally unconventional view of things. Art becomes as complicated as its historical context. Only with the Baroque period during the Counter Reformation is it once again placed in a less ambiguous position.

The German painters around Dürer accomplished from 1500 to 1520 a synthesis of northern and southern art, and served the rising bourgeoisie of the

The **Sistine Chapel** of the Vatican was constructed as a simple hall (1473–1484) under the commission of Pope Sixtus IV—from whom it received its name. With its frescos and moveable art objects, it is a treasure trove of Italian art. From 1481 on, its walls were adorned with frescos depicting the life of Moses, as well as scenes of the life of Christ, by the most important artists of the late quattrocento (Botticelli, Perugino, Pinturicchio, Signorelli, Ghirlandaio and Rosselli). After Michelangelo painted the ceiling, Raphael drew the giant cartoons for a tapestry depicting scenes from the lives of the apostles (1515/1516) which was woven in the workshop of Pieter de Aelst in Brussels (the cartons in the Victoria and Albert Museum, London; tapestries in the Pinacoteca, Vatican). With the fresco of the *Last Judgment*, Michelangelo completed the furbishings. The various phases of decorating establish a comprehensive theological program: after Genesis (ceiling) there follows (a level below) the history of Moses as the lawgiver of the Old Testament. The life of Jesus in the New Covenant, as the fulfillment of the words of the prophets and the *sybils* (individual figures on the ceiling), is typologically contrasted with that of Moses. On special occasions, Raphael's tapestries decorated the lowest strip of wall. Scenes from the lives of Peter and Paul connect the life of Christ with the pope as his vicar, who is also elected in this chamber.

southern German cities with portraits and images that reflected their secular lifestyles. The most modern medium became printed graphics, the calculated utilization of which gave the Lutherans an inestimable media technological advantage. This "Reformation art" attempted—with only moderate artistic success—to create a religious pictorial language modeled after the Catholic pictorial pattern. The monarchs of the early absolutist state which established themselves across Europe during the second half of the century upon the ruins of the old world order, are celebrated in complex Mannerist allegories and images.

Leonardo

The natural scientist, sculptor, architect, painter and theoretician Leonardo da Vinci (1452–1519) personifies, as a "universal man" accomplished in all scientific and literary disciplines, the Ideal of the intellectual Renaissance artist in an extraordinary fashion.

In 1482, he abandoned his unconstrained artistic existence in Florence, where he had gained stature in the workshop of Andrea del Verrocchio and had created his earliest masterpieces, in favor of a life as court artist to the Sforza in Milan. Several of his most famous works originate from this period [54], including the mysterious Last Supper, around 1495/97. From 1500 to 1508 he once again lived in Florence, where from 1503 to 1506 he worked on the fresco *Battle of Anghiari* (destroyed), ironically in direct proximity to his archrival Michelangelo, who was preparing the *Battle of Cascina* (also destroyed) in the same room of the Palazzo Pubblico (today Palazzo Vecchio).

1582
Calendar reform under Pope Gregory XIII
1588
Destruction of the Spanish Armada by England
1589–1610
Henry IV of France
1600
Giordano Bruno is burned at the stake for heresy in Rome.

[54]
Leonardo da Vinci, *Virgin of the Rocks*, around 1485, oil on canvas, transposed from wood panel, 78.4 x 48 in., Musée du Louvre, Paris.

[55]
Leonardo da Vinci, *Mona Lisa*, around 1500/1502, oil on wood, 30.3 x 20.9 in., Musée du Louvre, Paris
One secret of its success is the subtle correspondence of the Lisa del Giocondo with the wide, evaporating background landscape—and, of course, the unbelievable smile itself! Leonardo achieves spatial depth with the toning and shading of color.

The legendary portrait of the *Mona Lisa* [55] is also from this second Florentine period. The contours of the figure "vaporize" in the physically perceivable atmosphere of subdued color, the *sfumato*, that envelopes the figure like a landscape. This conforms to Leonardo's theory that human emotions, like land formations, result from cosmic motions. In the microcosm of the painting both are fragments cut from the macrocosm of the world.

Leonardo left Italy in 1516 and became court artist to King Francis I in Amboise on the Loire, where he died in 1519. The various versions of *The Virgin Child and St. Anne* (around 1506–1513, Louvre, Paris) date to this period. The trio melts into the world of the landscape in a manner that had already been foreshadowed in the backgrounds of both version of the *Virgin of the Rocks* [54] and of the *Mona Lisa* [55]. Leonardo further develops this classic pyramidal composition of High Renaissance Mannerism with the complicated arrangement of the seated group and the opposing movements of their limbs.

In his countless drawings and scientific notebooks he attempts to master, as has no other artist, the laws of nature, human anatomy, physiognomy and the ideal picture composition. The range of topics ranges from drafts of fortifications, to aircrafts, anatomical sketches, caricatures, and the late, pessimistic landscapes of the Great Flood.

After Leonardo's death, his pupil, Francisco Melzi, compiled a volume of scattered theoretical texts and theses, which became famous as the *Trattato della Pittura*. Leonardo was convinced that artists could only create their own painted world if they constantly

analyzed and examined scientifically the natural physical laws. For that reason, he rejected Alberti's perspective theory as too simple. He was interested in the various effects of light and shadow, which he transposed in the color perspective of his paintings. Many of his works remain incomplete, because he was apparently more interested by the process of conceptualizing the picture before painting it, and by the experimentation with new techniques and media, than by the completion itself. His luxurious lifestyle clearly indicates that he distanced himself from the traditional role of the painter as mere craftsman. Leonardo's influence on the art of his time is great. The invention of *sfumato* had an especially wide influence. The Lombard painting of the 15th century (Bernardino Luini, around 1480/90–1532) would have been inconceivable if not for his example.

Michelangelo

The Florentinian Michelangelo Buonarroti (1475–1564) thought of himself not as a painter or an architect, but as a sculptor. In fact, only Leonardo's *Mona Lisa* is as eminent in today's consciousness as is Michelangelo's *David* (1504, Accademia, Florence). Such sculptures as the *Pietà* in St. Peter's in the Vatican (around 1498–1500), the *Moses* (after 1513, S. Pietro In Vincoli, Rome) or the *Tombs of the Medici Chapel in the New Sacristy of St. Lorenzo in Florence* (around 1524–35) are largely responsible for his fame. The *Doni Tondo* [56], which remains in Florence and is still kept in its original frame, is perhaps his only preserved panel painting. The figures, which are distinguished from the clear air by sharp lines, stand in stark contrast to the shadowy painting of Leonardo. Michelangelo makes reference to the round pictures of the

[56]
Michelangelo Buonarroti, *The Holy Family (Tondo Doni)*, 1503–1507, tempera on wood with original frame, 41.2 in. in diameter, Galleria degli Uffizi, Florence. Michelangelo reworked the long tradition of Madonnas of the quattrocento; new is the plastic compactness of the main group, whose complex movement suggests a Mannerist comparison with Raphael's Madonnas.

Umbrian painter Luca Signorelli (around 1440/50–1523) with the detail of the nude youths in the background. In the visionary centerpiece of the Chapel of San Brizio in Orvieto [57] Signorelli

[57]
Luca Signorelli, *The Last Judgment* (detail), 1499–1505, fresco, San Brizio Chapel, Orvieto Cathedral. Details of the Sistine Chapel, especially Michelangelo's nudes, are only understandable through Signorelli.

displays before the startled viewer the most extensive *Series of John's Apocalypse* of the Renaissance. If any work of art depicts the apocalyptic visions surrounding the year 1500 in Italy, then this is the one.

The creation of the imposing *Ceiling of the Sistine Chapel* (begun in 1508, completed in 1512 after a pause from 1510to 1511) is shrouded in legends. In 1505, Michelangelo was summoned to Rome by Pope Julius II to tackle the grandiose, but never realized construction of a tomb for the Pope. Julius soon shifted his priorities, and commissioned Michelangelo for the ceiling fresco. Annoyed, Michelangelo fled Rome, but he reconciled with his benefactor in 1508. How he managed to complete the imposing work without assistance in so little time, remains the subject of speculation.

The *Sistine Ceiling* [58] is without question a milestone in the history of painting. Its influence extends from Baroque painting to the advertisements of today. It is a masterpiece in its formal composition as well as in its penetrating content. The main sections develop from small, partitioned scenes to become large-figured and strongly animated; a sudden change in scale can be explained by the pause from 1510 to 1511. The creation of Adam belongs to the last group, and has since become a synonym for the new human image of the Renaissance. After it was cleaned in the late 1980's, the ceiling no longer seems uniform, as the *sfumato* effect was peeled away with the layers of grime: the original brilliant

colors were revealed, and the overall impression gave way to the various individual sections and scenes. This is a distinctly Mannerist characteristic. Only now does it become obvious where the Florentine Mannerists like Rosso, Pontormo or Bronzino borrowed their use of brilliant coloration, and in what relation Michelangelo's work stands to the late Raphael: one can certainly maintain that the *Sistine Ceiling* represents the founding work of Mannerism.

Michelangelo was not commissioned to do the *Last Judgment* [59] for the altarpiece until 1534. This was also recently restored. The size of the people represented is in relation according to their significance in the picture, not according to some classical sense of perspective. This is an almost medieval characteristic for a work of its time.

The immensity of this work is due to its startling presence in the space of the chapel as well as being a sensorially overwhelming work of art. Contemporaries quickly realized that its celebration of the nude was not theologically appropriate, and allowed Michelangelo's student Daniele da Volterra

[58]
Michelangelo Buonarroti, *Sistine Ceiling* (detail), 1508–1512, fresco, 45 x 128 ft., Sistine Chapel, Vatican City. Michelangelo constructs an architectural framework as an outline on the barrel-vaulted ceiling and places fields in the central strip of the ceiling, in which he depicts scenes of Genesis and the Old Testament in remarkably three-dimensional fashion.

[59]
Michelangelo Buonarroti, *The Last Judgment*, 1534–1541, fresco, 56 x 43.6 ft., Sistine Chapel, Vatican City.

The painter makes do without any frame of architectural structure. The mostly naked bodies are shown either rising or falling within the apocalyptic event.

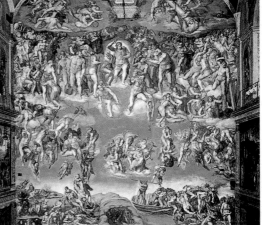

to paint cloths over the sensitive areas. The fresco thus marks a crisis in religious art from the perspective of the Church, which was only finally solved by Baroque Counter Reformation painting with its obvious intention of inspiring reverence.

[60]
Raphael, *The Holy Family from the Casa Canigiani*, around 1505/1506, oil on wood, 51.6 x 42 in., Alte Pinakothek, Munich.

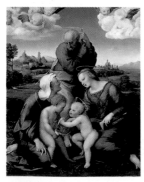

Raphael

Raphael Sanzio (1483–1520) completes Vasari's classical trinity of the Renaissance. Born in Urbino, he studied in Perugia under Pietro Perugino (1445/48–1523), whose altarpieces combine gently moving figure compositions with calm landscapes influenced by contemporary Netherlandish art. Raphael's early work is hardly distinguishable from that of his master. He was introduced to Leonardo and the early works of Michelangelo when he moved to Florence in 1504. During this time he was painting Madonnas [60], which combined Perugino's ideal with the linearity of the Florintines in their classical, pyramidal compositions. Raphael reduces his color scheme to only a few tones: red, blue, green and yellow. The preparational

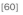

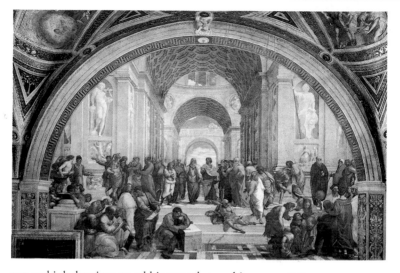

pen and ink drawings reveal his struggle to achieve the ideal form. Later academic tradition traces the influence of these works from the Baroque all the way to the Nazarenes (see p. 131) of the early 19th century. Pope Julius II summoned Raphael to Rome in 1508 with a commission to paint his private chambers in the Vatican. These *stanze* (or rooms), along with Michelangelo's *Sistine Ceiling*, underlie Rome's reputation as the center of Renaissance painting during the cinquecento.

The beginning, with the *Disputa* in the *Stanza della Segnatura* (1508–1512) is still conventional; heavenly and earthly spheres combine with one another in a balanced Renaissance composition. From fresco to fresco, Raphael visibly develops; his use of the opportunity to study Michelangelo's *Sistine Ceiling* during its creation is distinctly

[61]
Raphael, *The School of Athens*, 1508–1512, fresco, width approximately 25.25 ft., Stanza della Segnatura, Vatican City.
Raphael modeled the philosophers of antiquity after portraits of his artist colleagues, and thereby stresses the equal importance of antiquity and the Renaissance. The inner room is influenced by one of the plans for St. Peter's, which was being built at the same time.

Raphael developed for the series of frescos in the Vatican the so-called **Grotesque Paintings** (derived from the Italian *grotto*). Ornaments unroll from floral stems, from which animals and human figures grow. Raphael utilizes his knowledge of Roman wall frescos, which had been discovered in the *Domus Aurea*, the Palace of Nero (near today's Colliseum). Since Roman rooms on the first floor came to lie below the surface as soil later accumulated over them, the discoverers incorrectly thought of them as antique grottoes, hence the term "grotesque".

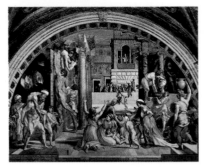

[62]
Raphael, *Fire in the Borgo*, 1514–1517, fresco, width approximately 30 ft., Stanza dell'Incendio, Vatican City.

[63]
Giulio Romano and Rinaldo Mantovano, *The Fall of the Titans*, 1530–1532, fresco, Palazzo del Té, Sala dei Giganti, Mantua. The Sala Dei Giganti depicts the chaos of a collapsing world that has left the optimism of the Renaissance far behind.

noticeable in the more relaxed, three-dimensionally present figures in *The School of Athens* [61]. Both frescos pictorially translate the aesthetic ideal of the High Renaissance: the balanced coexistence of classical learning with Christian revelation. Raphael already begins to explore new paths in the *Stanza dell'Eliodoro* (1512–1514): deep spatial chasms open themselves, and the calm of the High Renaissance recedes before the effects of Mannerism. Otherworldly light, which is for the Renaissance an unusual effect, breaks into the picture for the first time in *The Liberation of St. Peter*. The coloration becomes brighter. Finally, *Fire in the Borgo*, in the last room, with its fragmented deep spaces, the shift of main action to the background, and introduction of "repoussoir figures" (secondary figures that guide the viewer into the painting), is an influential masterpiece of Mannerism [62].

In addition to expressive portraits, famous altarpieces were generated in Rome, among them the *Sistine Madonna* (1513/1514, Gemäldegalerie, Dresden), and finally, *The Transfiguration*, which was completed by Giulio Romano after Raphael's death. In contrast to the Florentine works, Raphael broadens the scenery of the heavenly sphere: madonnas gaze down from lofty clouds and the Christ in the *Transfiguration* is suspended in the sky as a figure of light. These late pictorial inventions anticipated the foundation of the Baroque painting of the Bolognese School (see p. 86). Along with Dürer and Titian, Raphael became the first artist to consciously introduce new methods, and to supply the art market with reproductions of his works. In his studio, Marcantonio Raimondi (around 1480– 1530/34) engraved

many of his works in copper; Raphael drew his own sketches for printed graphics. In contrast to Michelangelo, he headed a large workshop, and his most important student, the painter and architect Giulio Romano (1499–1546), completed the frescos in the Constantine Chamber of the Vatican (1520–1524), before he began the construction and furbishing of the Palazzo de Té in Mantua, a highlight of Italian Mannerism [63].

Mannerism in Tuscany and Northern Italy

A number of distinctive artistic personalities were challenged by the painting of Leonardo, Michelangelo and Raphael. While Fra Bartolommeo (1472–1517) led the High Renaissance in Florence in the style of Raphael after his departure to Rome, Andrea del Sarto (1486–1530) was beginning early Florentine Mannerism with a sensitive synthesis of Raphael's compositions, the *sfumato* of Leonardo and a new, changing color composition. Jacopo Pontormo (1494–1556) got his start in del Sarto's studio. A precursor of his elongated figures and uniquely luminescent palette of pink, light blue, violet and orange is Michelangelo's work in the *Sistine Chapel*, which he consequently reworked manneristically. While like Michelangelo he avoids the use of *sfumato*, his compositions are completely linearly developed. He also makes use of details from woodcuts and copper engravings by Albrecht Dürer in his compositions, such as in the *Passion Cycle* of the Certosa di Galluzzo near Florence (1523–1525). He prepared all of his works, especially the destroyed later frescos in the chancellery of St. Lorenzo, with expert drawings, which reflect the personality of the painter like a psychograph. The acme of his work and a masterpiece of Mannerist art is *The Lamentation* [64]. The bold com-

[64]
Jacopo Pontormo, *The Lamentation*, 1525–1528, oil on wood, 10.3 x 6 ft., Santa Felicità, Capponi Chapel, Florence. The artist has immortalized himself with a self-portrait at the right edge of the picture, next to Mary. He simultaneously suffers with the viewer and demonstrates his inner participation in the religious occurrence.

[65]
Jacopo Pontormo, *Visitation*, around 1528/1529, oil on wood, 6.5 x 5 ft., Pieve di San Michele, Carmignano.

[66]
Agnolo Bronzino, *Portrait of Ugolino Martelli*, around 1537/1538, oil on wood, 40 x 35 in., Staatliche Museen Preussischer Kulturbesitz, Gemäldegalerie, Berlin. Bronzino formulates the prototype of Mannerist portraiture, which conceals the person's character behind the virtual flatness of the face, and makes it decipherable only by studying the additional attributes.

position is enhanced by the circling movement around the ice-blue center, in which the mourning is further intensified by the tragic interaction of hands. The empty center of a picture subsequently became an ubiquitous composition principle of Mannerism. In the *Visitation* [65], a group of four women not only encloses an almost abstract spatial chasm, but the luminescent color contrast and billowing robes transport the scene into the realm of the mystical, and distinguish it from the worldliness of the Renaissance. St. Mary and St. Anne are represented twice: once they fix the viewer with their irritating glances, standing frontally in the background, but then also "visit" each other according to Christian tradition. This almost cinematic aspect has inspired the American video-artist Bill Viola (born 1951) to one of his major works.

Pontormo's bold artistry is never self-aggrandizing; rather, it serves as an expressive narrative of a central Christian theme. His work, with the unconditionality of its statement, produced with the highest concentration, can only be compared with that of his contemporary Matthias Grünewald, who uses similarly glowing colors to intensify expression (see p. 74). Pontormo's student Agnolo Bronzino (1503–1572) soon became an influential portrait painter at the court of the Grand Duke Cosimo I de'Medici. The hard contour lines and the metallically shining, almost polished color

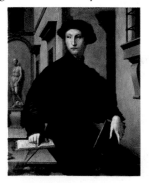

application of his portraits [66], religious pictures and allegories, reflect the bold, strictly regulated atmosphere of ceremonies of the early absolutist courts. Two Mannerists were active in Sienna: Giovanni Sodoma (1477–1549) was greatly influenced by the work of Raphael, while Dominico Beccafumi (1486–1551) referred more to Michelangelo and the Florentine Mannerists. In Umbria, Federico Barocci (around 1535–1612) enriched the Mannerist models of the previous generation with a highly delicate, early Baroque style.

Antonio Allegri, named after his birthplace Correggio (around 1494–1534) worked almost exclusively in northern Italian city of Parma. While painting a cathedral dome there (1526–30), he developed an original and innovative pale fresco painting with entangled figures that are expertly foreshortened when seen from below, and which foreshadow the Baroque. The miniature-like religious pictures and the delicate The Loves of Jupiter[67] are precursors of themes and a style of art popular well into the Rococo period.

[67]
Correggio, *Rape of Ganymede*, around 1531, oil on canvas, 65 x 28 in., Kunsthistorisches Museum, Vienna.

Cooler elegance is the trademark of the frescos and oil paintings of Sirolamo Mazzola, called Parmigiano

(1503–1540). He shines with extravagant experiments in form, such as the Madonna with the Long Neck [68], the surreal background architecture of which inspired Salvador Dali. His portraits, with their rich colors and porcelain surfaces, are equal to Bronzino's likenesses.

[68]
Parmigianino, *The Madonna with the Long Neck*, 1534/1535, oil on wood, 86.2 x 27.3 in., Galleria degli Uffizi, Florence.

[69]
Rosso Fiorentino, *The Descent From the Cross*, 1521, oil on wood, 11 x 6.5 ft., Pinacoteca, Volterra. The depth of space is only surrealistically perceptible through the tiny figures toward the right side in the background. The flat appearance of the work is broken up into individual segments by the depth of certain areas of the panel.

Rosso Fiorentino and the Fontainebleau School

Alongside Pontormo and Bronzino stands Rosso Fiorentino (1494–1540), the third important artist of Florentine Mannerism. Like Portomo, he began in the studio of Andrea del Sarto, and soon started enlivening his altarpieces with bizarre physiognomies, which led to a dispute with the commissioners of an altar panel in 1518. With that, the artist left Florence. His *Descent From the Cross* [69] reveals once again the fundamental problem of space and flatness in paintings, which was constantly being redefined since the introduction of perspective in the quattrocento. Here Mannerism signifies the extreme exhaustion of possibilities: the figures are frozen to a flat scaffold, which appears placed before the cold, deep-blue night sky.

Via Rome, central Italy and Venice, Rosso—like Leonardo before him—finally reached France in 1530, where Francis I entrusted him with the furbishing of the inner rooms of the Palace of Fontainebleau. Along with the Mantuan artist Francesco Primaticcio (1504–1570) he developed an innovative decorative style, which iconographically united fresco and stucco in a refined design. The elongated, nude figures of Venus and Diana became the symbol of the so-called First School of Fontainebleau. This, along with the sculptures of Jean Goujon (around 1510–1564/69) and abundant printed graphics, is the beginning of an Italianized French court art, begun by Jean Clouet (around 1485–1540/41), who, with Holbein, was the most important portrait painter north of the Alps during the first half of the century.

The Renaissance in Venice— Bellini and Giorgione

The later paintings of Giovanni Bellini (see p. 48) became the foundation of the Venetian High Renaissance. On his second trip to Italy (1505–1507) Albrecht Dürer wrote to his friend Willibald Pirckheimer that Bellini was still "der pest im gemoll" (the best painter) [70]. The final *Sacra Conversazioni* of the St. Zaccharia altarpiece, as well as the one in the Accademia in Venice, complete with their perfect tranquillity the long tradition of the Madonna in the company of saints. Bellini's fame was so great that the most important benefactress of the time, Isabella d'Este, wanted to acquire one of his paintings at any cost. Shortly before his death in 1514, the aged Bellini painted for her brother, Alfonso I d'Este, the *Feast of the Gods* (National Gallery, Washington) as part of a mythological series, which effectively demonstrates that, with his pupils Giorgione and Titian, Bellini developed a new classical-pastoral style, a dream of arcadia.

The new style is inseparably linked to the name of Giorgione (1477/78–1510). Little is known about his life. He appears to have painted for a small circle of commissioners among the Venetian patrician class. The figures in his few works blend with the surrounding landscape in a harmonious synthesis. Giorgione develops everything from a rich, refined coloration—in this way he is not unlike Leonardo. With glowing red, yellow, blue and green tones he creates the typical Venetian color scheme, and is perhaps the first Italian painter to fully exhaust the possibilities of oil painting. His pictorial world radiates a hermetic, self-contained unity. These new iconographic picture formulations [71] as well as the mythological (*Venus*, around 1510, Gemäldegalerie,

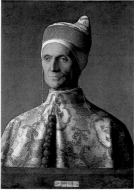

[70]
Giovanni Bellini, *The Doge Leonardo Loredan*, 1501/1505, oil on canvas, 24 x 18 in., National Gallery, London.
With this portrait of the Doge Leonardo Loredan Bellini formulates the classic Humanist princely image of the Renaissance.

[71]
Giorgione, *The Three Philosophers(?)*, around 1506/1508, oil on canvas, 49 x 57 in., Kunsthistorisches Museum, Vienna.

[72]
Titian, *Pesaro Madonna*, 1519–1526, oil on canvas, 15.7 x 8.7 ft., S. Maria Gloriosa dei Frari, Venice.
Kneeling in the foreground are members of the Pesaro family, for whom the saints intervene with the Madonna and Christ. The slanted placement and the cut columns make the scene more dynamic: a Mannerist moment.

Dresden) have motivated generations of art historians to attempt to decipher their subject matter—without success. The early Titian is so similar to the style of Giorgione that several works have been alternatingly attributed to both artists, for example, the *Concert Champêtre* in the Louvre.

Titian and Lotto

Tiziano Vecellio (around 1477 or 1488/90–1576) embodies the Venetian painting of the 16th century as did no other artist. Influenced by Giorgione, he soon developed a distinctive style, which often combines the High Renaissance with Mannerist elements. His late pre-Impressionistic style is totally ahistorical, and is only understandable as the endpoint of Titian's personal development. The number of commissioners of his art is large; among them are Venetian families like the Pesaro Family [72], the *scuolas*, northern Italian princes, and Pope Paul III Farnese. In 1548, Titian traveled to Augsburg and met there with Emperor Charles V [73]. Two years later, he met King Philip II of Spain, to whom Titian subsequently sold more than twenty-five works. Titian's domination of the art market marks a turning point in the developments leading to the modern artist: Charles and Philip no longer ordered pictures on a particular theme, but rather wished something from the hands of the master, who then offered them works from his existing stock. The artist's fame and his style are for the first time of equal or greater importance than the subject matter of his paintings. Titian is at home in all the traditional genres of painting: mythological paintings, religious pictures, portraits, woodcuts, and copper engravings were generated in his large studio. There, countless

copies of desirable paintings, to which Titian himself gave only the final polish, were at times produced—the beginning of art marketing in the modern sense. Compositions such *The Assumption of the Virgin* (*Assunta*) of 1516–1518 (S.Maria Gloriosa dei Frari, Venice) still served as models during the Baroque period, and the masterful coloration and loose brush strokes of his painting style were influential well into the 19th century (Géricault, Delacroix). In his later works, Titian's paint application becomes progressively thicker, the contours dissolve completely and paint and color determine the form [74]. Accounts of the aging artist rubbing the paint on the canvas with his bare hands are legendary.

In Brescia, Alessandro Moretto (1498–1554) and his pupil Giovanni Battista Moroni (1525–1578) developed a realistic portrait style of the highest quality, which lends the subjects a dignity of character in a totally un-Mannerist, direct style. Moroni considered even artisans pictureworthy [75].

[73]
Titian, *Emperor Charles V*, 1548, oil on canvas, 6.7 x 4 ft., Alte Pinakothek, Munich.

[74]
Titian, *Pietà*, 1573–1576, oil on canvas, 12.4 x 11.4 ft., Accademia, Venice. With the *Pietà*, which he intended for his grave, Titian synthesizes all of the traditions available to him (Byzantine mosaic, painting of the quattrocento, Mannerist architecture).

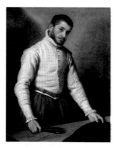

Lorenzo Lotto (around 1480–1556) worked in the provinces, in particular in the area around Ancona as well as in Bergamo. As one of the idiosyncratic personalities of the cinquecento, he combines in restless form the Venetian and Roman styles

[75]
Giovanni Battista Moroni, *The Tailor*, around 1562/1566, oil on canvas, 3.2 x 2.4 ft., National Gallery, London.

[76]
Lorenzo Lotto, *The Annunciation*, around 1527, oil on canvas, 5.5 x 3.7 ft., Pinacoteca Communale, Recanati.

[77]
Tintoretto, *The Last Supper*, 1592–1594, oil on canvas, 12 x 18.7 ft., S. Giorgio Maggiore, Venice.
Otherworldly light breaks into the brown darkness of his mature religious works.

with a northern realism of detail. His portraits testify to his interest in psychology, and his bold Mannerist color schemes are of the most vivid brilliance [76]. It seems as though the freedom to create unusual picture formulations was greater outside the artistic centers.

Veronese and Tintoretto

Besides Titian, two other artists, totally different in temperament, can be considered successful in Venice. Paolo Caliari, called Veronese after his birthplace (1528–1588), specialized in impressively large-scaled canvases, the religious content of which nearly drowns in the theatrical, masterly arranged chaos of courtly society [78]. Although it brought him in conflict with the Inquisition, he was nevertheless successful with this concept. He depicts the Venetian culture of an upper class that was forced to stand by and watch as Venice's political playing field became ever more reduced, despite the naval victory at Lepanto over the Turks in 1571. In collaboration with the most important Venetian sculptor of the time, Alessandro Vittoria (1525–1608), Veronese designed the inner rooms of architect Andrea Palladio's (1505–1580) *Villa Maser* at the foot of the Alps (around 1561). This, along with the Palazzo Farnese in Caprarola, the Vatican, and the palaces in Mantua, is an almost perfect synthesis of architecture,

sculpture and painting in the 16th century. Tiepolo and the interior designers of the Baroque period later rediscovered Veronese's art.

Jacopo Robusti, called Tintoretto (1518–1594), distinguishes

Veronese, *The Wedding at Cana*, 1562–1563, oil on canvas, 22 x 32.5 ft., Musée du Louvre, Paris.

The richly painted architecture, which is replete with innovative depth-illusion, reflects the classical architectural skills of Andrea Palladio (1508–1580). Trompe l'oeil effects and bold foreshortening foreshadow Baroque art.

himself from the colorfulness of Titian and Veronese after the 1550's with increasingly dark tones. Slanted Mannerist spatial chasms create clearings among the moving figures [77]. He rarely makes use of worldly themes, and his portraits are in their uniformity weaker than those of Titian, Lotto or Moroni. Though one can discredit specific works of his due to a certain formalism, no viewer can remain unaffected by the religious seriousness of the *Decoration of the Scuola di San Rocco in Venice* (1564–1587), which occupied him and his workshop for decades. The complex theological content, the rich, nevertheless paradoxically quiet religious effect of the dim rooms, and the overwhelming wealth of compositional ideas, make the canvas ensemble the Venetian counterpart of the *Sistine Chapel* in the 16th century—as well as the heroic feat of an artistic personality. From the contemplative absorption of the *St. Mary the Egyptian*, to the figure-filled *Crucifixion*, Tintoretto

A **trompe l'oeil** is a painting that attempts to deceive the observer through an optical illusion that is also the most exact rendition of the object. The viewer wonders if he sees a picture or the actual object. The artist achieves the effect through a mastery of perspective and refined shadow effects. Used from the 16th century on, trompe l'oeil reached its greatest achievement in 17th century Dutch art.

seems to exhaust virtually all narrative possibilities of the Gospel.

El Greco

The Spanish artistic landscape of the 16th century is remarkably diverse. Philip II collected Early Netherlandish works and Hieronymus Bosch, and in addition, he ordered erotic mythological pieces and religious painting from Titian. With his stiff royal portraits, the official court painter Alonzo Sánchez Coello (around 1531–1588) clearly pales in comparison to the portraitists of Italy and Flanders. The situation changed in 1577 with the arrival of Domenicos Theotokopolos, called El Greco (1541–1614). The native Cretan, son of a significant icon painter, first studied in Venice under Titian and Tintoretto. His miniature-like early works are already intriguing with their intense coloration. After a stay in Rome, the purpose of which was to study Michelangelo, he settled in Toledo. His painting style became transformed with his first major contract for the cathedral chapter. Ever more elongated and extended, the figures wind like colorfully dappled will o' the wisps around the room, which is irregularly illuminated by flickering light [79]. Since El Greco repeats compositional patterns once he has discovered them, one can clearly observe the emotional spirituality and the dematerialization of the forms in these series.

[79]
El Greco, *The Opening of the Fifth Seal of the Apocalypse*, around 1608–1614, oil on canvas, 7.3 x 6.3 ft., Metropolitan Museum of Art, New York.

Besides his religious works, there exist a few secular pictures, such as the apocalyptic *Laocoon* (1610, National Gallery, Washington, D.C.), as well as one of the first

autonomous landscape paintings, the *View of Toledo* (1610, Metropolitan Museum of Art, New York).

Philip II did not greatly value El Greco's art: the *Martyrdom of the Theban Legion* (1580–1583, Museum of the El Escorial Monastery), with which he hoped to acquire a position as court painter, displeased the monarch. Conflicts also existed with the Inquisition. Nevertheless, it is remarkable that, in light of their radical nature, El Greco's numerous works received any recognition in Toledo at all [80]. In art history, the commentaries pertaining to his collected works tellingly reveal the standards of the field itself. The misunderstanding of El Greco's painting peaked at the beginning of this century, with the assertion that he had diseased eyes and that his focus was distorted, resulting in the elongated figures of his paintings.

[80]
El Greco, *Fray Hortensio Felix Paravacino*, 1609, oil on canvas, 3.7 x 2.8 ft., Museum of Fine Arts, Boston.
El Greco's portraits are psychologically brilliant character studies, through which one can gain a better idea of his circle of commissioners: it consisted mostly of his intellectual peers.

Dürer and the German Renaissance

The northern German painting of the 15th century had achieved control of the spatial arrangement of pictures with the altarpieces of Lucas Moser (around 1390–after 1434) and the Swiss Konrad Witz (1400/10–1445), who left behind International Gothic art, and overcame the dominating Flemish influence of the Cologne School. In particular, the South Tyrolean woodcarver and painter Michael Pacher (around 1435–1498) successfully established the first compromise between Late Gothic and Italian art in his enormous altarpieces. The dramatic movement of the scenes, and the bold exploration of depth in the pictures, foreshadow the future, but remain exceptions. The medium of copper engraving took the lead in the development of new compositional formulas. The Hausbuchmeister [Master of the House-keeping Book] (active 1475–1490) and, above all, Martin Schongauer (around 1450–1491) made use of the graphical and painterly possibilities of this method with bravura [81]. After the invention

[81]
Martin Schongauer, *The Temptation of St. Anthony*, around 1480–1490, copper engraving, 11.5 x 8.5 in.

[82]
Albrecht Dürer, *Self-portrait*, 1500, oil on wood, 26 x 19 in., Alte Pinakothek, Munich. This self-portrait depicts the painter from a stern frontal view with parted hair, referring to a particular portrait type of Christ.

[83]
Albrecht Dürer, *The Archangel Michael Slaying the Dragon*, page from *The Apocalypse of St. John*, 1498, woodcut, 11.5 x 8.5 in.

of the printing press by Johannes Gutenberg in 1455, Franconia, Swabia, and especially the countryside surrounding the Upper Rhine, developed into book printing centers. Books were illustrated with woodcuts, with the technique blossoming around 1490–1520. Albrecht Dürer (1471–1528), born the son of a goldsmith in the burgeoning trade and art metropolis of Nuremberg, learned the techniques of panel painting and of woodcutting in the workshop of Michael Wolgemut. His wandering years led him to the Upper Rhine from 1490–1494, where he got to know the works of Schongauer, as well as the Humanist circles in Basel, and where he created his early woodcut series and the first ever autonomous *Selfportrait* in German art (1493, Musée du Louvre, Paris). He gained lasting impressions of Italian art (Mantegna, Pallaiuolo) as a result of his first trip through Italy to Venice (1494–1495). Back in Nuremberg, he achieved a fascinatingly rapid development of early masterpieces in every known graphic print, drawing, and painting technique. Especially outstanding are the first autonomous natural landscape studies, which Dürer executed in water color. The woodcut series of the *Apocalypse* [83] and the *Large Passion* (1497–1500) suddenly brought him fame in Europe. His self-perception as an individual and artist is revealed in his increasingly proud self-portraits [82]. Dürer's proportional studies of the human body became established as prototypes with the copper engraving of *Adam and Eve* (1504), and the paintings of this period culminate in the *Adoration of the Three Kings* (1504, Uffizi Gallery, Florence) , which embeds a colorful, emotional, and subtly differentiated scene in a deeply staggered landscape of ruins. His enormous productivity was only made possible by an expansion of his studio: Hans Suess von Kulmbach, Hans Baldung Grien and Hans Schäufelein all spent several years with Dürer.

Dürer set out on his second trip through Italy (1505–1507) as a well-known artist, and shared his impressions in letters to his humanist friend, Willibald Pirckheimer, in Nuremberg. In the autumn of 1506 he visited Bologna, in order to be instructed in the techniques of linear perspective, since until then his knowledge had been derived entirely from personal observation.

[84]
Albrecht Dürer,
Melancholia I, 1514,
copper engraving,
9.4 x 6.6 in.

Once again back in Nuremberg, where Dürer lived until his death, he occupied himself intensely with the refinement of his printing techniques. The so-called three *Master Etchings* (in addition to [84] also *The Knight, Death and the Devil*, and *St. Jerome in his Study*, all 1513) are so inclusive that they seem to sum up Dürer's philosophical, intellectual and theological insights: death and transience, contemplation and melancholy. In 1520 Dürer began another journey, this time as an official member of the Nuremberg Delegation to the celebration of Charles V's coronation in Aachen. This journey to the Netherlands was a personal triumph for the artist, who by that time was known all over the western world. He shrewdly was able to put his etchings on the market, sometimes as gifts to other artists he got to know, who later used his compositions in their own work (for example Lucas van Leyden). In his

In the graphic high-relief technique of **woodcuts**, all parts that do not belong to the drawing are cut out of the woodblock, while the ridges themselves remain and thus appear on the print. By superimposing different blocks and colored inks, one can achieve subtle effects. In the early 15th century, illustrated textbooks prepared from woodcuts foreshadowed bookprinting with moveable type. In the 16th century, woodcuts were widely distributed as Reformation and Counter-Reformation propaganda. However, its importance later declined in favor of copper engraving and etching. In the early 20th century, Expressionist artists belonging to the group called "The Bridge" (see p. 169) revived this technique.

Copper engraving is the oldest low-relief graphic technique. The drawing is scratched onto a copper plate, and the plate is then rubbed with printing ink. The ink remains only in the grooves, and the plate is pressed under high pressure against wet paper. The pinnacle of copper engraving as an autonomous artistic medium was from 1480–1540. Afterwards, it was used primarily for the reproduction of paintings, cityscapes and events.

[85]
Albrecht Dürer, *The Four Apostles*, 1526, oil on wood, each 7 x 2.5 ft., Alte Pinakothek, Munich. Much has been written about these two panels, and they have even been used for nationalistic propaganda. The differentiation of the heads of the four characters and the highly concentrated form and color transform the picture's spiritual content to the universal. Humanist, and implicitly Lutheran, intellectual content is condensed into absolute painted form.

final years, he created his moving last works: spiritualized paintings and the monumental completion of his work, *The Four Apostles*, which Dürer donated to the city council of Nuremberg [85]. In addition to the wealth of his artistic production, one must not forget Dürer, the theoretical thinker. As early as 1513, he began to write the manuscripts of four books on human proportion, and in 1525 his *Instruction on Measuring with Compass and Ruler* was printed in Nuremberg. His tracts on art theory achieved a similar importance in developing the German language as did Luther's Bible translation, because Dürer created the first terminology for aesthetic and theoretical artistic discourse.

Grünewald

In contrast to Dürer, knowledge of Mathis Gothart Nithart (1475/80–1528) remains sketchy. In his biography of 1675, Joachim von Sandrart (see p. 91) was the first to call him Matthias Grünewald. Grünewald lived in Aschaffenburg, Frankfurt and Mainz and died in Halle; he earned his living as a tunnel and fountain builder, and as a hydraulic engineer. His thirty five drawings, as well as about ten surviving panel pictures (one of which is included in the *Altar of Isenheim*), reflect, like no other work of their time, the religious upheaval of Martin Luther's reformation. It is not known if Grünewald was an active Lutheran; although the writings of Luther that were discovered among his personal legacy testify to his occupation with Luther's

[86]
Matthias Grünewald, *St. Lucy (Martyr with a Palm Branch)*, around 1511, oil on wood, Staatliche Kunsthalle, Karlsruhe.

philosophies, he also worked for Luther's greatest opponent, Cardinal Albrecht of Brandenburg, Archbishop of Mainz and Halle. The four *Saints* [86] executed in Grisaille for the Heller Altar, demonstrate Grünewald's extraordinary painterly talent with their exquisite gray-on-gray painting of the folding robes and plants.

The *Altar of Isenheim*, commissioned by the Prior of the monastery, the Sicilian Guido Guersi, is indisputably not only a high point in German painting, but also one of the greatest masterpieces of religious art. Since Grünewald's luminescent, changing coloration closely resembles the work of his contemporary, Pontormo, one wonders if Guersi approached Grünewald with Italian concepts. With a violent artistic, but also intellectual effort, the artist unites the cosmos of medieval and Humanist thought and wisdom into a daring synthetic whole: the contemplative meditation of the hermits Anthony and Paul in the loneliness of the desert (paradoxically one of the most peaceful and beautiful landscapes of the time), the eruption of lust and guilt in the temptation of St. Anthony, Mary's acceptance of the divine assignment in the Annunciation, the joy in the iconographically mysterious, fantastical concert of angels in the Christmas scene, the fiery redemption of humanity, the rapturously spiritual storm of color in the *Resurrection* [88] and the mourning of the *Good Friday Panel*, all testify to his deeply felt

[87]
Matthias Grünewald, *Altar of Isenheim, Good Friday Panel*, 1512–1516, oil on wood, center part 8.8 x 10 ft., Musée d'Unterlinden, Colmar.

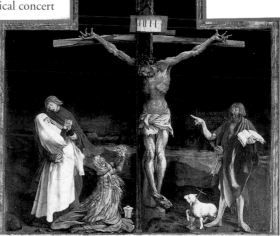

[88]
Matthias Grünewald,
The Resurrection of Christ, Altar of Isenheim (Easter panel), 1512–1516, oil on wood, Musée d'Unterlinden, Colmar.

religious humanism. The artistic treatment ranges from summarily done lazulite in the background of the crucifixion, to the minutely drawn detail, which to some extent is an expressive continuation of van Eyck's art. The unflinching realism of the tortured body of Christ, the suffering of Mary and John at the side of the cross, and the deathly dark, obscure primeval landscape in the background, form one of the most striking representations of the Crucifixion in the history of art [87]. Upon viewing the expressive altar, the classification of the work as either Renaissance-art or as Mannerist becomes of secondary importance. References to antiquity in the manner of the Italian Renaissance can be traced only in Grünewald's barely preserved later works, nor are cross-references to Dürer's work to be found. One simply must accept that this altarpiece cannot be understood with the usual art-historical categories, and definitely not within the framework of a nationalistically conceived "German-ness". With the German Expressionist movement of the 20th century a veritable "Grünewald Renaissance" established itself.

Holbein and painting in England

Hans Holbein the Younger (1497/98–1543) is the third great German Renaissance painter. The fame of his portraits during the English period unjustly overshadows his earlier works, which can be compared with Dürer's achievements in their diversity of themes and techniques. He was introduced by his father Hans Holbein the Elder (around 1460/65–1524) to the Late Gothic-influenced art of Rogier van der Weyden. In the humanist center of Basel, Holbein produced altarpieces, facade paintings, designs for stained-glass windows, and woodcuts (*Dance of Death*, before 1526, forty-nine pieces). Commissions came largely from humanist circles, and from the city council. Here Holbein had already developed portraiture to an early perfection (*Bonifacius Amerbach*, 1519, Kunst-sammlung, Basel; the *Series of Erasmus Portraits*). The life-sized *Dead Christ* [89] exists as a shocking exception not only in Holbein's oeuvre; it is perhaps a reaction to the art of Grünewald in nearby Isenheim. Holbein stayed in England for the first time from 1526–1528. Through his friendship with Erasmus of Rotterdam, he was introduced to the English Humanist and politician Sir Thomas Moore, whom he drew in a group portrait with his family (the painting is lost). He also painted other high-ranking personalities. He returned once again to Basel from 1528 to 1532. The striking portrait of Holbein's *The Artist's Family* seems softer and more intimately felt than the blank, polished faces of his public commissions. After his return to England he initially painted German merchants almost exclusively. The political parquet at the court of King Henry VIII was

[89]
Hans Holbein the Younger, *The Dead Christ*, 1521–1522, oil on wood, 8.8 x 6.6 ft., Kunstmuseum, Basel.

treacherous. It is possible that the imposing *The Ambassadors* (1533, National Gallery, London) caught the eye of the king, and led to Holbein's employment as court painter in 1536. As a result, Holbein was swamped with commissions [90]. For example, he had to go bride-hunting for the king, and complete portraits of the potential candidates. Holbein's painting technique was already admired during his lifetime. He usually preceded the painting process with detailed drawings, and it is possible that he used a wooden grid as a tool to sketch his subjects. The art of Nicholas Hilliard (around 1547–1619) was derived from Holbein's fine portrait medallions. His fine portrait miniatures depict the society at the court of Elizabeth I and late James I, and often contain hidden erotic messages [91].

[90]
Hans Holbein the Younger, *Sir Simon George Quocote*, around 1535, oil on wood, diameter 12 in., Städelsches Kunstinstitut, Frankfurt.
In his later works, Holbein reduces the picture background to a simple color surface, from which the heads emerge with greater plasticity.

[91]
Nicholas Hilliard, *Young Man in a Rose Garden*, around 1588, oil on parchment, 5.3 x 2.8 in., Victoria and Albert Museum, London.

Altdorfer and Cranach

In Regensburg and Passau, Albrecht Altdorfer (1480–1538) and Wolf Huber (1485–1553) developed with the Danube School their own form of pre-Romantic landscape painting. The lichen-covered, ragged firs, and the moving clouds reflect a longing for solitude, but also indirectly transmit the conflict of a politically restless time. Altdorfer painted the famous *Battle of Alexander* [92] in a series comprised of at least fifteen pictures for the Munich Residence. Like the forests of his landscapes, the battle formations here seem to sway and roar. The brutal reality of the battle is pushed far into the background because of the large scale, and the sun over the horizon reveals

an utopian future after the day of the battle, the curvature of the horizon transporting the martial action into the cosmic realm.

The woodcarver, copper engraver, and painter Lucas Cranach the Elder (1472–1553) also began in the style of the Danube School, into the landscapes of which he added tensely dramatic or calm, lyrical scenes [93]. In Wittenberg he befriended Luther, and the portraits of the reformer that he produced there and in Weimar distributed his likeness across Europe. Cranach was indispensable for early Reformation propaganda, which used woodcuts, particularly, as an artistic medium.

In his large altarpieces Cranach also attempted to develop a specifically Protestant iconography of religious painting, which contrasts standardized Old and New Testament scenes by referring back to medieval Cathedral art. He integrates Bible quotations and portraiture within these instructional panels of Lutheran theology. However, this Reformation art did not enjoy long-term success, and Cranach also had to serve the erotic fantasies of the Protestant princes with more profane subject matter. The Late Gothic prototypical Mannerism degenerates in his later work to countless mechanical reproductions by his large workshop.

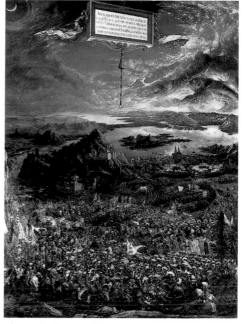

[92]
Albrecht Altdorfer, *Battle of Alexander*, 1529, oil on wood, 62 x 47 in., Alte Pinakothek, Munich.

[93]
Lucas Cranach the Elder, *Rest During the Flight Into Egypt*, 1504, oil on wood, 30 x 21 in., Staatliche Museen Preussischer Kulturbesitz, Gemäldegalerie, Berlin.

[94]
Hieronymus Bosch, *Flight and Fall of St. Anthony* (left wing of the triptych *Temptation of St. Anthony*), 1505/1506, oil on wood, 52 x 21 in., Museu Nacional de Arte Antiga, Lisbon.

Painting in the Netherlands— From Bosch to Brueghel

The artistic situation in the Netherlands and Flanders at the beginning of the 16th century is difficult to assess. For one thing, Early Nertherlandish Painting became rigid in its formalism, while the "Antwerp Mannerists" enriched and diffused traditional models by incorporating Italian architectural forms and complex compositions. More consequential is the work of Joachim Patinir (around 1485–1524), who was also admired by Dürer. He developed strong upwardly-focused, panorama-like "Weltlandschaften," in which he incorporates Biblical and secular scenes, and thus founded the Netherlandish landscape counterpart to the Danube School.

Strangely positioned between the Late Middle Ages and Mannerism is the work of Hieronymus Bosch (1450–1516). He became famous for his apocalyptic visions , which pessimistically attempt a universal conceptualization of the world. With an overbearing, bizarre imagination, he calculatedly stages horror in his scenes, and his rigidly religious ethic is mirrored in moralistic allegories. His major theme is human corruptibility, which only the saints can successfully resist [94]. Bosch was certainly no deranged idiosyncratic, and his pictures were purchased by princes in great numbers. Philip II of Spain had one

Karel van Mander: *The Schilder-Boek* of 1604. Karel van Mander (1548–1606) from the Netherlands is almost forgotten as a painter and talented draftsman. He failed to achieve fame in Rome or at the court of Emperor Rudolph II. In his last years he concentrated on writing *The Painter's Book* in Haarlem, which did bring him the desired recognition. After an introductory instructional poem, he describes in close imitation of Pliny the Elder the most important ancient painters. Then he adapts Vasari's *Lives*, to which he adds subsequent artists, such as, for example, the first biography of Caravaggio (see p. 87).

The most important part of this expansive work is the *Lives of the Famous Dutch and High German Painters*. He writes a kind of counter-Vasari from the Dutch point of view, but borrows Vasari's methods. He begins with Jan van Eyck instead of Giotto, and follows the history of painting up to his day, providing an invaluable source of information about the lives of such artists as the great engraver Hendrick Goltzius (1558–1617), who was a friend of Bartholomäus Spranger (see p. 83), or the most important Dutch Mannerist, Cornelis van Haarlem (1562–1638).

of the largest collections of Bosch's works in the Escorial. With the next generation of artists began the period of Netherlandish "Romanism". Inspired by Italian example, painters (Jan Grossaert, called Mabuse, around 1478/88–1532; Lucas van Leyden, 1494–1533; Jan van Scorel, 1495–1562; Martin van Heemskerck, 1498–1574) moved to Rome, drew the antique monuments, studied Raphael and Michelangelo, and developed an Italian-Mannerist painting style [97]. After Dürer, Lucas van Leyden is considered the most important copper engraver of the first half of the century. Pieter Brueghel the Elder (1525/30–1569) is an exception. He, too, traveled from 1551–54 through Italy, but in contrast to his contemporaries, one cannot detect a direct adoption of Italian forms in his total work of 40 pieces.

The painter is not the naive "peasant-Brueghel" as the 19th century portrayed him in trivializing fashion. This contradicts his personal role in the intellectual milieu of the cities of Antwerp, Mechlin and Brussels. The geographer of Philip II, Abraham Ortelius, and the archbishop of Mechlin and Secretary, Cardinal Granvelle, were among his

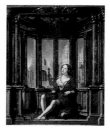

intellectual peers. Around 1561, he produced three commissioned paintings in the style of Bosch, though he rationalized and humanized the grim world view. The main theme is the life of the people and peasants, which

[95]
Pieter Breughel the Elder, *The Peasant Wedding*, 1568, oil on wood, 45 x 64 in.

[96]
Pieter Breughel the Elder, *Hunters in the Snow*, 1565/1566, oil on wood 46 x 64 in., both Kunsthistorisches Museum, Vienna. Breughel's view of the peasant world is not satirical, rather, it is for the first time deemed picture-worthy—and also a counter-image to the courtly world.

[97]
Jan Gossaert, called Mabuse, *Danae*, 1527, oil on wood, 45 x 37 in., Alte Pinakothek, Munich.

81

extends from the early *One Hundred Proverbs* (1559, Gemäldegalerie, Staatliche Museen, Berlin), to the late works *Peasant Wedding* [95] and *Peasant Dance*. His splendid landscapes are the six *Seasons of the Year* (one is lost), which adorned as a frieze the house of Nicolaas Jonghelinck in Antwerp (*The Gloomy Day, The Return of the Herd, Hunters in The Snow* [96] , Kunsthistorisches Museum, Vienna; *Haymaking*, National Gallery, Prague; *The Corn Harvest*, Metropolitan Museum of Art, New York: all 1565–1566). Idea and reality, natural representation and artistic vision, the individual and the world, all dissolve in the cosmos of the paintings.

The Kunstkammer—
The court art of Late Mannerism

The *Kunstkammer* or artchamber of Mannerism is derived from the *studioli* of the Italian Renaissance— those private rooms where rulers displayed their books, paintings, jewels, objets d'art, natural history specimens and curiosities for honored guests and visiting scholars.

The Habsburg emperor Ferdinand I used this term for the first time of his own royal collections. Under Emperor Maximilian II, the concept is extended. In addition to noteworthy natural objects, armory and gold artifacts, (such as Montezuma's Aztec jewelry), paintings by Giuseppe Arcimboldo (1527–1593) were included in his collections in Vienna and Prague. His portraits, composed of parts of plants, fruits and vegetables, are not so much marginal products of an exaggerated Mannerism, as they are a representation of the unity of nature, of the seasons, and of the macrocosmos in the human countenance. Maximilian's brother, Archduke Ferdinand of Tyrol, built one of Mannerism's most impressive art collections in Castle Ambras near Innsbruck, but the acme of all *Kunstkammers* is Emperor Rudolf II's collection in Prague. Until his death in 1612, he summoned a vast array of artists,

goldsmiths, watchmakers, philosophers and astronomers to his court—the so-called "Prague Court School." With his collection the emperor attempted to reveal the macrocosm of the concrete and abstract worlds in the individual pieces as well as in the wide range of objects throughout the entire collection. To dub him primarily a commissioner of erotic works [98] diminishes the scientific seriousness of his endeavor. The erotic allegories by Bartholomäus Spranger (1546–1611) or Hans von Aachen (1552–1615) are

[98]
Bartholomäus Spranger, *Hercules, Deianeira and Nessus*, around 1585, oil on wood, 44 x 32 in., Kunsthistorisches Museum, Vienna.

complemented by the Dutch paintings of Roelandt Saverys (1576–1639), whom Rudolf summoned to the Alps so that his fine landscapes painted on copper plates might be as naturalistic as possible. The monarch was also among Dürer's admirers, and was fascinated by his nature studies. However, in the person of Rudolf II, political talent and superb sponsorship of the arts were tragically unequal. The Thirty Years War disrupted the tradition of the *Kunstkammer*, and the picture galleries of the absolutist palaces banished the artistic crafts; for example, the mysterious ivory tusks of the narwhales and the decorated nautilus shells.
In the end, the rationalism of the Enlightenment decreed the encyclopedic reordering of all things, and thus divided into different special collections the multitude items of the Kunstkammer, as they continue to be divided in today's museums.

Baroque—
The Art of the 17th Century

Painting in the age of absolutism

The Baroque era is characterized by the stabilization of the religious division of Europe into Protestant areas and those that remained Catholic. When the Peace of Westphalia (1648) ended the Thirty Years' War, the national borders that were agreed upon remained largely in place until the 18th century rise of Prussia and the Napoleonic wars. Since the Edict of Nantes (1598), which had imposed religious peace from above, i. e. the ruling class, the growing power of France under Louis XIV was only to be compared with the Habsburg empire, a second Catholic and absolutist power.

The iconoclasm of the Protestant reformers caused churches in their regions to be stripped of much devotional art, and artists to lose an important part of their market. Nonetheless, the burgeoning economies of the Protestant countries, especially the United Provinces of the Netherlands, produced a surge of pictures on a scale unknown even to the Italian Renaissance. The Dutch Paintings both extol and exhort a pragmatically active (and actively trading) society which worked off what historian Simon Schama has called the "embarrassment of riches" by letting its reality be portrayed down to the smallest details.

In Catholic Europe, that is Italy, France, Flanders, the Habsburg and southern German areas, the Counter-Reformation of the Council of Trent (1545–1563) set strict standards for religious art. The religious paintings and frescoes of Mannerism had become too complicated and erotic to serve as guides for prayer. The Council demanded a new clarity in religious art, which again was to become comprehensible, simple, discreet, and worthy of its purpose. Not only the Inquisition, but the academies

established at the behest of the princes as work-shops for artists as well oversaw the compliance with the new standards for religious narrative pictures.

Behind this development was also the Jesuit order, which saw itself as the "army of God." Its founder, Ignatius de Loyola (1491–1556) had already in 1550 begun the construction of the first Jesuit church in Rome, Il Gesù, which functioned as a regular prototype for Baroque churches. The magnificent appointment of the interior, with its paintings, painted sculpture and Catholic ritualia, became a *Gesamtkunstwerk*, that is a total work of art (see p. 162). The furnishing of churches was one of the chief tasks of the Catholic Baroque: walls, ceilings, and cupolas were covered with frescoes, and altarpieces and panels decorated the numerous chapels.

In the Baroque palace, sovereign and consort, court, and outer world came together in magnificent chambers of state which formed the stage for the rituals of an absolutist political theater. The ceiling murals, the official state portraits, and even the pictorial translation of intimate erotic themes for the private chambers, built upon models from the Renaissance and Mannerism. The aim of official court art was always the idealized artistic representation of the sovereign and his or her family, who were often depicted among the deities in a Greco-Roman heaven. Religious and profane spheres—church and palace—remained strictly separate, both spatially and thematically, but shared the same animated pictorial language. Death and life, both are always present in Baroque art as the two poles of human existence.

1685
Georg Friedrich Handel and Johann Sebastian Bach are born
1688–1689
"Glorious Revolution" in England; Declaration of Rights, beginning of constitutional monarchy in England under William and Mary
1690
Huygens develops the theory of light waves
1703
Founding of St. Petersburg

The term **Baroque** originally referred in Portuguese to an irregular non-concentric mussel used by jewelers for pearls. In Italian the term *barocco*, in French *baroque*, has been used polemically since the 17th century for a turgid style in art and literature, overloaded with pathos. Only after the middle of the 19th century did the word lose its negative tone.

The starting point:
Carracci and the School of Bologna

In their Bolognese studio, Annibale and Ludovivo Carracci (1560–1609 and 1555–1619) experimented with all genres of painting; only Leonardo da Vinci can offer comparison. They created a restful form of Baroque landscape painting as well as the first examples of modern caricature. Combining the animation of Correggio, the color and composition of Raphael, as well as the dynamic figures of Michaelangelo, the Carraccis developed the prototype of the light-filled Baroque painting. Religious pictures are reduced to their most important figures; the pictorial statement is also easily recognizable to the laity. Color, following the model set in the Roman High Reniassance by Raphael, is refined to the foursome red-blue-yellow-green, leaving behind the ambiguous colorfulness of Mannerism. Only the central message is offered to the observer for worship or admiration [100], the religious scene set in a calming landscape. This use of color, and the relaxed, but vivid movement within the firm compositional structure, became hallmarks of the "Bolognese School," whose representatives, such as Domenichino (1581–1641), Giovanni Lanfranco (1582–1647), Guercino (1591–1666), and Guido Reni (1575–1642), were active largely in Bologna, Rome, and Naples [99, 101].

The Tuscan Pietro da Cortona (1596–1669), together with Lanfranco and Guercino, played a decisive role in the development of the Baroque ceiling painting. In a continuation of Corregio's

[99]
Guido Reni, *Bacchus and Ariadne*, ca. 1619, oil on canvas, 3.2 x 2.8 ft., County Museum of Art, Los Angeles.

[100]
Annibale Carracci, *Christ and the Samaritan Woman at the Well*, ca. 1605, oil on canvas, Kunsthistorisches Museum, Vienna.
The earnestness of the presentation allows no distraction from the religious experience, and thus fulfills the strictures of the Council of Trent.

work, they disclosed illusionistic heavenly landscapes, and super-elevated the allegorical and religious significance of the images. Their

figures are often depicted from an extremely low perspective (*sotto-in-su*). The brilliant highpoint of religious ceiling painting was reached in the church paintings of the Jesuit Andrea Pozzo (1641–1709). His foreshortened framing structures open the illusionistic, perfectly organized perspectives of imaginary rooms, effecting an ecstatic dissolution of the boundaries of the church into the heavenly spheres. These Roman and Bolognese painters defined an academic direction in Baroque painting which remained the pinnacle of painting for Goethe and the academies of the 19th century.

[101]
Guercino, *Aurora*, 1621–1623, ceiling fresco, Villa Ludovisi, Rome.

The alternative: Caravaggio

In contrast to the Bolognese School, Michelangelo Merisi, known as Caravaggio (1573-1610), used a stark chiaroscuro effect to hew his figures from a usually black-brown background. The colors are correspondingly limited to a few intermediary tones. A truly revolutionary painter, Caravaggio sought his models among the common people, and brought them to canvas without idealizing exaggeration. Saints with dirty fingernails, the corpse of a prostitute as model for St. Mary: his unconventional treatment of models and religious themes [103] led at times to rejection of his finished pictures. On the other hand, Caravaggio supplied cardinals with pictures of erotic youths [102]—a service that protected him at first from the Inquisition. Nonetheless, his life is hardly a success story. Under suspicion of murder, he rushed from Rome through Naples to Malta, dying at age 37 on his way back to

[102]
Caravaggio, *Bacchus*, ca. 1595, oil on linen, 3 x 2.8 ft. Galleria degli Uffizi, Florence.

[103]
Caravaggio, *The Entombment of Christ*, ca. 1602/1604, oil on canvas, 9.8 x 6.7 ft., Pinacoteca, Vatican City.

[104]
Giuseppe Ribera, *Apollo Flaying Marsyas*, 1637, oil on canvas, 6 x 7.7 ft., Galleria Nazionale di Capodimonte, Naples.

Rome. There is hardly another artist whose works established a school without his ever having had a workshop, and thus direct contact with a body of students. However, it became very quickly clear that his style of painting, if tamed, so to speak, could be employed by the Counter-Reformation as a popular alternative to the academic Bolognese and their school. Carvaggio's successors, known in art history as "Caravaggists," exploited this situation all the way from Naples, where Carracciolo (1570–1637) developed an independent style, to the Netherlands (Hendrick Terbrugghen, 1588–1629) and France (Simon Vouet, 1590–1649). The most important female painter of the Baroque is Artemisia Gentileschi (1597–1652). Like her father Orazio Gentileschi (1563–1639/40), who was a court painter to Charles I in England after 1626, she worked in the style of Caravaggio. Joining the stronger colors of the Bolognians with chiaroscuro was a guarantee of popular success. In this sense, the Spaniard Jusepe, or Giuseppe Ribera (1591–1652), who worked in Naples where he was known as "Lo Spagnoletto," increasingly lightened his palette. His *Apollo Flaying Marsyas* is an outstanding example of the synthesis of the Bolognese School, Caravaggio, and the Spanish tradition [104].

Velázquez and Spanish painting

The agitated painting of El Greco remained without successor in Spain. At court, the portraitists came into their day, still life developed into an important genre, and local schools arose in the provinces. Diego Silva de Velázquez (1599–1660) grew up in the artistically provincial milieu of Seville, at first producing genre paintings reminiscent of the chiaroscuro style of Caravaggio. With the ascension of Philip IV to the throne, the situation changed. In spite of, or perhaps because of, his diminishing political importance and economic recession, the king engaged artists to extol the majesty of his absolutist sovereignty. To be appointed court painter became the goal of all talented artists, whose entry ticket was always a period of study in Italy. Velázquez acquainted himself during his Italian sojourn with the painting of the Bolognese, Caravaggio, and later the Frenchman Poussin.

After his return to Spain, Velázquez's composition and figures, such as Apollo in *The Forge of Vulcan*, revealed his Italian discoveries (Michelangelo's muscular figures and studies drawn from antiquity). As court painter, Velázquez repeatedly portrayed the ruling family with series of canvases in an intriguing style, capturing the characters of courtly life with almost impressionistic brushwork. It is no accident that the French Impressionists look to this Spanish painter as a model. His *Portrait of Pope Innocent* X [106] marks one of the great moments of painting history. In the wavering, uncertain glance of the pope we meet a weak man, a prince of the Church whose actions are far too much determined by his family. In *Las Meninas* (*The Maids-in-Waiting*) [107], Velázquez reaches the apotheosis of his artistic

[105]
Diego Velázquez, *The Forge of Vulcan*, 1630, oil on canvas, 7.3 x 9.5 ft., Museo del Prado, Madrid.
The quality of Velázquez is evident in the realistic general impression of this masterly scene.

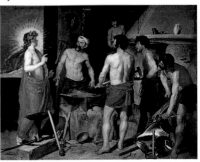

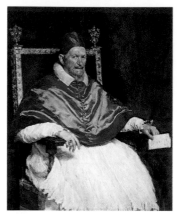

[106]
Diego Velázquez, *Pope Innocent X*, 1650, oil on canvas, 4.6 x 3.8 ft., Galleria Doria Pamphili, Rome.
The almost nervous application of color on the gown, and the tense posture of the model are signals of the actual presence of the portrayed person, a form of reality earlier reached in Spain only by El Greco.

[107]
Diego Velázquez, *Las Meninas*, 1656, oil on canvas, 10.4 x 9 ft., Museo del Prado, Madrid.
The observer will never be able to know what Velázquez was painting on his easel (the royal couple or the picture itself?), because only the reverse side is visible.

creativity. Presented are a colorful potpourri of court society, including the painter himself, who stands at his easel, looking out from the picture at the viewer. The royal couple entering the room appears only in a mirror on the back wall of the room. The result is an ambiguous interplay between painter, room, and viewer. The viewer stands in exactly the same place as the royal couple, visible only in the mirror. The painter glances up from his work to look at the couple, but therefore also at the present-day viewer of the picture. The reactions of the court ladies and dwarves are presented with a similar ambiguity. The pictorial space flows into that of the observer, but the closer the viewer approaches the picture, the less clear it becomes, even in its structure. At this point, the viewer can either now ask, along with the 19th century French writer Goncourt, where

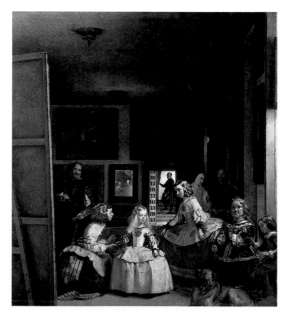

then is the picture to be found at all or like the French philosopher Michel Foucault, understand *Las Meninas* as the painting of a painting. The viewer remains caught by the picture as in a dream, and in this baffling position, is thrown back onto himself or herself as an individual, in the manner thematized in contemporary Spanish drama by Calderón de la Barca in *Life is a Dream*, or by Miguel Cervantes in *Don Quixote*.

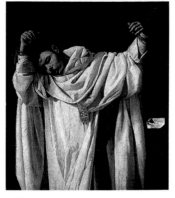

[108]
Francisco de Zurbarán,
St. Serapion, 1628, oil
on canvas, 4 x 3.4 ft.
Wadsworth Atheneum,
Hartford, Conn.

A group of artists around Velázquez imitated his style, but did not reach his level of complexity. A popular note was struck by the genre scenes and delicate madonnas of Esteban Murillo (1617–1682), whose style has influenced the popular madonna image in Spain and Latin America to this day. Francisco de Zubarán (1598–1664) represents an exception. Although the artist worked at Velázquez's side in Madrid after 1634, and achieved great recognition when he was named court painter, he soon withdrew to Andalusia, where he created the great religious cycles for the Carthusians of Jerez and the monastery of Guadalupe between 1637 and 1639. He succeeded in a transformation of Caravaggio's style, introducing a chiaroscuro, which depended on pure colors and his subtle use of the color white, developing all possible color nuances out of this difficult "non-color" [108]. Before a largely dark background, Zubarán modeled his figures through the careful apportionment of luminous colored surfaces, achieving a mystical effect.

The writings of **Joachim von Sandrart** (1606–1688) were more successful than his own paintings. In 1675 and 1679, he published a two-volume compendium of art biographies, tracts, inventories, and commentaries, as well as his own biography in German—after Vasari and Karel van Mander the third important written source of art history (*Teutsche Akademie der Edlen Bau-, Bild- und Mahlerey-Künste*—or "German Academy of the Noble Arts of Architecture, Drawing, and Painting").

[109]
Adam Elsheimer, *The Flight to Egypt*, 1609, oil on copper plate, 12.2 x 16 in., Alte Pinakothek, Munich. Elsheimer was one of the first painters to create romantic night landscapes filled with poetic nuance.

Central European painting

The lands of the Holy Roman Empire were especially hard hit by the Thirty Years' War (1618–1648). Its effects, together with the economic depression in the smaller principalities and imperial cities, explain to a large part why no golden age of central European painting followed in the 17th century after the great years of the Prague Court School. In addition, the attention of German painters was fixated upon Rome. Many painters went to Italy to study the masters, and stayed there to work because commissions in their homelands were not forthcoming. Adam Elsheimer of Frankfurt (1578–1610) painted on small copper plates, a technique that had come into fashion under German Mannerism, and allowed an extremely fine and brilliantly colored result. Elsheimer succeeded in adapting traditionally monumental themes to this smaller format, with a dramatic use of light [109]. His clear depictions influenced copper engravings by Lorrain, Poussin, Rembrandt, and Rubens.

Another equally influential course was followed by Johann Liss (ca. 1597–1629/30). After visiting the Netherlands and, naturally, Rome, where be became acquainted with Caravaggio's works, Liss settled in Venice. His brightly colored paintings—unlike Elsheimer's plates—correspond to our understanding of energetically moving "Baroque" art [110]. As a successor to Tintoretto and Veronese, Liss prepared the way for the painting of Piazzetta or Tiepolo.

One of the few painters of his age not influenced by Caravaggio was Johann Heinrich Schönfeld (1609–1684) despite his later concentration on religious pictures after

[110]
Johann Liss, *The Death of Cleopatra*, ca. 1622–1624, oil on canvas, 3.2 x 2.8 ft., Alte Pinakothek, Munich.

travels in Italy [111]. In Frankfurt, Georg Flegel (1566–1638) followed yet another course, becoming the first German painter who specialized almost exclusively in still lifes.

French Painting—Poussin, Lorrain, de la Tour

Upon the death of Louis XIII in 1643, his son Louis XIV, called the "Sun King," ascended the throne, and exerted absolute power in France until his own death in 1715. Based on the foundation that had been laid by Cardinal Richelieu, the chief minister under Louis XIII, the Sun King's control of the state in everything from centralized determination of the economy, to state support of the sciences, (the Académie Française had already been founded in 1635), to religious and foreign policy, became the model for every court in Europe.

It is therefore no wonder that that the "Académie Royale de peinture et de sculpture," established by the king in 1648, set up a court of review and school to carry out official art policy. The founding director was the painter Charles Le Brun (1619–1690), who along with the architect Jean Hardouin Mansart and the garden architect Le Nôtre, played a considerable role in the fitting out of the royal palaces, Versailles in particular. In his writings and lectures, Le Brun formulated standards for painting, from ideal facial expressions and gestures to the determination (laid down before the Academy in 1667) that drawing, and not color, be the most important element in painting—a clear rejection of the use of color by Rubens. However, in its lively Baroque movement, Le Brun's own painting did not necessarily conform to the official classical style, which also distinguished French architecture and sculpture from that of Italy.

[111]
Johann Heinrich Schönfeld, *The Triumph of Venus*, ca. 1640–1645, oil on canvas, 3.2 x 2.8 ft., Staatliche Museen Preussischer Kulturbesitz, Gemälde-galerie, Berlin.
His often apocalyptically darkened pictures do hommage to late Mannerism with exaggeratedly long figures and complicated, dramatically lit compositions.

[112]
Nicolas Poussin, *Et in Arcadia ego*, ca. 1638–1640, oil on canvas, 2.8 x 4 ft., Musée du Louvre, Paris.
The picture conveys the longing for the antique world, the poetry of nature, and the pervasive literary references of Poussin's art.

[113]
Nicolas Poussin, *Self-Portrait*, 1650, oil on canvas, 3.2 x 2.4 ft., Musée du Louvre, Paris.
The realistically painted portrait of the painter stands in contrast to the almost doll-like schematization of the figure in the picture-within-the-picture. Thus the artist demonstrates his command over multiple pictorial languages.

Nicolas Poussin (1594–1665) embodied the requirements of classical painting as taught by Le Brun. After 1624 Poussin worked almost entirely in Rome, where he stood in close connection to the Italian painters. The contemporary capital of art provided him with a knowledge of Roman antiquity, and the landscape of the Campagna became the model of his dream of *Arcadia* [112]. His pictures mark the birth of an academically teachable, classical painting on the highest level. With his placement of groups of people in antique settings, he determined the course of the religious and historical picture up to the time of Jacques-Louis David (see p. 122). The color is reduced to a few clear values, as in Raphael's work, and gestures and poses of the figures are determined according to strict geometrical patterns, corresponding to the contemporary theater of Corneille and Racine, who revived classical tragedy by means of a precise theory of drama for the royal stage.

Whether the classical coolness of Poussin's art was as suited for religious as for mythological themes is doubtful. Nonetheless, his pictures correspond with the pragmatically employed state Catholicism of the Sun King, whose absolutism was expressed by the formula of the preacher Jacques Bossuet: "Un roi, une foi, une loi"—one king, one faith, one law. In his famous *Self-Portrait* [113] Poussin produced a convincing reflection of his artistry.

In the landscapes and harbor scenes of Claude Lorrain (1600–1682), the figures recede more to the background than do those of Poussin. Proceding from Elsheimer's depictions of nature, Lorrain's pictures are strongly backlit, usually by

a setting sun, achieving a soft atmospheric mood. The mythological or religious themes themselves are often difficult to determine, because the figures almost disappear into the idealized landscapes [114]. Lorrain's paintings enjoyed great popularity, especially in 18th century England, and in fact very closely reflect the ideal of the English country garden.

[114]
Claude Lorrain, *Landscape with the Rescue of Psyche*, 1666, oil on canvas, 3 x 5.2 ft., Wallraf Richartz Museum, Cologne.
In Lorrain's paintings, persons, objects, antique architecture, and trees fade into the warm, silvery yellow of sunrise or sunset. Light spreads itself diffusely through the crowns of the trees, almost dissolving their contures.

Where the almost romantic subjectivity of Lorrain's art already indicated a rejection of official Classicism, at some time, in the provinces as well as in Paris itself, opposite tendencies were appearing. The Le Nain brothers (for example, Louis Le Nain, ca. 1602–1648) depicted the peasant life of their day in addition to mythological themes.

More strongly influenced by the Caravaggists was the Lorraine artist Georges de la Tour (1593–1652), who subordinated details to an atmosphere of dark, mystically inviting depths in which figures are reduced to simple plastic forms [115]. As court painter to Louis XIII, he created a meditative counter-world to that of the Classicism of Poussin. A special case is Jacques Callot (1592/93–1635), who raised etching to its own art form. Especially famous are his Series on the *Horrors of the Thirty Years' War* (1632/33) which depict the cruelties of warfare and serve as an example for Goya's prints almost 200 years later (see p. 125).

Historical painting depicts both past and present events. From the ancient Classical world to the Renaissance, historical paintings had always been used to depict real or imagined events, and in the academies the historical picture became one of the most elegant and proper of the genres. Only religious pictures and portraits held a similar status. Until well into the 19th century, the historical painting was the most important type of work for every academic painter (David, Delacroix, Géricault, and the salon painters).

Flemish Painting— Rubens and van Dyck

From 1568 to 1648, when it finally achieved independence, the Protestant northern Netherlands was split from the Habsburg-governed province of Flanders. The art of Catholic Flanders under Spanish Habsburg rule was lastingly influenced by Peter Paul Rubens (1577–1640) from the time he set up his workshop in 1609 in Antwerp. Born in Siegen, Germany, Rubens was a court painter in Mantua, Italy, between 1600 and 1608, and had the opportunity to study the works of his contemporaries Michelangelo and Titian, as well as the antique world during several journeys through Italy. His workshop in Antwerp became a smithy of talent for Flemish painting: such various artistic personalities as van Dyck, Jordaens, Snyders and Jan Breughel the elder spent formative years in this creative milieu and contributed their own particular knowledge, for example Snyders' exotic animal pictures. Rubens and his workshop were at home with all formats and genres: religious painting with large altar pieces and ceiling works (as those in Venice, composed of paintings on canvas), por-

traits, historical pictures, hunt scenes, and landscapes belonged to their repertoire. Rubens's works became favorite export articles for the Spanish governors, and soon found their way throughout Europe, as only Titian's had done before. Copper engravings based on Rubens's paintings increased his artistic influence, and Rubens was soon sent on political missions, traveling throughout Europe, particularly between 1622 and 1628

in the midst of the Thirty Years' War. As confidential secretary of the Spanish governor, he was named to the Spanish nobility in 1630, and was dubbed knight by Charles I in Whitehall. Testimony to the tremendous artistic energy of this artist-diplomat include the 25-part *Medici Cycle* (1622–1625, Musée du Louvre, Paris) glorifying the marriage of Maria de'Medici with Henry IV; the multiple-piece *Ceiling painting* (1634, Whitehall, London); the 112-part cycle for Princely Cardinal Ferdinand in Madrid, for whom Rubens became court painter in 1634, and the design of several series of large tapestries. Rubens's final political painting, *The Horrors of War* in 1637 for the grand duke of Tuscany [117], conveys a personal and pessimistic view of political developments. In many respects the painting is a late counterbalance to his *Philosophers* [116]. Rubens developed his compositions from the spirited employment of the paintbrush, clear in numerous oil sketches. As opposed to Poussin, color always took precedence over line. From these contradictory positions, a war of styles between the "Poussinists" and the "Rubenists" developed into one

[117]
Peter Paul Rubens, *The Horrors of War* (detail), ca. 1637, oil on canvas, 6.8 x 11.3 ft., Palazzo Pitti, Florence. For the historian Jacob Burckhardt, this canvas was the "eternal and unforgettable title page of the Thirty Years' War." Accordingly, the labile construction of the scene lacks a firm floor, and the entire construction falls away toward the right. Rubens prefered a loose application of color, the skin surfaces (flesh tones) of his figures shimmer in all color shadings from pink to green to blue. For Rubens, color was more important than line, in contrast, for example, to Poussin.

[118]
Anthony van Dyck, *King Charles I of England*, ca. 1635, oil on canvas, 8.7 x 10 ft., Louvre, Paris.
Van Dyck's individual and group portraits of the courtly and noble society of England are more elegant and psychologically more self-assured than those of Rubens.

of the Baroque period's most exciting debates. The seemingly effortless fluidity of his style, as well as Rubens's pragmatic approach to his patrons' wishes, led to criticism in the 19th century by those who prefered the supposedly "deeper" works of his contemporaries Rembrandt and Vermeer.

Among Rubens's students, Jacob Jordaens (1583–1678) oriented himself closely on the style of his master, painting rustic, sometimes rough genre pictures. More significant is yet another student, Anthonis van Dyck (1599–1641), who followed five years in Rubens's workshop with one in Italy, before becoming court painter to Charles I in 1632 [118]. His portraits were so successful that they not only decisively influenced the English portraiture of Sir Peter Lely (1618–1680), but remained formative even until Gainsborough in the 18th century. The "Van Dyck costume," with its glowing silks and lace ruffs, has become an enduring term of reference. With the decorative flower pictures of Jan Breughel the Elder (1568–1625) and Jan Breughel the Younger (1601–1678), and the inn and gaming scenes of Adriaen Brouwer (ca. 1605–1638) and David Teniers the Younger (1610–1690), who were largely active as genre painters, Flemish and Dutch painting reached the limits of its thematic and stylistic boundaries.

Originally small-scale preliminary studies before the patron granted a contract, Rubens's **oil sketches** became an art form in their own right. In them, he used the medium of color to experiment with the appropriate form for the picture, and the sketches acquired an importance that in the Renaissance had belonged to preliminary drawings. Later, such sketches became important as studies for Baroque altars and ceiling frescos, particularly with Tiepolo in Venice, and with Troger and Maulbertsch in southern German and Austrian Late Baroque style.

Dutch painting—The background

The rise of Holland and the other provinces of
the Netherlands is both politically and econo-
mically remarkable. One might say that during
its golden age in the 17th century, Amsterdam
became the capital of world trade, reducing
Antwerp to second place. Supported by England
in the struggle against Flanders, which remained
under Spanish control, the United Netherlands
used the opportunity to establish its own colonial
empire and fleet for world trade. As in the
Italian city states of the Renaissance, the
mercantile—and in this case Calvinist—
mentality of the Dutch was a prerequisite of
success. Calculating, observing, and analyzing
with eager curiosity and exacting precision, were
the basis of affluence as well as of worldly assur-
ance and success.

It is no accident that precisely in this environ-
ment Antonis van Leeuwenhoek developed the
first microscope and described blood cells and
sperm, while his contemporaries systematically
collected and illustrated flora and fauna in
comprehensive multi-volume books. The
improvement of optical instruments, in particu-
lar the increased use of the *camera obscura* (see
p. 106), enabled the exact depiction of life and
enriched painting as a new tool. Illustration
"from life" is the great theme of Dutch painting.
In contrast to Italy, where the *disegno* placed not

Svetlana Alpers: *The Art of Describing*. The questions posed by the American art histo-
rian in her 1983 book, have created a stir in art criticism, which had formerly con-
cerned itself mostly with questions of content (iconography) in Dutch painting. Alpers
places the visual culture of Holland in the foreground, and understands the art of the
17th century as one influenced by contemporary notions of sight and seeing, less
dependent on emblematic texts than on presice observation. She finds this emphasis
on seeing and representation to be distinctively Dutch, as opposed to the Renaissance
emphasis on reading and interpretation, a different assimilation of reality more charac-
teristic of Italian art.

[119]
Willem Kalff, *Still Life with the Drinking Horn of the St. Sebastian's Arquebusier's Guild*, ca. 1653, oil on canvas, 2.8 x 3.3 ft., National Gallery, London.

only the drawing, but in particular, the ideas of the artist in the foreground (see p. 30), Dutch art is characterized by the realism of the surface. The function of religious altar panels lost all its significance, and the question of whether the various specialized artists were depicting "only" the visible reality and nothing more, has concerned art historians since the 19th century, when they began to search for a deeper meaning. The emblem books of the time, which combine aphorisms with pictoral illustrations, provide a key for the understanding of still lifes, seascapes, and genre paintings. Wilted flowers, rotting fruit, a sinking ship, or a dead tree are references to *vanitas*, the transitoriness of all things and life itself; similarly, gleaming silver tableware also points to the vanity of earthly existence. This approach to Dutch painting emphasizes its religious content, even within genre and domestic paintings.

[120]
Pieter Saenredam, *The Grote Kerk in Haarlem*, ca. 1636/1637, oil on canvas, 2 x 2.7 ft., National Gallery, London.

[121]
Aelbert Cuyp, *Herdsman with Five Cows at the River*, ca. 1650, oil on canvas, 17.7 x 29 in., National Gallery, London.

The genres of Dutch painting—Mirrors of life

Still life: The enrichment of the still life with flowers or objects of daily life had already been recognized as an art form in its own right since the 16th century, but in the Netherlands, the still life reaches its high point [119]. For all their realism, the precisely calculated design of the paintings is clear, for example, in the careful "artistic" arrangement of flowers whose blossoms could never in reality be open at the same time.

Sea painting: Seascapes enjoyed great popularity. Ships in danger or in the midst of battle are major motifs which depict the transport problems of an ambitious world trading power as well as illustrating human existence at the mercy of nature before throne of God.

Landscapes: In contrast to the fantastic and generalized landscapes of Renaissance and Mannerist arts, for the first time paintings depict the actual landscape of Holland, characteristically with an expanded horizon. The genre served as a tool to ascertain and take stock of the environment, the opportunities and threats it presented, and to depict both peacefulness and the dangers to existence [121]. Especially in portrayals of the drained lands behind the dikes and in the orderly cityscapes, pride in economic and technical achievement is most evident. A special category of landscape and animal studies appears in the work of Albert Eckhout (ca. 1610–1666) and Frans Post (1612–1680), who produced exotic views of Brazil at the behest of the governor of the West Indian Company (founded in 1609).

Interior scenes: As with the world outside, interior space is also carefully measured and composed, often with the help of optical devices. Characteristic of this art is the interiors of churches [120] which set a sharply defined slanted perspective against the central perspective of Italian painting.

Animal pictures: The monumental pictures of cows and bulls by Paulus Porter (1625–1654) carry the

Important masters of still life:
Ambrosius Bosschaert (1573–1621)
Pieter Claesz (1597/98–1661)
Willem Kalff (1619–1693),
Willem van Aelst (1624/25–1683)

Important masters of sea paintings:
Ludolf Backhuysen (1631–1708)
Willem van de Velde the Younger (1633–1707)

Important masters of landscapes:
Hercules Seghers (1589/90–1638)
Jan van Goyen (1596–1659)
Salomon van Ruysdael (1600/03–1670)
Jacob van Ruisdael (1628/29–1682)
Philips Wouwermans (1619–1668)
Philips Koninck (1619–1688)
Aelbert Cuyp (1620–1691)
Meindert Hobbema (1638–1709)

Important masters of interiors:
Pieter de Hooch (1629–after 1683) domestic scenes
Pieter Saenredam (1597–1665) church interiors

Important masters of genre painting:
Pieter Codde
(1599–1678)
Willem Duyster
(1599–1635)
Adriaen van Ostade
(1610–1685)
Gerard Dou
(1613–1675)
Gerard Terborch
(1617–1681)
Jan Steen
(1626–1679)
Gabriel Metsu
(1629–1667)
Nicolaes Maes
(1634–1693)
Frans van Mieris
(1635–1681)

Important portrait masters:
Thomas de Keyser
(1596/97–1667)
Gerard van Honthorst
(1590–1656)
(the latter was also known for historical paintings)

Important masters of the historical painting:
Pieter Lastman
(ca. 1583–1633)
Govaert Flinck
(1615–1660)

compositional principle of "high art" into animal painting.

Genre scenes: Iconographic analysis is the most productive approach to these paintings because of their clear resonance with moralizing texts, and because a proven tradition exists with roots reaching back into the 16th century (Pieter Breughel the Elder and his successors). Domestic scenes, inn settings, and annual fairs provide a mirror for the elevated bourgeois society. A fine painting technique seemingly contradicts the apparently trivial objects included in the pictures: luxurious materials gleam in candle-light, and the secondary objects are ennobled through minute replication in service to the pictorial narrative.

Portrait: The single, double, family, and group portrait is perhaps the most distinguished genre of Dutch painting. The portraits serve for the communication and documentation of social connections, as in the group portraits of guild members. The attributes of position and objects in the paintings are (with the exception of Rembrandt) far less encoded than those in Italian or French Mannerist portraits. The portrayed figures are depicted in a natural environment, or with the emblems of their responsibilities in society.

Historical painting: Compared to Italy or France, the historical paintings play a smaller role, with themes from the ancient classical world occurring rarely, and from the Old Testament more often. More important are historical scenes from the revolt against Spain, usually commissioned by the young republic for official buildings.

Alois Riegl: *Das holländische Gruppenbild* ("The Dutch Group Portrait"). The Austrian art historian Alois Riegl, in his 1902 study of the Dutch group portrait, investigated the possibilities of art in the placement of figures in relation to one another. In contrast to Italian art, with its active figures to whom composition is subordinated, Dutch group portraits, according to Riegl, are a coordinated composition of attentively observed individuals within their socially determined environment (see also p. 165).

Frans Hals

After the occupation of Antwerp by the Spanish in 1585, the Hals family emigrated to Haarlem, where Frans Hals (1581/85–1666) remained for the rest of his life. After rather conventional beginnings, Hals developed into one of the most important portrait masters of his age, concentrating almost exclusively on portraits of his fellow Haarlem citizens, culminating in his late masterpiece *Regents of the Old Men's Almshouse in Haarlem* (1664, Frans Hals Museum, Haarlem). What Hals introduced to portraiture is the psychologically exact relationships among the figures. His brushwork became ever freer and more impressionistic in the course of his artistic development, and as a result, he became a reference point for art in the second half of the 19th century. His palette simplified in his later work, concentrating on black, gray, brown and white variations [122]. According to the conception of the 19th century, this general darkening of color was characteristic for a typical Dutch "Gallery tone."

[122]
Frans Hals, *Malle Babbe*, ca. 1650, oil on canvas, 2.5 x 2 ft., Staatliche Museen Preussischer Kulturbesitz, Gemäldegalerie, Berlin.
The "Malle Babbe" (Crazy Babbe) possibly symbolizes the vice of alcoholism. The jug, the uninhibited laugh, the owl—everything indicates that Hals is translating pictorially the Dutch saying, "as drunk as an owl." Already in 1869 Courbet recognized the particular quality of Hals' bold use of color in this painting, and copied the picture.

[123]
Rembrandt, *The Blessing of Jacob*, 1656, oil on canvas, 5.8 x 6.9 ft., Staatliche Kunstsammlung, Gemäldegalerie, Kassel.

Rembrandt

The significance of Rembrandt Harmenszon van Rijn (1606–1669) to the Netherlands is as important as that of Rubens for Flanders. In contrast to the virtuoso Catholic artist of color, the inward and "dark" Protestant character of Rembrandt has often been falsely interpreted since the 19th century. After training in Leiden, Rembrandt settled in Amsterdam in 1632. His life is marked by personal losses: the death of his wife Saskia in 1642 was followed by that of his beloved companion Hendrickje Stoffels in 1663, and his son Titus in 1668. Meanwhile, in 1656, his workshop had gone

The **etching** is a further development of copper plate engraving. The drawing is scratched onto a copper plate coated with wax or a similar material, and the plate is submerged in an acid bath to deepen the drawn lines through the corrosive action of the acid. After rinsing, the surface is used for printing. In the variation known as dry-point engraving, the etching is drawn directly onto the plate, without a cover layer. The corrosive etching makes shading with light-dark effects possible. Both processes were used, especially by Rembrandt [125], the master of the etching method that had been developed in the 16th century for the weapons industry (Daniel Hopfer from Kaufbeuren, Germany). Etching underwent a renaissance at the end of the 19th century under Impressionism and Symbolism.

bankrupt. These blows nourished romantic legends of an unrecognized genius, and only in the recent past has there been a new evaluation and accrediting of the comprehensive oeuvre associated with the name Rembrandt, which has especially resulted in turning attention to his many students. Rembrandt's artistic roots were international: Italian (Caravaggio) and German (Elsheimer) influences meet in the Dutch tradition in Rembrandt's early works. He developed his characteristic style in the 1630's: oil painting based on variations of brown and gold tones with few but powerful additions of red. The decisive moments are initially depicted almost theatrically, but later in a more restful style, as if called out of a dark background by means of a spotlight. In contrast to Caravaggio, Rembrandt's painting exhibited atmospheric transitions: forms are defined by nuances of color rather than by hard lines. His themes are multifarious. Landscapes stand next to expressive portraits (*Anatomy Lesson of Dr. Tulp*, 1632; the *Night Watch*, 1642; *Staalmeesters*, 1662), and especially important are the deeply felt illustrations of the salvation history of the Old and New Testament, culminating in canvases as *The Blessing of Jacob* [123].

Rembrandt's numerous etchings, preserved in various stages of completion, mark a second emphasis in his work, and his series of self-portraits, stemming from all periods of his creativity [124], convey an impressive image of the self-understanding of a great artist, unequalled between the time of Dürer and that of van Gogh.

[124]
Rembrandt, *Self Portrait*, ca. 1661, oil on canvas, 26.8 x 22.2 in., Staatsgalerie, Stuttgart.
In every phase of his life, Rembrandt's gaze into the mirror yielded both a psychological portrait of the painter, serving almost as a biographical protocol.

[125]
Rembrandt, *Christ Preaching*, ca. 1652, etching, 6.1 x 6.5 in.

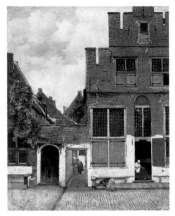

[126]
Vermeer, *Street in Delft*, ca. 1659–1661?, oil on canvas, 21.3 x 17.3 in., Rijksmuseum, Amsterdam.
The silence of the street scene is determined by the grainy, warm, almost tangible surface of the brick walls. The whitened ground floor gives the luminous color dots of the women's dresses even greater emphasis.

Vermeer

The work of Jan Vermeer van Delft (1632–1675) must be accounted among the wonders of painting. His teachers are unknown, and during his lifetime, Vermeer, being an art dealer himself, apparently sold none of the 36 works that are known to be his. Financially he was not well off, and probably he painted for friends or for himself. Upon his death, most of his paintings were appropriated to cover his debts. He seems never to have left his home city of Delft, and was only "discovered" by art history in the 19th century.

With only a few exceptions in his early career, his paintings must be classified as genre or interior paintings on the basis of the subjects painted, although there are two phenomenal cityscapes, *Street in Delft* [126] and *View of Delft* (ca. 1660/61, Mauritshuis, Den Haag).

All of Vermeer's pictures are iconographically interesting, and many refer to the problems of human relations against the background of religion. What makes the mid-sized pictures unique is their painterly texture. A Vermeer painting establishes a closeness with the viewer, who feels acquainted with its theme and composition. At nearer approach, the colored surfaces and the objects increase in significance, before vision finally submerges itself in a surface made up of the smallest possible lighted specks of color, into which the the picture dissolves. Attempts

As a forerunner of the modern photo apparatus, the **camera obscura** was already known in principle in the Middle Ages. The astronomer Kepler gave the device its name at the beginning of the 17th century. In this simple hole camera, the reverse image of an object is formed in a box, and is cast by an arrangement of mirrors onto the wall—or canvas. Vermeer, and later Canaletto and Reynolds, used the technique to produce "uncompromising" spatial images—naturally, also illusions.

have been made to explain this "miracle" of Vermeer's art through the use of the *camera obscura* during the painting process. The point-like application of pure color in many of the pictures supposedly reflects the fine rings around the points of color caused by the physical laws of the camera obscura, although this interpretation does not explain the atmospheric density of the pictures whose interiors are always furnished with the same objects: constantly the sunlight falls in from the left hand side, often the same chair or a geographical map being fixed on the wall are found. Vermeer's rich meditations on ordinary life, artistry and the Last Judgment [127], and his splendid technique place him artistically, as well as chronologically, among the masters of his age, while at the same time forming the greatest imaginable contrast to the Baroque painting of his contemporaries in Italy and Flanders.

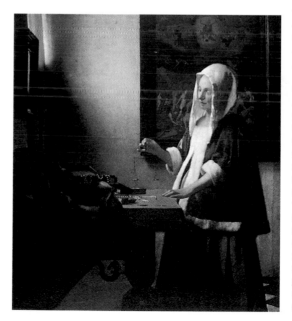

[127]
Vermeer, *Woman With a Balance*, ca. 1664–1665, oil on canvas, 16.5 x 15 in., National Gallery of Art, Washington, D.C.
The woman, concentrated and thoughtful, weighs pearls or coins with hand-scales, just as the Archangel Michael lays souls on the scales of the Last Judgment to prove their worth. The painting of the *Last Judgment* on the wall behind the woman suggests that she is also reflecting on the judgmental aspect of the biblical scene. The balance of the scales may be an indication that she is in every sense "expecting," even if the bright red stripes on her lower gown may refer to the sinful origin of her child.

1700-1848—
From Rococo to Romanticism

The disintegration of traditional genres of painting

Until the outbreak of the French Revolution in 1789, the absolutist courts of Europe continued to celebrate their own glory in magnificent festivals and paintings, even though their economic power was in serious decline. In the course of time, small-scale sentimentality crept into the arts—a pastoral play in comparison to the original great opera, so to speak. Venice, having meanwhile sunk to political insignificance, was the party place of Europe, undergoing a boom of popularity around 1750 as a stopover on the *grand tour*, that obligatory Italian educational journey undertaken by young English aristocrats. Through agents like the famous Consul Smith in Venice, the *milordi inglesi* bought Italian art for their country estates which they commissioned in the style of the Renaissance master-architect Palladio. Favorite souvenirs were the minutely detailed paintings, engravings or etchings of picturesque Venetian or Roman cityscapes, the *vedute*. Even more fashion-able were the *capricci*, free fantasies which combined pieces of unrelated architecture, scenes, and landscapes.

The art market is an 18th century invention. Aside from the traditional relationship between the com-missioning patrons and the artists, the purchase of art had been chiefly a personal affair in the 17th century, conducted within a narrow framework; but the 18th century saw the rise of the art agent as intermediary between artist and buyer. This development was furthered by the absolutist princes who sought additions to their painting galleries, and increasingly set about collecting examples of particular schools of painting, or the work of favored artists.

After 1700, religious art was produced chiefly in the lands most affected by the destructions of the Thirty Years' War, where commissions were largely a response to the building of new churches. Bavarian monasteries and the Habsburg lands from Bohemia to Hungary carried the splendour of the princely palaces into the Rococo decoration of the churches. Overturning traditional genre distinctions one last time, architecture, painting, and sculpture were joined together in composite works of art reflecting ecclesiastical might.

In the course of the Enlightenment, interest in religious pictures more or less diminished, and their iconography, in particular the pictorial formulas introduced during the Renaissance and the High Baroque, now became available to other genres, whether caricature, the bourgeois art of Hogarth, or the American historical painting of Benjamin West. In the 18th century, art styles like the Baroque, Late Baroque, Rococo, Neoclassic, and Early Romantic are found as parallel phenomena. The century of the gallant novel, the Enlightenment, and the French Revolution opened up new perspectives—which often enough established them-selves against the teachings of the academies.

Against the sober daylight of the Enlightenment stands its opposite image: the dark, the irrational, the threatening. From Alessandro Magnasco (1667–1749) to Piranesi, to Fuseli and Blake, a stream of irrationality cuts across the century of reason, preparing the way for the subjectivity of Romanticism. An important development is the connection between literature and painting. In the middle of the century, interest in the supposedly Celtic lays of Ossian and in Shakespeare's dramas gave a new literary inspiration to pictorial art, and demanded in turn appropriate new ways of expression in painting. Terms such as "sublime" or "picturesque" reflect a new experience of landscape. Romantic paintings reveal revolutionary

1769
Invention of the steam engine (Watt)
July 4, 1776
American Declaration of Independence
1783
Peace of Versailles: Great Britain recognizes the independence of the United States of America
1789
Beginning of French Revolution
1791
French Constitution proclaimed
1793
Beheading of King Louis XIV
1794
Fall of Robespierre
1795
Third partition and dissolution of Poland
1797
End of the Venetian Republic, city becomes Habsburg property
1804
French Code Civil becomes first modern legislation, Napoleon crowned emperor
1805
English victory over France in sea battle of Trafalgar
1806
Confederation of the Rhine founded
1812
Moscow taken by Napoleon

1813
Battle of the Nations at Leipzig, Napeoleon defeated
1815
Battle of Waterloo, Congress of Vienna concluded
1821–1829
Greek war of liberation
1823
Monroe Doctrine: the United States actively opposes future European involvement in the New World
1830
First railway, Liverpool-Manchester; July Revolution in France; Belgian independence
1830–1848
Louis-Philippe is "Citizen-king" of France
1848
Liberal revolutions in almost all European countries

[128]
Giovanni Battista Tiepolo, *The Angel Appearing to Sarah*, 1726–1728, fresco, Palazzo Patriarcale, Udine.

110

tensions in the swirling colors of a William Turner, or a new spirituality in the religious landscapes of a Caspar David Friedrich.

Romanticism was only one of the possible artistic answers to the replacement of the traditional content of painting with largely free invention. Much closer to the feeling of the French Revolution and, para-doxically, to the imperial empire of Napoleon, was the Neoclassicism that arose after 1780, offering politically clear criteria for art. Like Romanticism, Neoclassicism was also an idealistic art form based on traditional values. Only after the successive dis-appointments of the revolutions of 1830 and 1848/49 did the new art forms of Realism and Impressionism appear, and art begin to lose ist overtly ideological tension.

Continuing the great tradition—Tiepolo

The Chiaroscuro of Giovanni Battista Piazzetta (1682–1754) and the late, light-colored narrative frescos and canvases of Sebastiano Ricci (1659–1734) prepared the way for the comprehensive work of the Venetian Giovanni Battista Tiepolo (1696–1770). Only the Neapolitan virtuoso fresco painter Francesco Solimena (1657–1747) attained a similar popularity as successor to Luca Giordano (1634–1705).

At the conclusion of the Baroque period, Tiepolo's frescos apotheosize and allegorize the representatives of Baroque feudal society on ceilings and walls of great halls in an explosion of color. Thanks to intelligent investments, Tiepolo was able to proceed from his brilliant early efforts in the Palazzo Arcivescovile in Udine [128] to his more restrained late work in the Palacio Real in Madrid (1764–1766), making only a few stylistic concessions. He employed skillful quill and ink drawings as well as oil sketches in preparation for his altar paintings and frescos. His easily surveyed repertoire of figures, always cleverly varied, was newly re-composed for each work before a shallow, pastel foil of clouds. The profile of a young woman whom

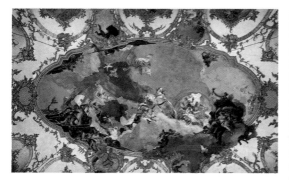

[129]
Giovanni Battista Tiepolo, *Apollo Bringing the Bride Burgundy to the Genius of the Holy Roman Empire*, 1751–1752, ceiling fresco with stucco work, 27 x 54 ft., Residence, Kaisersaal, Würzburg. Tiepolo's Venetian language of forms to some extent inter-nationalizes the medieval German topics of the vault and walls of the main hall of the bishop's castle.

the viewer meets now as Cleopatra, now as Armida or a biblical character, is convincing evidence of the artist's new and rational use of his resources, and equally of his consciousness of his audience's continuing approval of the recognizability of his style.

A peak of profane fresco artistry is reached in the Late Baroque painting of the Residence at Würzburg, where the frescos combine with the stucco work and architecture of Balthasar Neumann to form a successful whole [129]. The huge format and the iconographic design of the themes of the painting of Apollo and the allegory of the continents which decorates the staircase combines the revised Venetian style of Veronese and Tintoretto with the new perspective techniques of theater decoration to draw the observer ascending the double staircase into the composition of the ceiling fresco. (On Tiepolo's *capriccios*, see p. 117).

Any artist like Tiepolo, whose technical abilities shine above his rather distant subject matter, has often to defend himself from the charge of superficiality, especially when the body of his works was completed quickly in a large studio. Goethe (born 1749) expressed preference for the sober and, in the broadest sense, bourgeois pieces of the son, Giovanni Domenico Tiepolo (1727–1804), in the Villa Valmarana near Vicenza. Both father and son decorated the villa, and the contrast between their styles illustrates the passing of the old Baroque-inspired fresco.

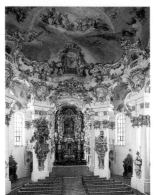

[130]
Dominikus and Johann
Baptist Zimmermann,
Wieskirche (interior),
1745–1754.

Rococo in central Europe

After the desolation caused by the Thirty Years's War, it was primarily Italian painters and stucco artists who were active as roving artists in Central Europe, especially in Bavaria and Austria. At the the start of the 18th century, the situation changed, and new teams of stucco artists, sculptors and painters imprinted buildings with their own decorative style. In their role as architects, sculptors and stucco artists, the brothers Cosmas Damian Asam and Egidius Asam (1686–1739 and 1692–1750) united the most varied media in the light-permeated stage settings of a religious theater (the chancel decoration in the Weltenburg Monastery and at Rohr, both 1716–1722). Johann Baptist Zimmermann (1680–1758) decorated the buildings of his brother Dominikus with wall frescos that opened the structures heavenward in a unity of form and color [130]. In the the transition from the Rococo to the beginning of Neoclassicism, ceiling paintings were once again clearly enclosed in frames which sealed off the previously accessible heavenly landscapes of the Late

Rococo (from French rocaille, mussel-shell work) in the narrow sense refers to a phase of French art extending from ca. 1730 to 1750 during the reign of Louis XV. This *style de rocaille* described a stylistically unified, highly ornamentalized art found in interiors, commercial art (porcelain and furniture), as well as architecture and painting. In France, the Rococo succeeded to the Regency style. Not until 1842 did the term appear in a supplementary volume to the dictionary of the French Academy.

As a style, Rococo lacks a theoretical base, but the term is used in art history outside of France to refer to a late phase of Baroque before the onset of Neoclassicism and Romanticism. From the "Friederician Rococo" in Potsdam, to the "Wilhelmine Rococo" in Bayreuth (the residence of the sister of Frederic II, the Marchioness Wilhelmine), to the Frankish and Bavarain Rococo found in palaces and churches (Cuvilliés, Fischer, Zimmermann, Neumann), through to the Piemontese architecture in the wake of Guarini (Vittone), completely different phenomena have been designated as "Rococo." Essentially, it was used to describe art of the period that was floridly frivolous; pretty, rather than serious.

Baroque and Rococo. In a return to the wall and ceiling paintings of the Renaissance, the usual Baroque undershot perspective was avoided in favor of the the side view, as can be seen in the work of Januarius Zick (1730–1797) (Church of the Wiblingen Monastery, near Ulm, 1778–1780). After 1765, Franz Anton Maulbertsch (1724–1796) also responded to the changing wishes of his patrons by toning down his work, and balancing the colors in his compositions. In many provincial areas of Hungary and Moravia, however, he still found scope for his agitated, extravagantly colorful style, and was able to pictorially translate religious ecstacy one last time in the flickering color cascades of his over-wrought chiaroscuro compositions [131].

[131]
Franz Anton Maulbertsch, *Annunciation*, 1766–1767, oil on canvas, 10.6 x 6.4 ft., Österreichische Galerie im Belvedere, Barockmuseum, Vienna.

The world as comedy and pastoral— French Rococo

The fusion of art genres, the blurring of their boundaries, is far more an essential characteristic of Rococo than of Baroque art. For the appointment of courtly and high bourgeois interiors, the result of this Rococo intermixing meant that framing, carving, and mirrors became equally significant as painted wall surfaces. In private chambers, ceiling and wall frescos gave way to the intimate canvases for which France became famous. Even during his own lifetime, the *Fêtes galantes* of Jean-Antoine Watteau (1684–1721) became synonymous with erotically flirtatious painting, and were accepted by the Académie as a new genre. Watteau lightened the weight of the silvery lustrous palette borrowed from Veronese with numerous interruptions of light blue, yellow, pink and green. Watteau's pictures translate the sparkling drawing-room comedies of a Marivaux into visual form. Like Tiepolo, he commands a surveyable range of figure types, with which he populates his scenes according to the theme of the picture. The floating ephemerality of the pictures corresponds to the supposed willfulness and coquetry of the artistic

process. A surprising exception within his oeuvre is the strongly expressive Gilles [132] with his direct and un-ironic humanity. Watteau's *L'Enseigne de Gersaint* (1720, Charlottenburg Palace, Berlin) is a miracle of finely nuanced color painting, yet was meant to be only an advertising sign.

The young crown prince Frederick of Prussia (later Frederick the Great) collected works both of Watteau and of his students Nicolas Lancret (1690–1743) and Jean-Baptiste Pater (1695–1736), who offered the prince a counterweight to his own constrained and duty-bound existence. Watteau was also influential for François Boucher (1703–1770), the favorite of Madame de Pompadour. In cheerful portraits, as well as in his skillfully arranged mythological scenes in which flesh-like pinks joined with the greens of nature to form an erotic synthesis, Boucher conveyed an apparently effortless existence emulated by the aristocrats who collected his work.

Jean-Honoré Fragonard (1732–1806) was the last great painter of the *Ancien Régime* before the French Revolution. In their easy brushwork, some of his portraits are reminiscent of Hals (see p. 103), and his drawings number among the best of the 18th century. *The Swing* [133] is a showpiece

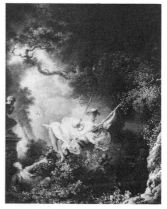

of late Rococo art. After the outbreak of the French Revolution, Fragonard almost ceased to receive contracts. The same was true for Jean-Baptiste Greuze (1725–1805), even though the enlighted author Diderot praised his "moral" genre scenes as the antithesis of the Rococo of a Boucher or a Fragonard.

Experiments with color

Jean-Baptiste Siméon Chardin (1699–1779) is, after Watteau, the second French painter for whose induction the Académie invented a new genre. As early as 1728, the institution had accepted him as a "painter of animals and fruits," even though his work clearly diverged from the official Académie style. Educated in the classical tradition, Chardin first concentrated wholly on hunt scenes and still lifes with fruit, later adding domestic petty-bourgeois interior scenes to his repertoire: kitchen maids, children praying, playing, learning, or drawing [134]. Suffering increasingly from eye problems that were worsened by the solvents used in oil paints, Chardin switched after 1770 to pastels, which he employed in portraiture in the tradition of the famous Venetian painter Rosalba Carriera (1675–1757). Chardin achieved amazing success with his non-chivalrous themes, which did not at all conform to the style of the times. His works, in fact, make demands on the observer: Like Van Eyck and Vermeer, Chardin makes the very process of seeing part of the object of the picture. In every painting, the artist seems to rediscover color itself, in order to define his object anew by means of the colored surface. Chardin does not paint a table as an image of a real table, as the Dutch painters of the 17th century had done, but rather translates his artistic idea of the a table onto the canvas. Thus viewers looking at the picture confront an image of the table's image, which they then must compare with actual tables they are familiar with. As with Vermeer,

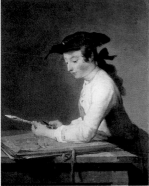

[134]
Jean-Baptiste Chardin, *The Draftsman*, 1737, oil on canvas, 2.7 x 2.2 ft., Staatliche Museen Preussischer Kulturbesitz, Gemäldegalerie, Berlin.
The observer remains excluded from the world of Chardin's still lifes, kitchens, and parlor scenes. The figures invite no contact with the viewer, for they are totally absorbed in their own activity. Thus also the draftsman, without pausing to look up, is already thinking about his work as he readies his tools.

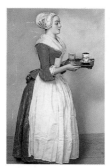

[135]
Jean-Étienne Liotard,
The Chocolate Girl,
1744, pastel, 2.7 x 1.7
ft., Staatliche Kunst-
sammlungen, Gemälde-
galerie, Dresden.
The subtly vibrating sur-
face of Liotard's por-
traits define his figures
against a usually
neutral background by
means of extremely
delicate gradations of
color.

[136]
Canaletto, *San Marco
with the Palace of the
Doge*, after 1730, oil
on canvas, 1.7 x 2.7 ft.,
National Gallery,
Washington, D.C.
Canaletto used the ad-
vantages of the *camera
obscura* in creating an
inventory of scenes for
later use in painting.

the viewer will never really understand the "making" of this painting of surfaces and textures. Chardin's world of color seems almost self-sufficient, and perhaps for this reason he chose for it lowly objects of daily life in all their banality, in order to visualize a new way of seeing.

Luis Eugenio Meléndez (1716–1780), known as the "Spanish Chardin," reduced the vocabulary of his pictures even more strongly than his namesake. Meléndez's still lives consist of a few, always recurring objects. His color, however, is more conventional and rustic than Chardin's. The Swiss pastel artist and etcher Jean-Etienne Liotard (1702– 1789) placed clearly delineated figures against the plainest of backgrounds [135]. His portraits of aristocrats in Turkish dress prepare the way for the orientalism of the next century (Ingres, Gérôme).

Veduta and Capriccio

Since the 17th century, the increasing demand for topographically exact cityscapes or landscapes, known as *vedute* (= plural of veduta), reflected a growing market for tourist souvenirs especially between 1720 and 1760, the golden age of the *grand tours* of the English aristrocracy. The desire for precise illustration of cityscapes and possessions went hand in hand with enlightened understanding of precise measurement and optical recording.

The first series of etchings in 1703 by Luca Carlevari (1663–1729) were forerunners for the art of Giovanni Antonio Canal, known as Canaletto (1697–1768). Through his contacts with influential art patrons and the art dealer Consul Joseph Smith, Canaletto's light-filled vedute of Venice, especially the Canale Grande (series also published as etchings in 1735), and of St. Mark's Square, made their way to England [136]. His late works often appear to repeat patterns he had developed earlier. Bernardo

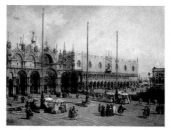

Bellotto (1720–1780), Canaletto's nephew, was extremely successful in exporting the art of the vedute to Vienna, Dresden, and Warsaw. The subjective, impressionistically vibrating cityscapes of Francesco Guardi (1712–1793) already approach the criteria for a capriccio. Only second to Venice as a popular tourist goal, Rome also became a center of the veduta-painters, with Giovanni Paolo Panini (1691/92–1765) as the most important representative.

The architectural capriccio arose with the posthumously published series of etchings of Marco Ricci (1676–1730). Panini recognized the advantage offered by the genre to the impatient fan and connoisseur by bringing many ancient monuments together in a single picture—all of Rome within a single frame, as it were.

In his architectural capricci, the inspired architect, copper engraver, and etcher Giovani Battista Piranesi (1720–1778) united the ornamentalism of French Rococo with the stage settings of Italian Baroque theater. Architectural detail was endlessly

[137]
Pietro Longhi, *The Rhinoceros*, 1751, oil on canvas, 2.1 x 1.7 ft., Ca'Rezzonico, Museo del Settecento Veneziano, Venice. Longhi's genre scenes depict everyday life in Venetian society, often with surprising constellations of figures, reminiscent of the capriccio.

[138]
Giovanni Battista Tiepolo, *Death Giving Audience*, page from the *Vari Capricci*, 1740, etching, 5.5 x 6.9 in., National Gallery, Washington, D.C.

The term **capriccio** designates an 18th century painting, etching or drawing that mixes elements of artistic fantasy with actual architectural structures into a picturesque whole. However, the term can also refer to purely imaginary works that place together normally unrelated elements in configurations that no human eye has seen on earth. (The word connotes various meanings in Italian, but originally probably refered to the unpredictable cavorting of a young goat; plural, capricci.) The capriccio tradition is rooted in Mannerist pictorial invention of the 16th century, and was already named by Vasari. In this broader sense, the term must include the imaginary scenes of Alessandro Magnasco (1667–1749), the capricci of Giambattista Tiepolo [138], *Los Caprichos* by Goya (see p. 124), and even the genre scenes of Pietro Longhi (1702–1785).

In the capriccio, the contents and formal elements of the painting tradition were suddenly set free and became available for new combinations. For this reason, the academies were skeptical of this new type of art, because it mixed the traditional content and genres of painting. In Romanticism, on the contrary, the capriccio became important for the same reason, particularly for the Romantic Arabesque.

[139]
Giovanni Battista Piranesi, *Plate VII of the Carceri* (2nd printed edition), 1750, etching, 1.9 x 1.5 ft.
Piranesi created imaginary landscapes of endless labyrinthine dungeons—an anticipation of the unfathomable depths of the novels of the Marquis de Sade. In Piranesi's dungeon chambers, the human being becomes the victim of his own imagination, and the figures are reduced to insignificance in relation to the nightmarish inescapability of their surroundings.

multiplied and enlarged, and the human figure disappears in the calculated intricacy of this artificial world of ruins, nature, and time. This tendency also reveals itself in the *vedute* depicting ancient Rome or the temples of Paestum, which take on a demonic character under Piranesi's engraving tool. A high point of the free use of fantasy in the capriccio was reached by the *Carceri d'Invenzione*, a series published in several stages of etching after 1749/50 [139]. The series of Piranesi's engravings must be seen as both an expansion of, and a counterpoint to, the philosophy of the Enlightenment. The recognition that the darkness of the human psyche cannot be completely illuminated was picked up by Romanticism around 1800. The nightmarish *Carceri*, the *Landscape Capricci* of Claude-Joseph Vernet (1714–1789) as well as the ruined landscapes of Hubert Robert (1733–1808) offer, so to speak, a negative starting-point for Romantic painting.

English painting

The 18th century saw the beginning of an independent British painting tradition; until then, a tradition, if there was one at all, had existed only in 17th century portraiture. Other genres also fared poorly in the 18th century: religious commissions were hard to come by, historical painting was bought in Italy or France, landscape painting remained under the shadow of Lorrain. The aristocracy was busy with the construction of its country estates with their gardens, and royal or official contracts were rare.

This is the situation in which William Hogarth (1697–1764) established the genre of pictorial satire, a subdivision of historical painting—with his cycles of small-formatted, moralizing engravings (for example, *The Rake's Progress*, painting cycle ca. 1733, Sir John Soane's Museum, London; edition of copper

engragings 1735). Hogarth's engraved cycles were designed for broad publication whose targeted public was the rising middle class. Hogarth consciously rejected the label of caricaturist, and novelist Henry Fielding raised a protective arm over him in the forward to Joseph Andrews by terming him a "comic history painter," closer to nature than to the sublime or the grotesque. Hogarth's compositions reflect their roots in the pictorial patterns of 16th and 17th century religious painting, motifs used by Hogarth to ennoble his bourgeois themes [140]. His lively character studies can be seen as the foundation of an English tradition of bourgeois, realistic portraiture of outstanding significance, and furthermore he presented his pictorial theories in *The Analysis of Beauty* (1753), defending the s-shaped natural "line of beauty" as basic for any real art. As a genre in its own right, caricature responded to the events of the French Revolution and the Napoleonic wars in the work of James Gillray (1757–1815) and Thomas Rowlandson (1756–1827). The Royal Academy was not founded until 1768— also a sign of the tardy development of English painting. The founding president of the Academy was Sir Joshua Reynolds (1723–1793), the most sought-after portrait painter of the age, who was raised to nobility in in the same year as the Academy's establishment. His numerous pictures reflect the social situation of his subjects in attitude, stance, and gesture [141]. His *Discourses on Painting* (published from 1769 to 1790) were highly regarded internationally, and in this theoretical text on 18th century English painting, the official art criticism of England first finds its voice. It is noteworthy that Reynolds nonetheless pays due respect to his opponent, Thomas Gainsborough (1727–1788) in the *14th Discourse* from 1788. The lives and approach to painting of these painters could hardly be more different. Gainsborough

[140]
William Hogarth, *Gin Lane*, 1751, copper engraving, 14.2 x 11.8 in.
It is interesting to see how Hogarth alters the style of his works according to his targeted audience.
The series *Marriage à la Mode* (1742–1744, National Gallery, London; also as copper engravings) is clearly more courtly, almost Rococo, in style, and is also more carefully engraved than the plates in *Gin Lane / Beer Lane* (1751), whose drastic portrayals of the harm caused by alcohol abuse were directed at the morals of the lower middle class.

[141]
Joshua Reynolds, *Charles Coote, Duke of Belmont*, 1774, oil on canvas, 8.1 x 5.4 ft., National Gallery of Ireland, Dublin. Reynolds is clearly not the dry Academician that he is often described as being. Despite their pomp, his portraits can be ironic to the point of sarcasm.

[142]
Thomas Gainsborough, *Mrs. Richard Brinsley Sheridan*, 1786–1787, oil on canvas, 7.3 x 5.1 ft., National Gallery, Washington. The short parallel strokes of the brush become an outline of form in the eye of the beholder. In Gainsborough's late work, the soft flowing outlines dissolve completely.

learned the principles of painting and drawing in the environment of St. Martin's Lane Academy, founded by Hogarth. Through his French colleague Gravelot, he became acquainted with the work of Watteau, whose colors and flow of line he adopted in his own work. Only in 1764 did Gainsborough leave the provinces for London, where he was confronted with the burgeoning art market as well as the politics of the Royal Academy. But Gainsborough could afford to bypass Reynolds and maintain his own artistic course. His great success as a portraitist did not prevent him from turning to new themes in advanced age (*Fancy Pictures*, after 1776, a series of pictures of the poor, painted from models Gainsborough found in the streets), and to experiment with mixed techniques. His style is characteristically buoyant, and the landscapes that are a part of his portraits and genre pictures took on an increasingly impressionistic tone [142].

Both the themes and painterly character of the works of Joseph Wright of Derby (1734–1797) move in a completely different direction. He too avoided the London vortex, working primarily in Derby and Liverpool. His pioneering major works do not fit any genre: formally historical paintings, they depict scientific

experiments and seem to reveal knowledge of Caravaggio and Rembrandt [143]. For the first time, scientific phenomena and experiments are brought to canvas, and clarified to an extent that they also serve to illuminate the viewer. The soundness of the experiments is visually proven and documented by the paintings. This kind of art is possible only in an advanced intellectual milieu, such as existed in the English Midlands, where the coming Industrial Revolution depended on a knowledge of physics and chemistry.

Not until 1773 did Wright travel to Italy, where the outbreak of Vesuvius in 1774 inspired him to paint more than thirty variations on the theme. Perhaps his Italian journey is also the starting point for his late landscapes, painted in a new experimental form, as well as for the literary themes he put on canvas after his return.

The first important American painter, Benjamin West (1738–1820) deserves mention here, because in 1738 he had already emigrated to England, where he succeeded Reynolds as director of the Royal Academy. West enlivened the traditionally un-English genre of the historical painting with the contemporary theme of the colonial wars in the New World [144], succeeding in creating a new definition of the noble genre by renouncing antique costume; on the other hand, his compositions borrow subtly from religious models in an effort to increase the weight of their contents.

[143]
Joseph Wright of Derby, *The Experiment with the Air Pump*, 1768, oil on canvas, 6.1 x 8.1 ft., National Gallery, London.
The figures are submerged in a darkness that is illuminated only by a single candle, resulting in a spotlight effect on portions of the faces.

[144]
Benjamin West, *The Death of General Wolfe*, 1770, oil on canvas, 5 x 7.1 ft., National Gallery of Canada, Ottawa.

Neoclassical painting—Jacques-Louis David

The international success of the anemic-looking classical painting of Winckelmann's friend Anton Raphael Mengs (1728–1779) and the Italian landscapes of Jacob Philip Hackert (1737–1807) in obtaining courtly commisions lies in the calming harmlessness of their painting [145]. For one final time, classical painting was able to conjure up the sort of wishful mythological images and Arcadian landscapes that were already becoming passé. Jacques-Louis David (1748–1825) is often termed the grand master of Neoclassicism, however, he followed a different course from that of Mengs. After he had completed initial work in the Rococo style of Boucher and the obligatory Italian tour, David's *Oath of the Horatii* [146] offered a classical event in Roman history, although independent of the usual structure

[145]
Anton Raphael Mengs,
Parnassus, 1761,
fresco, Villa Albani,
Rome.

of academic painting. Indeed, the composition was often criticized because the three main figures are placed one behind the other to the left, and are thus not clearly visible. It is more accurate to say that David

After approximately 1760, under the influence of the rational philosophy of the Enlightenment, forms and themes adopted from antiquity become increasingly a focus of interest—**Neoclassicism**. The tendency appears first in architecture and interior design. French Rococo is replaced by Louis-Seize, the style of King Louis XVI (for example, the Petit Trianon in the Garden of Versailles 1762–1768). The return to the classical form of 17th century monuments corresponds in interior decoration to a strictly systematic wall organization, and a slimming of the luxurious, richly inlaid Louis-Quinze furniture to the simpler brass-fitted forms of David Roentgen (1743–1807). In the comprehensive art work of the English country estate, the inclusion of antique buildings and monuments in early landscape gardens developed from a mixture of a Renaissance revival (Palladian architecture) and the 17th century influences. In the detailed repetition of antique motifs found in his his interior designs, Robert Adam (1728–1792) united the imaginative decorative forms of Piranesi with the actual knowledge of antiquity provided by the systematic excavations begun at Herculaneum and Pompeii in 1738 and 1748, respectively (for example, Kedleston Hall, Syon House, Osterley Park).

[146]
Jacques-Louis David, *The Oath of the Horatii*, 1784, oil on canvas, 11 x 14 ft., Musée du Louvre, Paris.

[147]
Jacques-Louis David, *The Death of Marat*, 1793, oil on canvas, 5.2 x 4.3 ft., Musées Royaux des Beaux-Arts, Brussels. Every detail of this "icon" is precisely constructed, from the pictorial axes to the opposing placement of the murder weapon in relation to the quill— that eternal weapon— of the victim. The position of the body in the bath is reminiscent of the paintings of the laying of Christ in the grave, or a Pietà— lending additional significance to the martyrdom of the "holy" revolutionary Marat.

radicalized the formal language of Poussin (see p. 94) with antique figures. In the shifting milieu of the 1780's, the choice of an antique theme provided a certain amount of political insurance, even if the form deviated from the standard. The overwhelming success of the painting, however, probably lay precisely in the revolutionary content of its oath-motif, just as prerevolutionary elements appear in the music of the contemporary Mozart operas *The Marriage of Figaro* (1786) and *Don Giovanni* (1787), as well as in da Ponte's libretti.

Whether David was concerned at this time with revolutionary ideas is doubtful. In the first place, he actively managed his acceptance into the Académie, although he made himself generally available to the Revolution once it had begun, and became a friend of Robespierre and president of the Convention, the most important instrument of the Terror. His major work of the Revolutionary period is *The Death of Marat* [147]. After the Revolution, Napoleon exploited David's artistic abilities, but with reservations. In preference, Napoleon turned to a less politically incriminated student of David's, Antoine-Jean Gros (1771–1835), to chronicle his deeds on large-format canvases. Nonetheless, David's *Coronation of Napoleon*

and Josephine in Notre Dame (1805–1807, Musée du Louvre, Paris), in skillfully referring to the *Medici Cycle* of Rubens, stands in splendid magnificence as the monumental major work of the Napoleonic Empire.

In overcoming the academic tradition with his new pictorial language, David is perhaps the most influential painter of the turn of the century.

Goya

[148]
Francisco Goya,
Drawing for *El sueno de la razon produce monstros* (*The Sleep of Reason Produces Monsters*), ca. 1799, quill and sepia, 8.7 x 5.9 in. Museo del Prado, Madrid.

Like David, Francisco de Goya y Lucientes (1746–1828) carried out commissions for many noble patrons, particularly after 1786 as the court painter of the Spanish Bourbon king. Goya, too, dealt pragmatically with the poltical situation, in spite of his probably liberal convictions, but unlike David, he seems to have made no artistic concessions to his patrons in his portrait style. One may well ask what the aristocrats whom he painted must have thought of Goya's unsparingly honest portraits. However, this undisguised portrayal of physiognomy is perhaps a characteristic of Spanish painting, for the portraits of El Greco and Velázquez had also been less flattering than those of the Italian painters.

The variety of Goya's painting style makes it difficult to characterize. In 1774, the painter began working on large cartoons (the painting from which weavers patterned their tapestries) in a late Spanish Rococo

With his "Thought on the Imitation of Greek Works in Painting and Sculpture" (1755) and the "History of the Art of the Ancient World" (1764), the German researcher of the antique world Johann Joachim Winckelmann (1717–1768) brought ancient Greek art into the limelight for the first time, giving it precedence over Roman in its "noble simplicity and silent greatness." His efforts were enormously successful: both Sturm und Drang and Romantic literature looked to the the epics of Homer, Weimar Classicism (Goethe, Schiller) concerned itself with Greek tragedy, and Piranesi made etchings of the previously overlooked temples at Paestum. Winckelmann's arguments remained the base for the "Pan-Hellenism" of the 19th century and the romantic enthusiasm for Greece of Lord Byron. Winckelmann's art criticism is significant to the history of ideas because he was the first to develop descriptive categories for the appearance of art according to a system that can also be applied in the analysis of other epochs or styles. Like Vasari, he based his history of antique art on a unified concept of development which Hegel (1770–1831) later extended into one of the pillars of his philosophy of history.

style for the royal manufactury. At the same time, he completed religious frescos, and the first significant paintings of the kind that were to guarantee Goya success throughout his lifetime. The French Revolution and the violent disturbances in its aftermath that Goya had lived through took forceful shape in his masterworks: the events of May 2 and 3, 1808, appear in two large-format oil paintings under the names of those dates [149].

The complicated personality of the sceptical humanist Goya speaks most clearly in his printed graphic work. Already in 1799, the eighty etchings of his *Caprichos* mocked the stupidity of human existence. After he had humorously castigated human sins and vices in his prints, a turning point occurs with the famous No. 143 [148]: insanity and witches are shown plaguing humanity. Still more pessimistic is the series of 82 *Disasters of War*, created 1810–1820. Here Goya, as the successor to Callot (see p. 96), lashes out at the horrors of war, but also those of the delinquent church.

Goya reproduced the themes of his etchings for the 14 *Black Pictures* (1820–1822, Museo del Prado, Madrid) on the walls of his own house in front of the gates of Madrid (including, among others, *Saturn Devouring his Children*). They were removed by a collector from the walls and transferred to canvas long after his death.

In 1824, Goya left Spain for exile in Bordeaux. He had founded no school, and his fame spread beyond Spain only after he was "rediscovered" by Impressionism.

[149]
Franciso Goya, *The Execution of the Rebels on the 3rd of May 1808*, 1814, oil on canvas, 5.5 x 11.5 ft., Museo del Prado, Madrid.
The picture movingly borrows from Goya's honored models, Rembrandt and Velázquez, and establishes (before Delacroix) a brilliantly colored contemporary historical painting whose boldness derives from its brushwork, without any trace of artificial classicism. The painting was also a model for Manet (see p. 144) in his *Execution of Emperor Maximilian* (1867, Kunsthalle, Mannheim).

Romanticism

Romantic impulses and tendencies in Western painting are found in every epoch. What is questionable, however, is whether the basic liberation of the individual from the chains of convention that underlies the Romanticism of the late 18th and early 19th centuries can already be found in earlier periods of the history of art. Is, for example, the landscape painting of Lorrain in 17th century France already "Romantic?" It is hardly likely. Lorrain only combined selected pictorial props together with a sentimentally soft atmosphere. Or is Goya a Romantic? Does the art of David reveal Romantic elements? It would explain why art history reaches for the crutch of "Romantic Classicism" to describe him.

Romantic tendencies were growing stronger in the course of the 18th century. The notion of the capriccio, especially those depicting landscapes, is impossible to explain without the concepts of individuality and subjectivity. Vernet's or Loutherbourg's *Seastorms*, Piranesi's wild *Architectural Fantasies*, the 170 *Alpine Views* [150] painted in 1773–1778 of Caspar Wolf (1735–1798), or the landscapes of Alexander Cozens, that vacillate oddly between systematic conprehension and subjective experience—all these were already playing with the possibilities of Romantic forms of expression, even if theoretical formulations were lacking.

The theory was supplied by Germany. Friedrich Schlegel coined the term "Romantic" for the first time in the journal *Athenäum* in 1798, deriving the concept from medieval verse epics and romances. His definition, however, also applied to the already existing literary work, composed parallel to the heat of the Sturm und Drang movement and standing as the counterpoint to the Weimar classical style of Goethe and Schiller. All that was incomplete, hinted at, mystically suggestive, religiously ecstatic, magical, legendary, folkloric, or chivalrous became

From Rococo to Romanticism

appropriate themes for Romanticism. After 1810, Madame de Staël's *De l'Allemagne* made these ideas accessible also to French and English readers, who entusiastically welcomed them.

[150]
Caspar Wolf, *The Geltenbach Fall in Winter*, ca. 1773–1778, oil on canvas, 2.7 x 1.8 ft., Museum Oskar Reinhart, Winterthur.

In England, already in 1756, Edmund Burke's use of the term "sublime" defined a category that included the eerie, supernatural, or powerfully gigantic. In addition, the word "picturesque" was first used to describe the visual experience of the delicate austerity of the overpowering landscapes of the English Lake District.

Romanticism also served as the artistic arm of the liberation movement against Napoleon, taking on specifically nationalistic tones in the process. It was in this sense that Romanticism flowered first in Central Europe, but also in Scandinavia. In the period of Restoration after 1815, emotional outbreaks of the Romantic spirit were no longer politically desirable. In Germany and France, Romanticism drifted into a comfortable, withdrawn form of bourgeois respectability epitomized by the terms "Biedermeier" and "Juste milieu." Only later in the

Romanticism refers to a late 18th and early 19th century pan-European phenomenon in art, architecture, literature and music. Unlike either the Baroque and Rococo movements, Romanticism developed its own theoretical basis, and was the first cultural movement to involve all of Europe. Three basic tenets from the Dictionary of Art can help define it. Romanticism implies, first, the placement of the emotions and intuition above (or at least equal to) reason; second, the firm belief that there exist decisive, but neglected, moments of experience which cannot be comprehended by reason; third, the conviction of the comprehensive importance of the individual, the personal, and the subjective. For the first time in cultural history, Romantic writers provided the visual arts with a vocabulary competent for the discussion of its own creations. Since then, a theoretical analogue to artistic production has been a part of every successful art movement, and thus Romanticism is still effective up to the 20th century.

century would the Symbolists resurrect some aspects of the Romantic (see p. 159).

Fuseli and Blake

Johann Heinrich Fuseli (born Füssli) (1741–1825) united the Middle European with the English tradition. This native Swiss poet and painter, who settled permanently in London in 1779, had already been persuaded by Reynolds in 1767 to give up the

study of poetry and theology for painting. On his travels to Italy, the heroes of the academies (Raphael, Carracci, and Reni) interested him less than Michelangelo and the Mannerists, by whom he was fascinated. After settling in London and changing his name from Füssli to Fuseli, the artist developed a mannered style of painting based on line. He invented his own themes or took them from literature, achieving sudden fame with his *Nightmare* [151], in which an incubus in the form of a small, nightmarish creature, squats upon a sleeping woman, while a white horse noses its way into the room from behind a curtain. Fuseli in depicting the symbolic figures of an erotic nightmare had entered an unconscious and uncontrollable realm beyond the ability of rational analysis. What makes the whole particulary effective is that the threat is presented on the highest aesthetic level. Although he became an Academy member in 1790, his erotic pictures of women, and sublime, eerie mythologies, as well as his theoretical writings, made his distance from the academic tradition clear.

[151]
Johann Heinrich Fuseli, *The Nightmare*, 1782, oil on canvas, 25.5 x 21 ft., Freies Deutsches Hochstift, Goethe Museum, Frankfurt am Main.

To account William Blake (1757–1827) a Romantic is not entirely correct. However, with his concept of genius and his obscure, gnostic theological system, this poet and artist fits well into many Romantic categories [152]. In spite of his friendship with Fuseli and the sculptor John Flaxman (1755–1826), whose

contour drawings based on Homer's epics may have influenced him, Blake remained a loner. He experimented with hand-colored engravings which fused text and illustration to express his own mystical philosophy (*Songs of Innocence*, 1789) or other texts (*The Book of Job*). His curving line seems to look back to Mannerism and ahead to Symbolism and Art Nouveau, yet he remains an outsider, thematically and technically, and achieved success only long after his death.

Runge and Friedrich

Philipp Otto Runge (1777–1810) was, like Blake and Fuseli, both a poet and artist, but in addition he possessed a strongly developed interest in art theory that expressed itself in his *Farbkugel* 1810. His short life allowed him time to complete few works, but his understanding of art and theological orientation toward natural philosphy are clear in his portraits, and especially in his cycle of paintings *The Times of Day* [153].

The comprehensive works of Caspar David Friedrich (1774–1840) are the climax of German Romantic paintings. Unimpressed by his colleagues rushing off to Rome—such as the important landscape painter Joseph Anton Koch (1768–1839) who became known as the head of the *Deutschrömer*, German Romans—Friedrich spent his life between Dresden and Greifswald on the Baltic coast. Through his contact with the Romantic poet Ludwig Tieck in Dresden, and in the environs round about the city, Friedrich found ample themes for his landscape painting. Already with his first large oil painting of a cross mounted in nature, *The Cross in the Mountains* [155], Friedrich succeeded

[152]
William Blake, *The Ancient of Days*, 1794, etching with water color, 9.2 x 6.6 in., British Museum, London.

[153]
Philipp Otto Runge, *The "Little Morning"*, 1808, oil on canvas, 3.6 x 2.9 ft., Hamburger Kunsthalle, Hamburg.

[154]
Georg Friedrich Kersting, *C. D. Friedrich in his Studio*, 1811, oil on canvas, 1.7 x 1.3 ft., Hamburger Kunsthalle, Hamburg.

in producing the first Protestant altarpiece in the Romantic spirit.

Friedrich's theme of human loneliness is depicted in the portrait of him, *C. D. Friedrich in his Studio* [154], painted by Georg Friedrich Kersting (1785–1847). The still interior scene documents Friedrich's manner of working, for the artist drew, but did not directly paint, from nature. His oil canvases, completed at the easel in a closed room, according to ideas he already had thought out. The partly-open window does not provide a view into the landscape, and thus increases the impression of the isolation of the lonely painter. From his *Monk on the Sea* (1809–1810, Charlottenburg Palace, Berlin) to his *Man Walking Above the Sea of Clouds* (1818, Kunsthalle, Hamburg), Friedrich was concerned with the Romantic themes of the evanescence of life, loneliness, and endless spaces. The relatively large canvas *Arctic Sea—Shipwrecked Hope* [156] took as its subject a wrecked, icebound ship as a paradigm of the failure of human efforts. The French sculptor David d'Angers coined the phrase of the "tragedy of landscape" on the occasion of visiting Friedrich in his studio in 1834.

German and Danish painting: Between the Romantic and the Real

The idealized landscapes of Carl Gustav Carus (1789–1869) do not attempt to deny the influence of Caspar David Friedrich, nor do the scenes of the

[155]
Caspar David Friedrich, *The Cross in the Mountains (Tetschener Altar)*, 1808, oil on canvas, 3.8 x 3.7 ft., Staatliche Kunstsamm-lung, Gemäldegalerie Neue Meister, Dresden.

important architect Karl Friedrich Schinkel (1781–1841), which conjure up a fusion of German Gothic, Romantic landscapes, and classically calm composition that are reminiscent of Lorrain. However the pre-Impressionistic landscapes of Karl Blechen (1798–1840) are peculiar for the ironic sense of the absurd he brought to his luminous landscapes. In this, Blechen anticipates Menzel. Influenced by Germany, Denmark developed into a center of Romanticism. Christoffer Wilhelm Eckersberg (1783–1853), a friend of the classical sculptor Berthel Thorwaldsen, produced significant portraits, but painted especially small-sized views of Rome with color finesse. His pupil Christen Schjelderup Købke (1810–1848) surpassed his master in psychological insight of his portraiture [157] and landscapes. Already by 1809–1810, the Nazarenes Friedrich Overbeck (1789–1869) and Peter von Cornelius (1783–1867) had set off in a direction of their own by a rigorous return to the art of the Renaissance, especially to the works of Raphael and Dürer [158]. Their *Lukasbrüderschaft*, "Brotherhood of St. Luke" reflected a stylized religiosity that reached its peak with the withdrawal of the painters into a monastery near Rome. In Late Romantic German art, the currents of the real and the romantic unite in calm and balanced paintings and frescos that seek happiness in small things or in references to a supposedly perfect world, often tinged with a decorous irony (Moritz von Schwind, Ludwig Richter, Carl Spitzweg). The Nazarenes anticipate the English Pre-Raphaelite School (see p. 142).

[156]
Caspar David Friedrich, *Arctic Sea—Shipwrecked Hope*, 1823–1824, oil on canvas, 3.2 x 4.2 ft., Hamburger Kunsthalle, Hamburg.

[157]
Christen Schjelderup Købke, *The Landscape Painter Frederik Sodring*, 1832, 1.3 x 1.2 ft., Hirschsprungske Samling, Copenhagen.

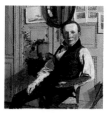

[158]
Johann Friedrich
Overbeck, *Germania
and Italia*, 1828, oil on
canvas, 3.2 x 6.5 ft.,
Bayrische Staats-
gemäldesammlungen,
Neue Pinakothek,
Munich.
The painting depicts
wishful thinking about
an close relationship
between German and
Italian art, as the ideal
was visualized by the
Nazarenes.

Menzel

Adolph von Menzel (1815–1905),
perhaps the greatest German draftsman
of the 19th century, already had one
foot in the post-Romantic world. With
painful precision he attempted to get to
the bottom of things; his realistic
tendencies are more evident in his
drawings than in his oils. However, his
phenomenal studio walls, knightly armor,
atmospheric interiors, and his romanticizing
depiction of the Rococo court of Friedrich II, a
full one hundred years after its time, are all oddly
fragile facets of a career that remained, in the end,
stamped by Romanticism—a style torn between
the original and the philistine. Menzel's interiors,
his back lot landscapes, and the first illustrations of
industrial labor, draw a kind of German Impres-
sionism out of the colorful Romantic
palette [159].

Constable and Turner

John Constable (1776-1837) grew up in the
country, and a longing for the untouched land-
scape of his childhood followed him throughtout

his life. Build-
ings (often
the Cathedral
of Salisbury),
country folk,
the farm cot-
tages of his
childhood,
Stonehenge,
natural pheno-
mena like
thunderstorms
and rainbows,
are the ele-
ments of his

[159]
Adolph Menzel,
*Selfportrait with Worker
Near the Steamham-
mer*, 1872, gouache,
6.3 x 4.9 in., Museum
der bildenden Künste,
Leipzig.

pictures. At the end of his life, Constable's art became increasingly unreal, because he sensed that the unity of the idyll he had created was falling apart in early industrial England. Even when the painter tried to pattern himself on the model of 17th century Dutch painting, his work remained typically his own in its bright colorfulness. According to one anecdote, a patron complained about the grass-green coloring of the picture, and demanded the usual brownish "gallery tone." Constable led him in front of the house, laid a violin on the lawn, and asked whether the grass was as brown as the instrument—a lesson that brought the patron around.

Constable's best-known work, *The Hay Wain* [160], garnered praise chiefly outside of England: in 1824 he won a medal from the Paris Salon, and later, Delacroix and the "School of Barbizon" took inspiration from his work.

[160]
John Constable, *The Hay Wain*, 1821, oil on canvas, 4.3 x 6.2 ft., National Gallery, London.

William Turner (1775–1851) followed a completely different course. Landscape held no interest for him as an intact world, but rather conveyed the dynamism of mythological and historical processes. Landscape offered a stage for the events of myth, saga, and his own time. Turner's style of painting brought images of both city and landscape together in eddying movement. After detailed study of traditional painting, the water-colorist Turner soon learned to appreciate the advantage of oil painting. He quickly obtained official recognition, becoming a member of the Royal Academy in 1802, and an instructor of perspective in 1807. On his travels to Germany and Italy he

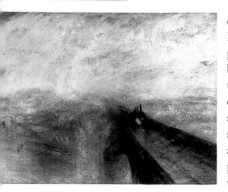

[161]
William Turner, *Rain, Steam and Speed—The Great Western Railway*, 1844, oil on canvas, 3 x 4.1 ft., National Gallery, London. The more abstract his studies of color and movement became, the more incomprehensible Turner's art grew for his contemporaries.

completed many watercolors. He freely made use of the complete color palette in order to bring dynamism, action, and temporal sequence into an eventless picture by means of subtle gradations of color— similar to what Delacroix later attempted. Through this process, Turner successfully visualized even abstract processes like the movement of an arriving locomotive through swirling whirlwinds of color, lit by momentary flashes of realistically painted details [161].

Géricault and Delacroix

Théodore Géricault (1791–1824) spent four years diligently copying in the Louvre (1811–1815), whose exquisite collections of the old masters had been renewed by Napoleon's pillages through Europe. Inspired by the modern Napoleonic historical paintings of Antoine-Jean Gros (see p. 123), Géricault set to work with varying success on military pictures. His larger-than-life *Officer of the Imperial Guard* (1812, Musée du Louvre, Paris) immediately won the gold medal of the Salon. Critics were irritated by their difficulty in categorizing the painting's style, which is not at all classic, but rather looks back to Rembrandt in its muted coloration and dynamic line. In 1819 Géricault unveiled his masterpiece before the Salon: *The Raft of the Medusa* [162]. It depicts the survivors of the shipwreck of a French frigate whose loss three years earlier had occasioned a scandal in France. "La Méduse's" captain and officers had deserted the 150 passengers and crew, and Géricault's painting portrays the critical moment when the fifteen survivors sight a rescue ship on the horizon after thirteen days afloat on

a raft. Depressed by the lack of enthusiasm for his canvas, Géricault later concentrated on lithographs, sketches, drawings, and a few works in oil. Only long after his death did the sensitive portraits of the insane dating from 1822 find appreciation.

Eugène Delacroix (1798–1863) has always been defined as a great Romantic painter in comparison to the more classical Géricault and, especially, David and Ingres. In fact, the the literary references in his works indicate his concern with the traditional Romantic matter (Dante, Shakespeare), but also with the Romantics themselves (Byron, Scott, and Goethe's *Faust*). Formally, Delacroix worked rather in the spirited Empire style of Gros and Géricault. His work opened a new era in Salon painting, just as his friend Frédéric Chopin enriched salon music. Delacroix is not at all a withdrawn, brooding Romantic of the German tradition, but an inspired Romantic of the great Salon, just as his large, successful canvases [163] presented him to an amazed public.

Particularly after his journey in 1832 to North Africa and Spain, where he learned to appreciate Goya, Delacroix increasingly adopted Arabian themes, hunt scenes, and harem pictures into his work. After 1833, he was fully occupied with public commissions for wall paintings in Paris; in his usual impulsive manner, he carried them out in a mixture of wax and oil painting, rather than as frescos.

[162]
Théodore Géricault, *The Raft of the Medusa*, 1819, oil on canvas, 16.4 x 24 ft., Musée du Louvre, Paris.

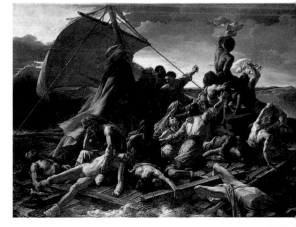

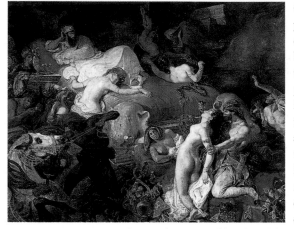

[163]
Eugène Delacroix, *The Death of Sardanapalus*, 1827, oil on canvas, 13.1 x 16.5 ft., Musée du Louvre, Paris. Delacroix depicts here the end of the Assyrian King Sardanapalus, who had himself and his entire harem immolated after the capture of Ninevah. The king serenely observes preparations for the horrible end. The basis of the picture is Lord Byron's Romantic tragedy Sardanapalus, completed six years before the painting.

Over the years, Delacroix recorded both his artistic and private life in his diary, the *Journal,* and noted theoretical ideas and reflections, especially concering color, in the pages of his sketch books. For him, "color for the sake of color" was more important than either line or chiaroscuro. He does not contrast a color with darkness, but rather with its complementary color, as Delacroix had learned from the theoretician Chevreul: red-green, blue-orange, yellow-violet. (Thus a yellow coach casts a violet shadow.) Delacroix's use of color is far more modern than his style of composition. Later, his work would have an influence on the Post-Impressionist Signac (see p. 157).

Until the end of the 19th century, the **salon** was the most important form of art exhibition in France and was often under the protection of the royalty. The selection of participants, as well as the awarding of prizes, was an expression of official art politics and was determined by an artistic jury. To a very large extent, the salon determined an artist's financial value on the art market; rejection by the salon therefore often led to a desperate effort by the artist to have his/her work appear in an "anti-salon." Courbet was the first artist who exploited this system to propagandize his own works (see p. 140). The name "salon" arose from the original location of the annual exhibitions, the "Salon d'Apollon" in the Louvre Palace, Paris.

Ingres

Jean August Dominique Ingres (1780–1867) was
the bridge between David's Neoclassicism and the
beginnings of Impressionism, although he does
not seem to have been impressed by the fact.
With a certain amount of stubbornness, he
argued the supremecy of line against the color
so successfully used by his contemporary,
Delacroix. Perhaps the critical emphasis on Ingres'
soft, marzipan-modelled figures rests on a
misunderstanding of his art, whose smooth
surfaces vibrate like the polished bodies of the
Italian Mannerists. His female nudes have always
given him a rather risqué reputation, but they
remain nonetheless a bold experiment with effects
of refined formal stylization reaching far into the
20th century (see front cover). Ingres always
characterized the figures of his portraits precisely,
conveying the differences between male and female
even below the skin, down into the layers of
subcutaneous fat. For all the apparent facility of
his surfaces, the often-puzzling actions of his
figures, and the symbolically-weighted interiors
of his paintings draw his figures back into a kind
of manneristic Romanticism. It is the miracle of
the details of color and material that make most
of his portraits unforgettable: a ribbon of silvery
satin, a dark yellow shawl thrown onto a
chair [164], the red ribbon affixed to a
medal. The almost aggressive presence of
these flecks of color increases the seemingly
noncommittal softness of his female faces:
all at once the heroine of Stendhal or
Flaubert' s novels seems to look out at the
viewer. In a sense, the Manet who painted
Olympia [172] may be Ingres's only true
heir even though he banishes the smell of
perfumes from the rooms and nudity turns
into an invitation being expressed almost
aggressively.

[164]
Jean-Auguste-Domi-
nique Ingres, *The
Countess d'Hausson-
ville*, 1845, oil on
canvas, 4.4 x 3.1 ft.,
Frick Collection, New
York.
Ingres' extremely varied
portraits seem to be
the least time-bound of
his works. He prepared
his portraits with
minutely precise pencil
drawing, and they
remain among the most
impressive art work of
the 19th century.

From Realism to Art Nouveau

The awakening of the modern world

The revolutionary eruptions that took place throughout Europe in 1848–1849 were a result of changing social conditions. Growing masses of industrial workers created a new political force. In a parallel development, large cities became melting pots of various social groups, with Paris emerging as the western cultural capital of the century. The growing middle class whose wealth was based on trade and industry now took the political lead, slowly replacing the aristocracy. In 1815 the Congress of Vienna and the resultant restorations fixed European national borders, with the unifications of Germany and Italy following later. Overseas, European colonial powers accomplished an expansion of their power that was hardy possible inside Europe. After the American Civil War, the economic and political role of the United States steadily grew, and by the beginning of the 20th century, almost unnoticed, it had reached a position of leadership soon made evident by its entry into World War I.

The arts responded with varying speed to these developments. Architecture in the age of large capitalist expansion at the end of the 19th century had at its disposal a wide variety of historical building styles; only later did the use of iron and steel as building materials exert an influence on building aesthetics. The construction of the Eiffel Tower, the glassed passages, exhibition "palaces," and railway stations functioning as cathedrals of capitalism signaled the start of the twentieth century. Both sculpture and commercial art once more attempted to awaken feudal memories, and offered the public pre-industrial values. Only with the work of Auguste Rodin (1840–1917) and Medardo Rosso (1858–1928) did sculpture strike out in new directions.

The invention of photography by Daguerre and Fox Talbot in 1839/1840 had a revolutionary effect on art. It soon was able to capture momentary events as had never before been seen by the human eye. After an initial lethargy, painting also began to exploit what photography had to offer—but at the same time it reacted to this new competition by placing new emphasis on the craft of painting and on the artistic concept behind it. Theoretical reflection on the process of artistic creation, an impulse that had been critically important since Neoclassicism and Romanticism in the explanation of a work, now became a standard accompaniment to painting. At an ever faster pace, "isms" began to replace each other: manifestos, pamphlets, journals, catalogues and the beginning of professional art criticism in the newspapers both accompanied and steered the process. Art was no longer bound to princes or patrons, but became a commercial ware on an art market operating under the laws of capitalism. From this point onward, the new discipline of art history, working hand-in-hand with a scholarly criticism largely oriented toward stylistic considerations, offered its commentaries on artistic production. Academies and large exhibitions exerted a normative pressure on artists—partly in the interests of conservative cultural politics seeking to dampen an overly energetic process of artistic and social change.

The realism of Courbet established a new direction for art, whose aim was now to change society and to negate age-old values by means of the evidence offered by artistic truth. Under Impressionism, the official artistic doctrine and the artistic avant-garde went off on separate paths for the first time in history. Painting took the lead. The innovative artists were part of a bohemian world willing to starve for its ideals, and to romanticize its own various manifestations. Impressionists invented the modern image of the artist as a self-conscious individual suffering for his or her ideals. Between artistic

1861–1888
William I, King of Prussia
1863
Slavery abolished in the United States
1863–1867
Maximilian, Emperor of Mexico
1864
Founding of the First Socialist International in London
1867
Meiji restoration in Japan
1869
Opening of Suez Canal
1870–1871
Franco-Prussian War
1871
William I proclaimed German Emperor in Versailles (founding of Second German Imperial Reich); Revolt of the Paris Commune
1875
Proclamation of the Third Republic in France
1876
Telephone invented by Bell and Gray
1881
Invention of autotypy (mass reproduction of black and white photographs)
1882
Occupation of Egypt by Great Britain
1888–1918
Emperor William II of Germany
1895
Discovery of the X-ray

production and social acceptance there arose a temporal divide that became the rule in the 20th century, and today still characterizes our relation to contemporary art.

Courbet and Realism

Jean-Désiré Gustave Courbet (1819–1877) was the first painter actively to think and work in political categories. Having grown up in a peasant family in the mountains of southern France, he was confronted as a young man in Paris with the anarchist philosphy of Pierre-Joseph Proudhon, who had announced his famous thesis that "property is theft" in 1840. Proudhon developed a theory of a future state in which money and interest would cease to exist, and property could only be gained through a just distribution of labor. For Courbet's pictorial world this theory is significant in that he dreamed of an anachronistic utopian society populated by peasants and craftsmen. Reflecting these ideas, Courbet caused a stir with his early painting *The Stonebreakers* [165], the first life-sized portrayal of common laborers—and in worn clothing to boot. With his *Funeral at Ornans* (Musée d'Orsay, Paris), painted in 1850, Courbet depicted the village of his birth, and consciously sought conflict with both the Académie and Salon in order to publicize his social utopia. The subtitle of the painting, *Tableau Historique*, not to mention the comparatively crude working of the details, was in itself a provocation to the Salon.

Courbet refused to work with the Paris exhibition of 1855 in spite of being invited, and instead organized the famous exhibition of his works in the temporary "Pavillon du Réalisme," where his huge canvas *The Painter's Studio* [166] was also displayed. In the center of the picture, the painter is at work

[165]
Gustave Courbet, *The Stonebreakers*, 1849, oil on canvas, formerly Dresden (lost in the Second World War).

on a landscape, while behind him, the symbol of artistic truth is represented as a full-length female nude figure. A boy, gazing at the picture as it is being painted, symbolizes the innocence of humanity in its natural state. On the left of the landscape, social reality is represented in the figures of the exploiters and exploited, while on the right are the friends of the artist, including Proudhon and the poet Baudelaire.

Courbet ignored classical genre distinctions. His landscapes did not seek to awaken romantic associations, as were still evident in the light-filled lyrical mood-paintings of Camille Corot (1796–1875), or in the "Barbizon School" with the work of Théodore Rousseau (1812–1867). Courbet's scenes of simple peasant life connect him thematically with Jean-François Millet (1814–1875), whose atmospheric paintings led his contemporaries to compare him to Michelangelo [167]. Millet's works lacked the incendiary social power of Courbet, but perhaps for this very reason had more success in the long run. Both van Gogh and, later, Dalí copied Millet's

[166]
Gustave Courbet, *The Artist's Studio* (detail), 1855, oil on canvas, 11.8 x 19.6 ft., Musée d'Orsay, Paris.
This programmatic painting gives the artist a decisive role as the creator of social change.

[167]
Jean-François Millet, *The Gleaners*, 1857, oil on canvas, 32.7 x 43.7 in., Musée d'Orsay, Paris

The Pre-Raphaelites

[168]
Wilhelm Leibl, *Three Women in Church*, 1878–1882, oil on wood, 44.5 x 30.3 in., Hamburger Kunsthalle, Hamburg.

dreamlike, peaceful scenes. However, the early pieces of a van Gogh or the American Realism of Eakins (see p. 148) would hardly have been possible without Courbet.

He also influenced Adolph von Menzel, whom Courbet met twice, and even the work of the important German realist Wilhelm Leibl (1844–1900) whose acquaintance Courbet made in 1869. In the pure colors and fine technique of his pictures of rural life [168], Leibl oriented himself moreover on early Netherlandish painting.

The Pre-Raphaelites

In the revolutionary year 1848, William Holman Hunt (1827–1910), John Everett Millais (1829–1896), and Dante Gabriel Rossetti (1828-1882) founded the Pre-Raphaelite Brotherhood in London. Their membership soon increased to seven. The Brotherhood was modeled after the German Lukasbrüderschaft (see p. 132), with whose goals they were familiar through Ford Madox Brown (1821–1893), who was loosely associated with the Pre-Raphaelites and a friend of the German Nazarene, Friedrich Overbeck. The English Brotherhood's painting was rooted in the precise observation of nature. Every element of the picture, whether figures or landscape, was treated with equal importance. Pre-Raphaelite colors are luminous and clear; technically, the movement looked back to the period of painting before Raphael (hence the name of the group), and to 15th century Netherlandish painting. Rejecting Courbet's realism and

[169]
John Everett Millais, *Ophelia*, oil on canvas, 29.9 x 40.1 in., National Gallery, London.

later, Impressionism, the Pre-Raphaelites worked with refined primers, bases, lacquers, and varnishes in order to lend the greatest possible luster to their pictures. In an attempt to revive religious painting, the artists experimented both with new iconographic inventions and variations of traditional images [170]. In addition

they sought their themes in Shakespeare [169], Keats, and medieval history. The first Pre-Raphaelite exhibition earned criticism, particularly for the free invention of themes and supposedly weak drawing. As a group, the Pre-Raphaelites dissolved in 1853, but the influence of its individual members increased in later years.

In Oxford, Rossetti had become acquainted with Edward Burne-Jones (1833–1898) and William Morris (1834–1898), both of whom eventually represented a second generation of Pre-Raphaelite artists. They created designs for stained-glass windows, books, tapestries, curtains and rugs. Burne-Jones also turned to the illustration of sagas and the

[170]
Dante Gabriel Rossetti, *Ecce Ancilla Domini,* 1849–1850, oil on canvas, mounted on wood, 28.7 x 16.5 in., Tate Gallery, London.

[171]
Edward Burne-Jones, *The Wheel of Fortune,* 1877–1883, oil on canvas, 78.7 x 39.3 in., Musée d'Orsay, Paris.

John Ruskin (1819–1900)—British artist, philosopher, art critic, and conservative cultural revolutionary—was one of the most colorful figures of the 19th century. In the early 1850's, he supported the Pre-Raphaelites, whose theory of artistic creation conformed to his own. For Ruskin, the aim of art was to precisely trace the ideal lines of Creation that were to be found in nature. Later he studied the architecture of Venice, described in his famous book *The Stones of Venice* (1851–1853) in which he holds up the Italian city, in its harmony and craftsmanlike perfection, as a total work of art, in contrast to the painfully ugly industrial cities of his native land. On many points, the theories of Ruskin and Courbet clearly overlap. Ruskin's enthusiasm for the painting of Turner and the Pre-Raphaelites appeared again in his four volume *Modern Painters* (1843–1860), and his influence on the Victorian understanding of art cannot be overestimated. From his efforts to establish art schools in industrial centers, to his work as the first Professor of Art History at Oxford (starting in 1864), Ruskin was a tireless critic and teacher who held himself ever open to influence, reflected critically, and gave new impulses to the art of his age.

creation of literary picture-cycles. Within the "Arts and Crafts" movement founded by Morris, Burne-Jones attempted to create a Gesamtkunstwerk (see p. 162) with his interior designs, uniting Romanticism, Symbolism, and Art Nouveau motifs into an almost decadently refined counter-image to contemporary industrial society, with its smoking chimneys and social problems [171]. Burne-Jones left behind the political utopias of the early Pre-Raphaelites and of writer John Ruskin, and thus created the basis on which his art and that of his successors became the "official" art of England at the turn of the century.

Manet

Raised in a bourgeois family, and classically educated by the Salon painter Couture, Edouard Manet (1832–1883) pursued a critical, bourgeois realism, without the socio-revolutionary goals of Courbet. Rather, Manet's goal was broad social recognition, which he only reached, however, in 1881 when he took second prize in the Salon competition. Paradoxically—and on his part unconsciously—Manet and his pictures became a bourgeois taboo. On the first occasion, in 1863, his *Le Déjeuner sur L'Herbe* (Musée d'Orsay, Paris) provoked a scandal. After being rejected by the official Salon, the picture was exhibited in the "Salon des Refusés," which had been appointed by Napoleon III to show the paintings denied access to the Salon. The method of painting was less shocking than the open liberality of the modern subject of an erotic park scene peopled with naked prostitutes and their customers. Also shocking was Manet's play upon famous patterns of

[172]
Edouard Manet, *Olympia*, 1863, oil on canvas, 51.4 x 74.8 in., Musée d'Orsay, Paris.

the old masters, in this case Giorgione's *Concert Champêtre*, a well-known masterpiece in the Louvre. The scandal repeated itself with *Olympia* [172], which reinterpreted a Titian *Venus* as a reclining modern female, cast in bright daylight, who is offering herself naked to the viewer, not nude. The young early Impressionist painters admired Manet as a forerunner of their movement, although he kept a friendly distance from them, and did not participate in any Impressionist exhibitions.

Manet's compositions typically contain figures that are bathed in a bright light, and set against a gray or relatively dark background being influenced by Hals, Velázquez, and Goya. His painting balances an emphasis on line with strong color, and his broad brush strokes spread the color over large surfaces, a technique contributing to the luminosity the pictures. His late masterpiece *The Bar at the Follies Bergères* [173] courageously plays with the theme of Velázquez's *Las Meninas* (see p. 89): the viewer sees a woman behind the counter. Behind her, the room is closed by a full-wall mirror in which the rear view of the woman, the bar with its bottles, and the interior of the music hall are visible. As in Velázquez, where the viewer in fact occupies the position of the king and queen whose reflection the viewer sees in the mirror, in Manet, the position of the viewer remains unclear—the viewer's position corresponds with that of the man seen in the mirror as if standing before the melancholy young bar maid. But in the "reality" of the picture, he is replaced by the viewer.

[173]
Edouard Manet, *The Bar at the Follies Bergères*, 1881–1882, oil on canvas, 36.6 x 51.2 in., Courtauld Gallery, London.
The painting takes up an Impressionist theme that might well have been selected by Degas, Renoir, or Toulouse-Lautrec. On the other hand, the intellectual interplay of surfaces and spaces are pure Manet. The borders between picture and reality merge not only conceptually, but also technically in the Impressionistic style of painting.

Salon painting and Orientalism

Beside the Realists and Impressionists, a number of contemporary artists successfully regaled the public with painting as "grand opera." This form of academic Salon painting portrayed historical events and myths of antiquity, the Middle Ages, and the Renaissance, as well as literature, on large canvases and in grand style. The phenomenon occurred throughout Europe in the second half of the 19th century, but subsequently these canvases lost their popularity only to be rediscovered again by Postmodernism. The style found resonance in Symbolism and *Jugendstil*, the German form of Art Nouveau, which infused it with new meaning.

The monumental canvas of *The Romans in Times of Decadence* (1847, Musée d'Orsay, Paris) by Thomas Couture (1815–1879) was a triumphant success in the Paris Salon. Similarly, Jean-Léon Gérôme (1824–1904) at first devoted himself to antique themes; his *Cock Fight* [174], with its barely hidden eroticism, depicts a scene typical for the Salon. Nevertheless, with his brilliantly executed work, he became the forerunner of the Neo-Greek movement in Paris, before turning to exotic themes after a journey to the Orient in 1856, and, like Delacroix, devoting himself to Orientalism.

In London, Frederic Lord Leighton (1830–1896) and Lawrence Alma-Taddema (1836–1912) also pursued antique motifs. Their style brings an obsessively precise replication of materials and surfaces onto the canvas. The subjects are largely moralistic, but only superficially; underneath lies a subtly encoded lechery, appropriate to the double standard of both the France of

[174]
Jean-Léon Gérôme,
Cockfight, 1846, oil on
canvas, 56.3 x 80.3 in.,
Musée d'Orsay, Paris.

Napoleon III and Queen Victoria's
England.

German Salon painting is comparatively
restrained. Karl Theodor von Piloty
(1826–1886) achieved his greatest suc-
cess with his brilliantly painted historical
picture *Seni and the Corpse of Wallenstein*
(1855, Neue Pinakothek, Munich). His
student Hans Makart (1840-1884) was
even more successful, inspiring a
"Makart style." His almost Baroque flair
for painting large groups of people led to
his greatest commission—the decoration
of the main stairway and ceiling of Vienna's
Kunsthistorisches Museum in 1881. Franz von
Lenbach (1836–1904), after early work with inti-
mate genres, became the prince of the Munich
portraitists who painted prominent figures during
the industrial boom years following the Franco-
Prussian War. The more strictly academic Anselm
Feuerbach (1829–1880) also may be numbered
among the painters of the Salon style—although he
would have rejected the designation [175].

[175]
Anselm Feuerbach,
Paolo and Francesca,
1863–1863, oil on
canvas, 53.9 x 39.2 in.,
Schackgalerie, Munich.
The artist's inter-
pretation of the story
borrowed from Dante's
Divine Comedy as a
large-format chamber
drama of a strong,
melancholically-tinged
woman.

Painting in North America

During the 19th century, the development of
American painting gained tremendous momentum.
While never becoming completely independent of
European traditions, the speed with which the
crests of continental art waves reached America
became ever shorter, with the Impressionist move-
ment, in fact, attaining a peak simultaneously in
France and America.

Early in the century, Thomas Cole (1801–1848)
founded the "Hudson River School," a romantic
movement which flourished between 1825 and
1880, concentrating on the beauties of the
mountains, valleys, and lakes of upstate New York
and other wilderness areas in the eastern United
States. The second generation of the School,

[176]
Frederick Edwin Church, *Twilight in the Wilderness*, 1860, oil on canvas, 41.7 x 63.8 in., Museum of Art, Cleveland.
The glowing atmospheric pathos of Church's landscapes sometimes approaches the border of kitsch, but their peaceful presentation of wild and distant scenes made them very popular.

especially Albert Bierstadt (1830–1902), whose European studies in 1853 had concentrated on Lorrain, and Frederick Edwin Church (1826–1900) [176], looked further West. In 1859, Bierstadt first crossed the country, and later painted views of the Yosemite Valley and the Rocky Mountains. His pristine motifs idealized a supposed paradise of lyrical, even sublime, atmosphere. That the Indians depicted so picturesquely in some of their works were still being killed or driven into exile did not disturb these artists's conception of the New World, nor that of their audience.

In contrast were the unidealized portrayals of the suffering and human tragedy of the Civil War (1861–1865) by Winslow Homer (1836–1910) for the magazine *Harper's Weekly*. Homer later pursued various themes, the most well-known of which are his sea scenes, which convey pictorially the loneliness of the human being in the struggle against the elements. Rejecting the Romanticism and the polish of the "Hudson River School," he showed nature's power through his use of color and strong brushwork.

The greatest of the American Realists is Thomas Eakins (1844–1916). After studying academic painting under Gérôme in Paris, and anatomy by dissection in Philadelphia and Paris, he developed an almost Rembrandt-like chiaroscuro and seriousness after his early regatta scenes [177]. Eakins' controversial depiction of a medical operation in *The Gross Clinic* (1875, Jefferson

[177]
Thomas Eakins, *The Biglin Brothers Racing* (detail), ca. 1873, oil on canvas, 23.6 x 35.8 in., National Gallery of Art, Washington.

Medical College, Thomas Jefferson University, Philadelphia) was rejected by the Philadelphia Centennial Exhibition as too offensive in its realism for family viewing. Unpopular in his days, he had no followers despite his years of teaching art, though today his "scientific realism" is greatly admired.

Impressionism

Impressionism achieved a decisive break with the history of painting: finally, the painting acquired the status of an independent work of art, that is, an independent and self-sufficient creation of the painter's art, free from commissioning patrons, assigned themes, or conventions of painting style. For Impressionism, there was no theme or motif too negligible to be worthy of pictorial representation. However, Impressionist painting did in fact display certain thematic emphases, for example life in the modern metropolis, whose sheer movement, with its colorful boulevards and strollers, flourishing prostitution, brilliant café life, popular music halls, and horse races drew the painters' attention. Glamour and misery were close partners—although the socially critical and revolutionary impetus of a Courbet was absent from Impressionist paintings.

On the other hand, Impressionists also looked away from the city into the countryside, to Pontoise, Argenteuil, and Giverny, where they painted the modest scenes of the nearby provinces in all their fleeting, but also threatened, beauty. In such works, joy at the discovery of peaceful moments beyond the reach of the swirling metropolis takes the foreground: boat regattas, breakfast in the open, garden cafés, and houses with magnificently blooming front yards are preferred themes. The artists's eyes were caught by everyday motifs, the play of light and shadow,

color and form. They attempted to capture both the ephemeral moods of nature and the disjointed activity of metropolitan life in plain-air painting—quick, outdoor work done directly in front of the subject, without lengthy preliminary drawing on the canvas. The artists brought the studio to the subject: they carried easel, palette, canvas, and paint tubes along with them. Both this image of the artist and of Impressionism itself still stubbornly survives today in the cliché of the hobby painter.

There is no greater contrast imaginable than that between the frugal and enclosed studio of the romantic Friedrich [154] and Renoir's portrait of Monet sitting at his easel in the brilliantly colorful garden of his house in Argenteuil (1873, Wadsworth Atheneum, Hartford). A prerequisite for plain-air paintings was ready-made oil paints in zinc tubes that became available in the middle of the century and relieved the artists of the lengthy mixing of their own paints. With short, sometimes delicate, sometimes thickly-applied, almost thrown, strokes, the picture came into being in the painting process itself. In a comparatively fast process of development, painters increasingly lightened the colors of their paintings after 1870 by the juxtaposition of strokes or points of pure color next to each other, and discontinued the sealing coats of varnish that in the past had been applied to a painting's surface—an omission that was noted critically by the academic painters.

Many Impressionistic painters had undergone academic training, and in the 1860's met together with the naturalistic ladscape painters of the "School of Barbizon" in the Forest of Fontainebleau. Later, the two movements went their separate ways, until around 1870 Impressionism had fully emerged: in 1873 Monet created *Impression: Sunrise* [178]. From the title of this

painting came the name for the new style. Though most critics scorned the "Impressionists," in 1874, Jules-Antoine Castagnary correctly argued that the Impressionists did not reproduce the landscape as such, but rather the feeling that it called up in the artist observing it. The

[178]
Claude Monet,
Impression: Sunrise,
1873, oil on canvas,
18.9 x 24.8 in., Musée
Marmottan, Paris

remark was a reference to a similar attempt, but with different means, already begun in 18th century French painting with Chardin (see p. 115). Nevertheless, even with the seemingly spontaneous tossing of colors onto the canvas, the intellectual process of the painter's reflection on both the visual stimulation and the act of painting itself remained intact. This complicated process was taken up by the Post-impressionists (see p. 157) as their starting point for a comprehensive rethinking of the use of color and the process of painting itself. Eventually there were attempts at a systematic comprehension of nature in the 1880's, best exemplified by Monet's series of paintings of the *Cathedral of Rouen* [181] or of the *Haystack*.

Only Monet and Degas sought approval in official art circles. The others, after early rejection by the Salon, took a different approach to publicize their work. In 1874, the first of eight Impressionist exhibitions took place in the studio of the photographer Nadar, where thirty artists were exhibited. To the core of this first exhibition belonged Cézanne, Degas, Monet, Morisot, Pissarro, Renoir, and Sisley; in the last exhibition in 1886, from the original group, only Degas, Morisot, Guillaumin, and Pissarro took part. The others, as well as newcomers with wholly different temperaments, such as Seurat, Signac, Caillebotte, Cassatt, Gauguin, and Redon, participated

[179]
Max Liebermann, The Bleaching Field, 1882, oil on canvas, 42.9 x 68.1 in., Wallraf-Richartz Museum, Cologne.

increasingly in single or group exhibitions set up by art dealers or galleries. Impressionism had an important effect on the later development of painting. Cézanne, van Gogh, Gauguin, Signac, Seurat, Matisse, Picasso—all began in the Impressionist style. Many American Impressionists, such as Theodore Robinson (1852–1896), who visited Monet in Giverny, and Mary Cassatt (1845–1926), learned from the French painters, as did the Dutch painter Josef Israël (1824–1911), known as the founder of the "Hague School."

In Germany, the chief representative of Impressionism, Max Liebermann (1847–1935), had acquainted himself with all facets of French painting during his years in Paris from 1873 to 1878. He integrated what he had learned in France together with his impression of the "Hague School" into a darkly-toned style, after the fashion of Frans Hals, lying between Realism and Impressionism [179]. Liebermann, unlike the French Impressionists, also addressed socially critical themes. As chairman of the Berlin Secession from 1899, he exerted a significant influence on German cultural policy at the turn of the

Although Vasari wrote of **women painters**, until recently, female artists were either ignored, dismissed as "sweet," "lyrical," or "feminine," or criticized for being un-womanly in technique or in choice of profession. Drawing, like music or flower arranging, was considered suitable for ladies—supporting oneself by one's art was not. Yet many had done so, most notably the powerful Caravaggist Artemisia Gentileschi (1593–1652/53), the influential pastel portraitist Rosalba Carriera (1675–1757), the most highly paid portraitist of her day, Elizabeth-Louise Vigée-Lebrun (1755–1842), and founding member of the English Royal Academy Angelica Kauffmann (1741–1807). Rosa Bonheur (1822–1899) belonged to no school, but Impressionism claimed many women, among them Berthe Morisot (1841–1895), and American expatriate Mary Cassatt (1844–1926), who earned the respect of their peers and of posterity.

century. Not only did Liebermann possess a select collection of French Impressionist paintings, but he also actively supported the progressive purchasing policy of Hugo von Tschudi, the first museum director, to acquire large numbers of Impressionist works for the Berlin Gemäldegalerie.

[180]
Lovis Corinth, *Self-Portrait with Skeleton*, 1896, oil on canvas, 26 x 33.8 in., Städtische Galerie im Lenbachhaus, Munich.

His influence only ended with his dismissal as president of the Prussian Academy of the Arts by the Nazis in 1932.

Lovis Corinth (1958–1925) was a contemporary of Liebermann's Paris. After early salon painting, he incorporated Impressionistic tendencies in his work, especially in his emphatically clear pallette [180]. After a stroke in 1911, his paintings become nervously Expressionistic, especially the almost abstract landscapes in his late series *Walchensee*.

Important Impressionist artists

With good reason, Claude Monet (1840–1926) can be accounted as the driving force behind the artistic development of Impressionism. For Monet, painting meant color, and his sure painterly grasp of even the smallest atmospheric variations gives his work an impressive unity. Monet was never satisfied with what he had already achieved, but instead refined his technique in a constant process of discovery. Thus he worked more and more with series of pictures in order to discover every nuance in variations on a single theme [181]. Monet's travels extended his painterly education, especially his discovery of Turner's work in London in 1871. Upon his return, he spent a number of years in Argenteuil, and finally settled in Giverny in 1904, where the waterlilies in the pond of his own carefully planned garden inspired him to ever more abstract, and often large-format, variations

[181]
Claude Monet, *5 Paintings from the Series on the Cathedral of Rouen*, 1894, oil on canvas, from 35.8 x 24.8 in. to 42.1 x 28.7 in., Musée d'Orsay, Paris.
In this impressive series, Monet discovered even the most subtle differences in color and atmosphere of the morning, afternoon, and evening light falling on the facade of the Late Gothic cathedral.

[182]
Auguste Renoir, *The Loge*, 1874, oil on canvas, 31.5 x 25 in., Courtauld Gallery, London.

on these plants. The brilliance of form and color in these studies had a long-lasting effect on the non-objective art of the 20th century, reaching all the way to Abstract Expressionism (see p. 192).

The virtuosity of Pierre Auguste Renoir (1841–1919) provides another side of Impressionism. In 1867–1870, Renoir and Monet developed a full-toned colored depiction of Parisian life, culminating in the paintings of the 1870's [182]. After journeying to Italy and North Africa, Renoir concentrated on the female nude: *The Bathers* (1884–1887, Museum of Art, Philadelphia). In addition to strongly expressive portraits, the vitality of his later nudes (1904–1906), painted after his hands were gnarled with rheumatism, belie the critics who accused him of being passé and too prolific.

The artistic goals of Edgar Degas (1834–1917) differed from those of the majority of the Impressionists, although he worked among them, and also participated in their exhibitions from 1874. After academic training, and early historical pictures in the classical Académie tradition, Degas turned to the world of cafés, dancers, and the theater—but also to the life of the simple people. He aestheticized his subjects by cropping his figures artfully in the composition. His angle of view, and his often surprising over- or underviews are calculated attempts at the creation of a new type of picture

whose expressiveness in pastels or oils gave it a quality that a photograph could not possess [183].

With his paintings of music halls and bordellos, Henri de Toulouse-Lautrec (1864–1901) can be seen as the chronicler of the life of Monmartre, the center of the Parisian art scene. His media were chiefly the color lithograph and the poster, which he raised to the level of art. In contrast to the Impressionists, he composed his figures of large colored surfaces, as fitted the requirements of those new pictorial media, the colored poster and the lithograph [184].

In the course of his extraordinarily short but pro-ductive life, the Dutch painter Vincent van Gogh (1853–1890), an outsider to the Impressionist

movement, created a com-prehensive oeuvre between 1885 and 1890. As an auto-didact, he came late to paint-ing, and only after he had failed as a religious minister [185]. Van Gogh moved to the banks of the Seine at the invitation of his brother Theo, who operated a gallery in Paris, where van Gogh soon became known to the

[183]
Edgar Degas, *Absinth*, ca. 1876, pastel, 36.2 x 26.7 in., Musée d'Orsay, Paris.
In his studies of dancers, as well as of everyday life, Degas's deep sympathy for the social situation of his subjects is always evident.

[184]
Henri Toulouse-Lautrec, *La Goulue*, 1891, color lithography, 75 x 45.7 in.

In the printing process of **lithography**, a chalk or fat-containing ink is transfered to a porous limestone or slate surface. Normally the plate is then placed in an acid bath that eats away the exposed surface of the stone, thus allowing the drawing, which is now higher than the corroded surface of the stone, to be printed. The process, developed at the end of the 18th century by Alois Senefelder in Munich, soon became very popular because these "drawings on stone" allowed the artist a free choice of line direction, unlike wood-block printing, for example. After the masterpieces by Géricault and Honoré Daumier (1808–1879), the Impressionists made lithography fashionable, and in the second half of the century, lithography became the standard process used in book illustration.

[185]
Vincent van Gogh, *Weaver Near an Open Window*, 1884, oil on canvas, 27 x 36.6 in., Neue Pinakothek, Munich.
In van Gogh's early work, the dark-toned realism of the "Hague School" flowed together with the artist's own restless temperament into a moving synthesis of socially critical pictures.

Impressionists. However, he did not acquire his strong color or typical style until after moving to Arles in 1888. There in Provence, he created his famous masterpieces. Adapting the short brush strokes of the Impressionists to even greater effect, he defined objects in both their linear and inner structure through the character and dynamic repetition of his strokes. Van Gogh structured his paintings to create an artistic world, rather than to capture optical impressions, as did Monet. The pure colors, without gradations or mixed tones, that van Gogh applied to the canvas served to characterize persons, objects, atmospheres, and feelings, but were not intended to relate to reality.

In a moving series of letters to his brother Theo, who remained van Gogh's personal and economic support, van Gogh described his theoretical concepts. His ideas arose particularly from his exchanges with Gauguin, who had come to Arles in 1888 at van Gogh's invitation. Van Gogh's favorite themes were landscapes [186], portraits, still lifes with flowers, and interiors. His series of self-portraits, in their psychological acuteness and self-critical intensity, stand in a direct line from those of Rembrandt

[186]
Vincent van Gogh, *Wheat Fields*, July, 1890, oil on canvas, 28.9 x 36.2 in., Neue Pinakothek, Munich.

(see p. 105). After a short productive period, van Gogh and Gauguin's friendship ended catastrophically with van Gogh's psychological break-down—at which point he cut off his ear. After a transitory mental recovery, which released yet another period of productivity, van Gogh fatally shot himself with a revolver.

Post-impressionism—Gauguin, Seurat, Signac

The so-called Post-impressionists—including Cézanne and Van Gogh—developed an independent theory of art to distinguish themselves from the Impressionists.

Paul Gauguin (1848–1903) began painting in the Impressionist style, but later, along with Emile Bernard (1886–1941), developed an independent approach known as Synthetism, or more precisely as Cloisonnism. In the painting of enamel, the word *cloison* designates a partition around a colored area—a small raised border that prevents the molten enamel from running over into the other cells. In just this way, Gauguin separated the colored "cells" of his painting's surface with distinct lines. This style is based on a process of artistic reduction that translates the visible world into an ideal one, by means of exactly this process of reduction, of fields of pure, absolute color. In 1891 Gauguin traveled to Tahiti, where he settled permanently in 1895. There, the surface-oriented primitive art of the native islanders strengthened the artist in his *Peinture Idéiste*, or idea painting. The titles of his pictures help to decode the symbolically laden portraits of the Tahitian women [187]. Weariness of civilization, cultural pessimism, and multi-layered religious undertones supported Gauguin's indirect approach to European Symbolism (see p. 159–162).

The pointillism of Georges Seurat (1859–1891) and Paul Signac (1863–1935) pursued a fundamentally different goal. Seurat systematized the painting technique of Impressionism by covering the surface of the painting with identically-sized dots, or points, of color. The canvas was meant to correspond to the image actually produced on the retina of the eye [188]. The monumental effect of Seurat's large-formal masterpieces *A Bathing Place in Asnières*

[187]
Paul Gauguin, *Nafea Faaipoipo (When are you to be married?)*, 1892, oil on canvas, 30.7 x 30.3 in., Kunstmuseum, Basel.

[188]
Georges Seurat, *The Bridge of Courbevoie*, 1886–1887, oil on canvas, 18.1 x 2.8 in., Courtauld Gallery, London.

[189]
Paul Cézanne, *La Montagne Sainte-Victoire*, 1898–1900, oil on canvas, 25.6 x 31.9 in., Museum of Art, Baltimore.

(1883–1884, National Gallery, London), and *Sunday Afternoon on the Island of La Grande Jatte* (1885–1886, Art Institute, Chicago) form themselves into pictures only when the observer stands at a distance. The reduced dimensionality of bodies is reminiscent of Piero della Francesca or Uccello. After Seurat's death, Signac collected his theories into a book, *D'Eugène Delacroix au Néo-Impressionisme*.

Cézanne

No other painter associated with Impressionism had as wide an influence as Paul Cézanne (1839–1909), particularly on Cubism. After beginning with a dark coloration derived from Courbet and Daumier, Cézanne's palette lightened steadily after 1873. He moved from Paris back to his native Provence in 1882, and under the influence of its southern light, Cézanne dissolved objective forms into small, pure-colored flecks. In a second step, decisively distinguishing him from the Impressionists, he reconstructed the subject of the picture from these non-objective flecks of color. Thus, on the heels of his

analysis followed the synthesis of something entirely new, which unfolded its own reality, independent of the painted object. Central to Cézanne's approach was color, which for Cézanne always determined the proper form. He painted still lifes, portraits, and landscapes, often using the

same motif a number of times. Cézanne's best-known works are his *La Montagne Sainte-Victoire* (View of the Mont Sainte-Victoire in Provence) [189], and the preliminary studies and various versions (water color and illustrations) of *Les Grandes Baigneuses* [190], a picture standing stylistically between the Impressionism of Renoir and Picasso's *Les Demoiselles d'Avignon* of 1907 (see p. 171).

[190]
Paul Cézane, *Les Grandes Baigneuses*, 1895–1905, oil on canvas, 50 x 77.2 in., National Gallery, London.
With this traditional theme taken from painting history, Cézanne both summarizes his previous work, and opens artistic perspectives into the 20th century.

Symbolism

The artistic experiments of Impressionism and Post-impressionism inevitably produced a counter-reaction. Alongside to these movements, the currents of Romanticism continued to flow, offering industrial society a world of dark myths, occult thoughts, and erotic fantasies from which a line to 20th century Surrealism can be traced (see p. 183).

The key text of Symbolism (a term which was in fact originally used in 1886 in a literary connection) was Charles Baudelaire's *Les Fleurs du Mal*, published in 1857, in which Baudelaire set the tone for the experience of the deep uncertainty of the individual. Even if the Symbolists at times allowed positive impulses of a naively intact world to glimmer on the horizon, their primary concern remained the themes of the unconscious and of repressesion, which Symbolist painters intuited before Freud's formulation of psychoanalytical theories.

The artistic expression and themes of the Symbolist painters ranged from the Late Impressionistic, symbolically weighted Alpine landscapes of Giovanni Segantini (1858–1899) to the work of Michail

[191]
Gustave Moreau,
L'Apparition, 1876,
watercolor, 41.7 x 28.3
in., Musée du Louvre,
Paris.

[192]
Ferdinand Hodler, *Lake
Thun*, 1905, oil on
canvas, 31.5 x 39.3 in.,
Musée d'Art et
d'Histoire, Geneva.

[193]
Arnold Böcklin, *The Isle
of the Dead*, 1st
version, 1880, tempera
on canvas, 43.7 x 61
in., Kunstmuseum,
Basel.

Wrubel (1886–1910), who derived themes from the world of Russian ballet. As an important precursor of Symbolism, James Abott McNeill Whistler (1834–1903) had created subtle "Symphonies" and "Nocturnes" which link musical ideas to color, sometimes almost abstract figurative compositions.

Gustave Moreau (1826–1898) was the first French Symbolist. His famous *L'Apparition* [191] varies and demonizes the theme of Salomé, so important to the artist Aubrey Beardsley and the writer Oscar Wilde. Moreau's work can be seen as a decoratively overgrown synthesis of the color of Delacroix and the religious art of Rembrandt. After Moreau, Odilon Redon (1840–1916) effected a connection to literature with his lithographic cycles, and illustrated Edgar Allen Poe, St. John's Apocalypse, and Baudelaire's poetry. His oil paintings deliberately leave many details in fragmentary form, with a cloudy application of color which evokes the world of Huysman's influential novel *A Rebours*, which Redon also illustrated, at the author's request.

The Swiss painter Arnold Böcklin (1827–1901) called up the antique myths once again, to let the Nereids and Tritons play once more in the waters surrounding the island of death. He concluded the long tradition of German-speaking painters who had moved to Italy since the time of Goethe. His refined painting technique combines the precision of a Friedrich wit the energy of Salon painting [193].

The work of Ferdinand Hodler (1853–1918) is strongly marked by its religious content. In his large-format allegories of the hours of the day and seasons of the year (from 1889–1890), he placed his figures, which were primarily defined by flat surfaces, in front of ornamentally designed backgrounds, betraying the influence of Art Nouveau. His later pictures are significant, such as his Swiss landscapes, in which water, clouds, and mountains, reduced to a mere outline, work together in an almost abstract composition of surfaces [192].

[194]
Edvard Munch, *The Scream*, 1893, tempera and pastel on cardboard, 35.8 x 29.1 in., Nasjonalgalleriet, Oslo.
Before the gaze of the viewer, the picture emerges in wide colored streams; the figure in the center seems to be caught in the glowing colors of the background. Munch also made a lithograph of this work.

The Norwegian Edvard Munch (1863–1944) is the most important painter of 19th century northern Europe, and at the same time a characteristic Symbolist. His art is as dramatic as the plays of his contemporaries Ibsen and Strindberg. In 1889–1890, Munch made the acquaintance of van Gogh and Gauguin, and spent much time in Germany and France, but returned to Norway after suffering a nervous breakdown. His most effective works, such as *The Scream* [194], reflect his interest in the psychologically gray areas on the borders of sanity. Equally powerful are Munch's woodcuts, whose expressive lines reflect the fragility of the human psyche.

The work of Henri Rousseau (1844–1910) forms an exception to most late 19th century art. Starting in 1886, and without any training in art, he exhibited in the "Salon des Indépendants," and was, in fact, known to his contemporaries as "the customs officer" because of his bourgeois profession. Rousseau was in contact with Gauguin, Delaunay, and Picasso, but they had no influence on his

painting style. In 1891, he began his series of *Jungle Scenes* which made his reputation. Rousseau's jungles conjure up a seemingly peaceful world in which bloody or dream-like encoded scenes are played out. For this reason, his work can be termed symbolic, even when it reveals a tendency to the surrealistic.

The Jugendstil in Munich and Vienna— Stuck, Klimt, and Schiele

The development called Art Nouveau in English and French-speaking lands was known as the "Jugendstil" ("youth style") in Germany, and the "Sezessionsstil" in Austria. The terms designated an entire style of decoration noted for its sinuous lines, whose influence was greater in the commercial arts (jewelry, tableware, furniture, glass) than in painting.

In Munich, Franz von Stuck (1863–1928) was one of the co-founders of the local Secession, a term used in general for regional organizations in opposition to the official artists's group or the Academy. Like those of the Symbolists, his pictures portrayed the conflict of the sexes in dark, irridescent oils, whose frames he also designed. On his private estate, Stuck attempted to fuse architecture, sculpture, and painting into a Gesamtkunstwerk.

In 1897, Gustav Klimt (1862–1918) and 18 other artists left the official artist organization in Vienna

Symbolism, the reform movements of the 1880's, and Art Nouveau shared the idea of a **Gesamtkunstwerk**, or total work of art, a concept originating in the theatrical operas of Richard Wagner (1813–1883). In his *Ring of the Nibelungs* (first full performance in Bayreuth, 1876) and the *Parsifal* production mounted for the opening of the opera house in Bayreuth in 1882, music, literature, and the stage setting worked together for the greatest possible unity. The music at the scene changes in *Parsifal* accompanied by the changing of the settings on the open stage, while painted props were slowly rolled into place to signify the transition from outdoor scenes to the temple of the Grail. Gurnemanz remarked on the occasion that space in this way was transformed into time. In spite of this bold overstepping of boundaries, the Gesamtkunstwerk remained illusory. Rudolf Steiner's attempt to create a Gesamtkunstwerk in the Goetheanum of 1913–1914 also failed. With the invention of movies, however, many of the ideas that were a part of the Gesamtkunstwerk became reality in modern cinema: accompanied by music, an artistically created world, whose complete structure aimed at a single impression, was offered to the amazed viewer.

to start their own organization of graphic artists known as the Vienna Secession. The exhibition hall of the same name constructed by Josef Olbrich in 1898 brought together new architectural designs, sculpture, and art works in changing exhibits. Klimt's own contributions included subtle, Late Impressionistic landscapes, portraits [195], and mythological pictures.

[195]
Gustav Klimt, *Adele Bloch-Bauer I*, 1907, oil on canvas, 54.3 x 54.3 in., Österreichische Galerie im Belvedere, Vienna.
Typical of Klimt's painting is a richly decorative surface, that included stucco-effects and layers of gold leaf.

Almost the opposite of the extroverted art of Klimt are the ink drawings and oil paintings of Egon Schiele (1890–1918). By means of nervously sensitive lines, glaring color values, and the convoluted, expressively tense postures of his figures, he attempted to capture the febrile inner-life of the hollow, glittering last days of the Austro-Hungarian empire. In repeated experiments, the artist portrayed himself in states of erotic tension, in which a female figure fuses with the mirror-image of the artist into a threatening, androgynous being [196].

The Austrian dramatist and painter Oskar Kokoschka (1886–1980) also had his start in the Viennese Art Workshop and the Secession, but from the beginning, picked up the already Expressionistic tendencies of the *Viennese Sezessionsstil* and developed them into a very personal form of Expressionism. In a picture like *The Tempest* (1914, Kunstmuseum Basel) however, the linear tradition of Klimt and Schiele remains evident in spite of Kokoschka's new dynamism.

[196]
Egon Schiele, *Embrace*, 1917, oil on canvas, 39.4 x 27.5 in., Österreichische Galerie im Belvedere, Vienna.

Modern Art— From Expressionism to 1945

The beginnings of modern art history— Wölfflin, Riegl, Warburg

At the beginning of the 20th century, art scholarship felt the need to develop new categories and points of reference, partly for the sake of a better understanding of the history of art, but more importantly for a better grasp of the newly developing possibilities of contemporary art. In some cases, the art critics and scholars worked out their theories simultaneously with the appearance of new art forms, and thus the theory was able to provide the art with the terms it needed to explain itself. Early 19th century art historians, like Karl Friedrich von Rumohr (1785–1843), for example, had looked to the past in order to provide a continuous history of the development of art, along the lines of Georg Wilhelm Friedrich Hegel's theory of historical development. Cultural historians like Jacob Burckhardt and Jules Michelet presented their readers with panoramic views of cultural development that influence our understanding of art to this day.

Conrad Fiedler (1841–1895) was the first art historian to establish clear and comprehensible aesthetic categories, independent of the historical development of art. This revolutionary principle distinguished between the traditional perception of art and the experiences conveyed by the artwork itself. Continuing in this direction, Adolph von Hildebrand (*The Problem of Form in Visual Art*, 1893) conquered new conceptual territory for modern art by separating the "existent form" (*Daseinsform*) of a work from its "effective form" (*Wirkungsform*).

Whereas Hildebrandt limited himself almost exclusively to Renaissance and Baroque art, the Swiss art historian Heinrich Wölfflin (1864–1945) developed general formal principles for the interpretation of art of all ages and kinds. In *Principles of Art History*

(1915), Wölflin set up five pairs of opposites as aids for the interpretation of architecture, sculpture, and painting. For example, the catetories linear versus painterly-pictorial, or clarity versus unclarity, allowed a purely formal analysis of an individual work of art, independent of time-related terms and categories. In order to grasp the intrinsic qualities of an artwork, especially in modern art, such an approach is inestimably important, because the qualities of a work can then be determined and be made concretely comprehensible by means of specific terms which are independent of the norms arising from a developmental history of art.

Wölfflin attempted to define the emotional effect of a work of art in universally accepted concepts that could be used as tools in interpreting and placing the work in terms of accepted art history, and even in evaluating the place of the given work in the entire concept of art. But Wölfflin's was not the only new approach. In his *Late Roman Art Industry* (1901), Alois Riegl (see p. 102) proposed a reevaluation of neglected products of artistic creation by discovering in them a "will to be art" (*Kunstwollen*), which produced wholly different artistic results, according to the conditions and background of the artwork. Artistic form could be understood only in a cultural-historical context—even though Riegl defined the "will to be art" as an autonomous process, essentially separate from its social environment. In Riegl's theory, supposedly ugly, or unsuccessful, art becomes understandable, because it, too, contains the "will to be art" of its own given era. Equally far-reaching is Riegl's justification for the inclusion of the applied arts in his philosophy, for such art expresses the "will to be art" to precisely the same extent as paintings, sculpture, or architecture. In his inclusion of applied art, Riegl's theory reflects the significance of the decorative arts in the contemporary Viennese Secessionist movement. Riegl, who to some extent drew from the milieu theory of Hippolyte Taine (1828–1893), is, along

1928
Fleming discovers penicillin
1929
Crash of American stock marcket triggers world depression
1933
Hitler assumes power in Germany; President Franklin Roosevelt's New Deal points way out of economic crisis
1936–1939
Spanish Civil War ends in dictatorship of Franco
September 1, 1939
German attack on Poland starts Second World War
1942
Wannsee Conference in Germany determines the "final solution of the Jewish question"
June 6, 1942
Invasion of western Allies at Normany (D-Day)
May 1945
End of Second World War in Europe
August 1945
Atom bombs dropped by the United States on Hiroshima and Nagasaki, end of war in the Pacific

with Wölfflin, crucial for the understanding of modern art.

The third key figure of modern art scholarship was the Hamburg cultural historian Aby Warburg (1866–1929). He laid the basis for iconology as an independent branch of research. Warburg was particularly interested in the transition from the Middle Ages to the Renaissance. In pioneering studies in these areas, he compiled material drawn from a very broad range of sources—inventories, the physical sciences, astrology, poetry, philosophy—and made it available for interpretation. Only from the entire perspective of the period's full cultural and historical framework, which his research had brought to light, could a probe or test of the essence of the individual art work be made. Moreover, Warburg attempted to prove that particular forms of expression in art, such as gestures and motifs, which he designated by the term "pathos formula," were anthropological constants from antiquity to the modern world. This approach enabled Warburg to draw connections between an ancient work of sculpture and a contemporary postage stamp, and signified an immense broadening of the horizons of art scholarship in terms of both the history of culture and of forms. Warburg himself visited the Hopi pueblos in Arizona to research the Indians' snake ritual for its connections to motif patterns from antiquity and the Renaissance. His constant assumption was that the products of art are a reworking of ancient pictorial traditions stemming from cultural memory. The contemporary work of psychologist Carl Jung also explored the idea of a "collective unconscious," and Jungian archetypes correspond to Warburg's ideas about the cultural memory and the pathos formula. The Library of Cultural Sciences which Warburg founded in Hamburg in 1926 played an important role for art history after the First World War. The work of the institute was saved from the Nazis in 1933, and moved to London, where the Warburg Institute exists today. Warburg's successors trans-

mitted the universal principle of a cultural history of art into the more pragmatic process of iconology. After the analysis of the content of a picture (iconography), came the next level of iconological analysis, which attemps to consider the cultural and historical relationships of an artwork by a consideration of literary and philosophical texts. Erwin Panofsky (1892–1968) is the most important representative of this approach, and after the exodus of Jewish scholars from Germany after the Nazis came to power in 1933, he exerted a decisive influence on art history in the United States and Great Britain.

Fauvism, Expressionism, and Matisse

In 1905, a new and alarming kind of canvas made its appearance in the Paris autumn Salon— and once again in the history of art, a critic's disparaging description of the artists gave the group its name. From approximately 1898 to 1906/1908, the *fauves*, or "wild ones," formed a loose collection of artists gathered around André Derain (1880–1954), Maurice de Vlaminck (1876–1958) and Henri Matisse. Proceeding from the work of van Gogh, Gauguin, and the Post-impressionists, the Fauvists attempted to create a new kind of painting that would constitute a full expression of the painter's feelings in relation to the subject by means of the intensive application of pure colors [197]. Favorite themes of the Fauvists were portraits, landscapes, and female nudes. Fauvism soon spread beyond the borders of France, and its Berlin exhibition of 1906 caused an uproar— naturally, mostly negative. It was paradoxical, but understandable, that in these years the ill-fame of the Fauvists indirectly resulted in the growing reputation of the tamer Impressionists.

[197]
André Derain, *Collioure, the Village and the Sea*, 1904–1905, oil on canvas, 19.7 x 31.9 in., Museum Folkwang, Essen, Germany.

[198]
Henri Matisse, *Harmony in Red*, 1908, oil on canvas, 70.9 x 86.6 in., Hermitage, St. Petersburg.

Henri Matisse (1869–1954) is of particular importance to the history of painting because he used the surface value of color an autonomous value. He set forth his color principles in 1908 in his *Notes of a Painter*, a kind of anti-manifesto to Cubism (see p. 171) as developed by Braque and Picasso, whose breakdown and reconstruction of the subject of the picture was based on form and line, rather than color. For Matisse, however, color was the purest expression of light, and form existed only in, and through, color. His moving, rhythmical pictures are full of musicality [198], a quality also evident in his designs for the dance theater of Sergei Diaghiliev. In the first half of the 20th century, Matisse was the fixed star of reference for later painters—and not only for those who moved away from abstract painting to figurative (i. e., paintings with recognizable human figures and objects.) German Expressionism made its first appearance when four young Dresden architecture students formed themselves into a group they called *Die Brücke* ("The Bridge"). Fritz Bleyl (1880–1966), Erich Heckel (1883–1970), Ernst Ludwig Kirchner (1880–1938), and Karl Schmidt-Rottluff (1884–1976) were the original members, later joined by Max Pechstein (1881–1955) and Otto Mueller (1874–1939) after 1910. Emil Nolde (1867–1956) was also active with the group for a short time.

The German Expressionists were more politically engaged than their Fauvist counterparts in France. Even more than the early Expressionsts of the "Worpswede School," and in particular Paula Modersohn-Becker (1876–1907), the Brücke painters used glaring, emotion-weighted colors and swaying lines to depict life in industrial society. Unlike the work of the

Blue Rider movement (see p. 174), Brücke paintings always retained a visible relation to reality.

[199]
Erich Heckel, *Liegende*, 1909, colored woodcut.

There were recognizable stylistic differences among the individual Brücke members. Otto Mueller, for example, painted landscapes and female nudes in earthy and muted tones, whereas Nolde soon turned to religious themes. However, behind such differences, the unconditional desire for honest expression remained constant. After the Fauvist exhibit in Berlin in 1906, the influence, especially of Matisse, on the group is unmistakable; but the work of the Brücke is also filled with references to Edvard Munch, the Belgian James Ensor (1860–1949), the old German tradition, and the art of Africa and Polynesia as well. The "primitive" expression and the reduction of non-European wood sculpture to essential emotions and modes of expression, which had already fascinated Gauguin now became an important point of reference in European art. In the face of the growing power of photography, the starkly expressive quality of the traditional woodcut, with its flowing, but also interrupted lines, also became popular [199] through the work of the Brücke.

After 1910, members of the group moved to Berlin, where the movement peaked in 1915. The avant-garde art and literary journal *The Storm*, published by Herwarth Walden, began printing the theoretical writings of the group in 1910. Three years later, though the group officially dissolved, the style of painting survived. In 1918, in the revolutionary turmoil at the end of the First World War, Max Pechstein became co-founder of the "November Group," which sought to establish socio-revolutionary connections between the populace and artists through a "Working Commision of Art." Kirchner [200] withdrew to Davos, Switzerland, after a nervous breakdown in 1917, and Nolde moved to northern Schleswig-Holstein, where he was denied permission to paint in

[200]
Ernst Ludwig Kirchner, *Self-Portrait with Model*, 1907, oil on canvas, 59 x 39.4 in., Hamburger Kunsthalle, Hamburg.

1941 by the Nazis. The works of the Brücke were officially declared "degenerate" by the Nazis, and after being seized for the infamous "Degenerate Art Exhibition" of 1937, the works were either destroyed or sold abroad to finance German arms at the beginning of the Second World War.

Paths to abstraction

Between 1900 and the outbreak of the First World War in 1914, various and parallel developments of style arose that in large part make up what we understand today as "Classical Modern" art. Cubism, Expressionism, Futurism, and Suprematism all shared the tendency to abstract the image from the depicted object. In the end, the relation between the abstract picture and the reality behind it disappeared completely—an abstractive process intrinsic to modern cultural understanding as a whole. Various aspects of this tendency emerged in different forms in different lands, but the original point of reference was always the dissolution of the traditional world at the end of the 19th century. Technical progress, revolutionary social upheavals, and war experiences are all elements of modern art, together with the drive for rigorous realization. The artist became at once the engineer and magician of developments which touched a broad public through new forms of social and domestic life, and the explosive spread of "design."

It is impossible to construct a neat view of the Classical Modern. Modern artists work, exhibit, and teach internationally. Pamphlets and journals of individual groups have become respected forums of international exchanges of opinion. Exciting developments take place not in tandem, but parallel to each other, making the chronological presentation of modern art difficult—a situation which in turn places emphasis on individual biographies. Wassily Kandinsky, for example, was first a member of the Blue Rider movement, but later became a Bauhaus artist; on the other hand, a colorful personality like Paul

Klee is difficult to designate as a Bauhaus artist, although he taught there. Furthermore, Klee's work betrays tendencies both to abstraction—although he never wholly gave up reference to actual objects in his work—and to Surrealism, in the dream-like aspects of his pictures. The problem of classification becomes even more difficult with Picasso, who experimented with all the art forms of the 20th century, often introduced his own trends, and even worked simultaneously in various styles.

Thus, a list of the various artistic "isms" can indicate only general artistic directions and aesthetic positions that were often vehemently and polemically debated, but cannot explore the artists' individual forms of expression.

[201]
Pablo Picasso, *Les Demoiselles d'Avignon*, 1907, oil on canvas, 96 x 92.1 in., Museum of Modern Art, New York.
Designed as a paraphrase of Cézanne's *Les Grandes Baigneuses*; Picasso reconstructs his female figures, made up of bold fragments, into a new whole. The viewer experiences a new kind of integrative seeing in the process of establishing the connection between the recognized separate elements.

Cubism

In 1907/1908, Cubism was simultaneously developed by Pablo Picasso (1881–1973) and Georges Braque (1882–1963) in France. Later, other artists, including the Spaniard Juan Gris (1887–1927), and for a short time Marcel Duchamp (1887–1968) and Fernand Léger (1881–1955) adopted the style. The philosophy of Henri Bergson, who envisioned time and life as a flowing, many-faceted continuum, provided the background for the Cubist experiments of Picasso and Braque. Borrowing pictorial themes from Cézanne's still lifes, portraits, and landscapes, the two artists dissolved forms and figures into multiple, simultaneously visible prisms and cubes. As Picasso moved toward Cubism, he gave up the solidity and realism of his earlier Blue Period, and after many preliminary studies for the work, he produced the key painting of Cubism with his *Demoiselles d'Avignon* [201]. As in

[202]
Pablo Picasso, *Woman with Mandolin*, 1910, oil on canvas, 36 x 23.2 in., Museum Ludwig, Cologne.

[203]
Marcel Duchamp, *Nude Descending a Staircase*, No. 2, oil on canvas, 57.9 x 35 in., Museum of Art, Philadelphia.

the paintings of Cézanne, so in Cubism, the traditional analysis of an actual object and the process of artistic synthesis were no longer the subject of the painting. Instead, in a decisive reversal of all tradition, the artist's idea of the object replaced its empirical image [202]. Following this breakthrough on canvas, Braque and Picasso used three-dimminsional objects, or various kinds of paper or newspaper excerpts, to make flat or quasi-sculpted collages, similar to the techniques employed by the Dadaists (see p. 178).

Marcel Duchamp's famous *Nude Descending a Staircase* [203], which caused a sensation when shown in New York at the 1913 Armory Exhibition, analyzes motion by breaking the movement down into its successive phases, and simultaneously reconstructing the sequence of actions into a picture. The process reflects the photographic studies of motion made by the English photographer E. James Muybridge (1830–1904). And finally at the edge of Cubism, the Czech artist František Kupka (1871–1957) painted his first abstract picture wholly without a figure of reference, *Fugue in Red and Blue*, in 1911–1912.

Futurism

In 1910–1911, the Italian Futurists Umberto Boccioni (1882–1916), Gino Severini (1883–1966), Carlo Carrà (1881–1966), and Giacomo Balla (1871–1958) arrived at results similar to Braque and Picasso in France. However, in contrast to the Cubists, who were only loosely connected with each other and lacked a unified theory for their experiments, the Futurists published two aggressively formulated manifestos in 1910 announcing their rejection of all tradition, before exhibiting their work in 1911. In comparison to sedate and constructive

Cubist com-postion, Futurism drew its life-blood from the dynam-ism of speed and sport [204], and revealed an obses-sion with techno-logy, up to the late flowering of

[204]
Umberto Boccioni,
Dynamics of a Football Player, 1913, oil on canvas, 76 x 79.1 in., Museum of Modern Art, New York.
Powerful lines give dynamism to the paint-ings of intercrossing layers of time and space.

"Aeropittura," which placed them in the camp of the initially progressive-seeming Fascism of Mussolini. Many Futurist artists expressly refered in their paintings to the early Renaissance Italian painters, in whom they found their own questions about the treatment of surface and space already formulated.

Orphism

The French writer and art critic Guillaume Apol-linaire coined the term "Orphism" in 1913, after the most important works of the movement had already been completed. Robert Delaunay (1885–1941), who had started painting in the analytic Cubist style of Braque and Picasso, is the chief representative of the group. Delaunay's famous Cubist constructions, (*Eiffel Tower*, 1910–1911, Kunstmuseum, Basel), disassembled the object of the picture into colored surfaces that the artist then systematically reorganized according to the color theory of Chevreul. In this process, Delaunay approached a lively abstract painting that utilized the Eiffel Tower only as the starting point for a crystalline illumination of pure colors. The prismatic colors redefine themselves further into pure abstract forms. This recognition that color itself releases movement—that is, that the object itself, as still found in the analytic

[205]
Robert Delaunay, *The Simultaneous Windows*, 1912, oil on canvas and wood, 18.1 x 16 in., Hamburger Kunsthalle, Hamburg.

Cubism of Braque, is no longer necessary to painting—found its logical end contemporaneously in the first purely abstract improvisations of Kandinsky.

[206]
Wassili Kandinsky,
Church in Murnau,
1910, oil on cardboard,
25.5 x 19.7 in.,
Städtische Galerie im
Lenbachhaus, Munich.
The succession of the
various landscapes
surrounding the Bavarian village fascinatingly
and concretely portrays
the transition of the
objective landscapes
into abstract colored
surfaces. Only the
church tower remains,
as a last visible
reference to reality.

The Blue Rider movement

In December 1911, as a successor to the New Artist Union in Munich, the group known as the *Blaue Reiter*, was created by Wassily Kandinsky (1866–1944), Franz Marc (1880–1916), Gabriel Münter (1877–1962), Alfred Kubin (1877–1959), Paul Klee (1879–1940), and August Macke (1887–1914). After their first exhibition, they published an almanac of their paintings in May 1912. Both Alexej von Jawlensky (1864–1941) and Lyonel Feininger (1871–1956) also exhibited with the group.

In contrast to the Brücke artists, who remained close to reality, (see p. 168), the Blue Rider group emphasized the spiritual as the source of all art. Mystical experience, natural philosophy, and enchantment are incorporated into their pictures. Their almanacs printed masterpieces of primitive cultures and Western art and their own paintings and woodcuts on opposing pages. The artists' drew their mode of expression from the older traditions which they believed conveyed a sense of cultural memory—a process Warburg at this time also was discovering in the Italian Renaissance (see p. 166).

Both Kandinsky and Klee often described their works in terms of musical categories; Kandinsky's also contained a theosophic component (his essay *On the Spiritual in Art* appeared in 1912). Musical sounds formed themselves anew as colored "sounds" in the pictures. In the case of Kandinsky, pictorial abstraction inevitably followed musical [207], and his abstract improvisations and compositions of 1910–1911 seem far removed from his painting of the previous years [206]. Neither Franz Marc nor August Macke were able to take this further step, both artists having lost their

lives in the First World War. Marc's animal pictures projected the joy and suffering of human existence onto the animal, which, unlike the human being, is not yet alienated from nature. Alexej von Jawlensky traced

[207]
Wassili Kandinsky, *Composition IV*, 1911, oil on canvas, 62.8 x 100.2 in., Kunstsammlung Nordrhein Westfalen, Düsseldorf.
The clouds of color, overdrawn with shallow, linear surfaces and dots call up musical associations.

religious features in the human face ever more strongly after 1917, and finally moved to quasi-abstract pictures with symbol-like crosses and lines. The work of Paul Klee was both comprehensive and tirelessly inventive. In his dreamlike figurative paintings, as well as in his abstract pieces, Klee drew inspiration from every source available to an artist between 1912 and 1920. Along with August Macke, he shared the elemental experience of color and cubic forms they discovered in the casbahs of Tunisia on their joint travels in 1914 [208]. During his years at the Bauhaus from 1921 to 1930, Klee devoted himself intensively to his teaching, and his own painting during that time became concerned more with the subjective creative act than in intellectual synthesis, a change of emphasis which alienated him from his Bauhaus colleagues. His painting nourished itself on motifs of a romantic and

lyrical nature, set free from the subconsciousness by the act of painting. The dreamlike character of the innumerable works in various techniques which Klee completed was

[208]
Paul Klee, *Red and White Cupolas*, 1914–1915, watercolor on paper, 5.7 x 5.4 in., Kunstsammlung Nordrhein-Westfalen, Düsseldorf.

reflected in their poetic titles, and united them with Surrealist painting.

Suprematism and Constructivism

Simultaneously with the appearance of Futurism in Italy, similar tendencies toward abstraction began to emerge in Russia. The "Rayonism" of Michail Larionov (1881–1964) and his friend and companion Natalia Goncharova (1881–1962) attempted to depict movement through series of parallel and intersecting colored lines representing rays of light. Their work formed one of the important bases for the art of Kasimir Malevich (1878–1935), whose abstract pictures arise from complex mystical and philosophic concepts uniting time and space by means of images [209]. For Malevich, this synthesis could be accomplished only through non-objective—that is, abstract—forms, which was the foundation of his Suprematism. Malevich held that certain colors had philosophical content, and that a concrete form such as his painting *Black Square on White Ground* (1915) does not "imitate" anything: it exists in its own right. Under his influence, most Russian painters reduced their modes of expression to an extremely formal concentration.

The *Proun Paintings* (or "concrete projects," which synthezised form and material) [210] of El Lissitsky (1890–1941), for example, or the artist Liubov Popova (1889–1924), whose early work was influenced by French Cubism, reflect this reductionistic trend. For a short moment, avant-garde art corresponded to the revolutionary reality in Russia, both phenomena embodying the violent rejection of czarist Russian traditon. Following the 1917

[209]
Presentation of Malevich's Suprematist works at the last Futurist exhibit: 0, 10, Petrograd 1915, Photograph. After beginnings in the Realist tradition, Malevich exhibited 35 abstract painitings (squares and other forms against a neutral background) for the first time in 1915 in St. Petersburg.

[210]
El Lissitzky, *Colored Design for the "Abstract room" in the Province Museum of Hannover*, 1927, Sprengel Museum, Hanover.

revolution, polemical discussion raged in Russia on the value of art in the new, revolutionary society. Vladimir Tatlin (1885–1953) and Alexander Rodchenko (1891–1956) argued that the job of the artist, in his or her role as the creator of the new society, was to provide socially relevant works, in the design of posters or books, or in the applied arts. Painting as a traditional genre was replaced by Constructivism, in which the artist became the engineer of the revolutionary future by organizing the patterns of human life in all available media, and with all the materials available to the modern world. The formal language of this new art was abstract, characterized by strong lines and dynamic accents, in contrast to the art of Malevich, which was turned inward upon itself. Constructivism and Suprematism were parallel developments, initially enjoying state support, but later only tolerance, until finally, in 1934 Stalin decreed that Socialist Realism was the sole possible form of artistic expression. In 1935, the funeral procession of the disgraced Malevich was led by a truck decorated with a black square on a white ground, and Soviet art descended to the level of the contemporaneous Nazi propagandistic "realism."

De Stijl

Like Russian Constructivism and the German Bauhaus, the Netherlandish journal *De Stijl* ("The Style"), founded by Theo van Doesburg (1883–1931), broke upon the world in 1917 with the promise of a radical renewal of all

[211]
Piet Mondrian, *Composition*, ca. 1922, oil on canvas, 29.7 x 20.7 in., Museum Folkwang, Essen.
According to Mondrian, perpendicularly intersecting lines bring together life and immortality to a cosmic unity. The horizontal line stands, moreover, for the feminine, the vertical for the male principle.

Important Dada
painters:
Hans Arp
(1887–1966)
Hans Richter
(1888–1976)
Marcel Duchamp
(1887–1968)
Francis Picabia
(1879–1953)
Man Ray
(1890–1976)
John Heartfield
(1891–1968)
Hannah Höch
(1889–1978)
Raoul Hausmann
(1886–1971)
George Grosz
(1893–1959)
Kurt Schwitters
(1887–1948)

[212]
Kurt Schwitters, *Mz
150. Oscar,* 1920,
collage, 5.1 x 7.7 in.,
Kunstsammlung
Nordrhein-Westfalen,
Düsseldorf.

traditional genres of art. The jounal remained in publication for sixteen years. The first issues, dating from 1917 to 1920, chiefly reflected the theories of Piet Mondrian (1872–1944). As an artist, Mondrian had begun with landscapes whose organization of the trees and strikingly flat depiction of the church towers of his home region already were concentrated on the relation of surfaces and space. Like Malevich and the painters of the Blue Rider group, Mondrian became interested in theosophical and mystical philosophy. In the thought processes of the painter, sea and forest became reduced to pure line, and the tones of the landscape and nature to the primary colors. What emerged was the often repeated framework of straight lines and colored squares and rectangles which Mondrian called "neo-plasticism" [211].

Dada

Although the Dadaists had already made their way to abstract forms in 1916, their roots lay in their reponse to the barbarism of the First World War, and the effects of nationalism and materialism: the modern world could only be experienced in fragments. The Swiss writer Hugo Ball had applied the significantly meaningless name "Dada" to the style in the magazine Cabaret Voltaire, and in the course of the years, the ideas migrated from Zurich, to New York, Barcelona, Berlin, and Cologne.

Dada artists employed broken bits and pieces of the world they criticized, in order to disclose through an artistic fragmentation both the incomprehensible alienation of the status quo, and the absurdity of any attempt to restructure it. In this sense, Dada is less an organized movement than a way of looking at the world. In every Dadaist group, this sense of splintering constituted the essential criterion. Dada expressed itself both in literature and the visual arts, and introduced performance per

se as art in the modern sense, that is, a fusion of theater, reading, and self-portrayal by the artist in a public presentation.

In Dada, painting gave way to the collage, which reached out toward the Cubist influence eminating from Paris, but passed beyond the formalism of analytical Cubism. In addition, Dada also took impulse from Russian Constructivism, which led to both groups attending a congress in 1922 in Weimar. A further influence was Surrealism, found, for example in the work of Max Ernst (see p. 183). The majority of the Dadaists in Paris soon joined this movement.

In Germany, Dadaists Raoul Hausmann (1886–1971) and John Heartfield (1891–1968) used the photomontage to excoriate the evils of post-war society. In 1919, Kurt Schwitters (1887–1948) founded a one-man Dada movement called the "Merz" (short for Commerzbank, "Commercial Bank"), in Hannover. Schwitters also wrote experimental poetry, composed his Merz pictures from newspaper extracts and the fragments of daily life [212], published a paper (naturally, the Merz), and in 1924, as a synthesis of Constructivism and Dada, started building a Merz-construction, a pile of wood and theatrical set pieces, in his own home. (The work was destroyed, but has been partially reconstructed in the Niedersächsisches Landesmuseum, Hannover.)

Bauhaus

Founded in Weimar, Germany, by the architect Walter Gropius in 1919, the Bauhaus became the most important school of European Modernism. Particularly in the years before moving to Dessau in 1925, the Bauhaus drew exceedingly different artists together in a place where they could practice and teach what they had been writing about in such books as Kandinsky's *Point, Line, and Plane* (1926), and Klee's *Pedagogical Sketchbook* (1925).

[213]
Georg Grosz, *Portrait of Max Hermann-Neisse*, 1925, oil on canvas, 39.4 x 39.7 in., Städtische Kunsthalle, Mannheim.

In addition to Klee and Kandinsky, Oskar Schlemmer (1888–1943), Lyonel Feininger (1871–1956), and Johannes Itten (1888–1967) were active in the movement. The latter was a color theorist who, together with Gropius, developed an integrated two-part curriculum made up of the study of form and its practical application in the workshops. However, conflict soon arose with Gropius, who wanted to place the social relationship of art in the foreground of the study. Ittens' successor László Moholy-Nagy (1895–1946) combined Russian Constructivism with German traditions, and from this point, painting receded in importance at the Bauhaus, giving way to film, photography, and the applied arts. In any case, after 1925, architecture assumed the central role in the school, especially after the subsequent appointments of Hannes Meyer in 1927–1930 and Ludwig Mies van der Rohe (1930, until the dissolution of the School under the Nazis in 1933).

The New Objectivity and Realism in America

The term "New Objectivity," originally the name of a 1925 exhibit in Mannhein, Germany came to refer to a painting style developed in the 1920's. Painters such as Otto Dix (1891–1967), George Grosz (1893–1959), and Max Beckmann (see p. 181) took the people and society of the Weimar Republic as the theme of their realistic paintings. The New Objectivity, like Dada, was a phenomenon, rather than a movement. In contrast to Expressionism, New Realism carefully worked out its detail, in the case of Dix, almost in the manner of the old masters. With Grosz, on the other hand, a Dadaist background is traceable in the collage-like construction of his paintings. Without illusions, both he and Dix unsparingly commented on the Nazi infiltration of the Weimar

[214]
Grant Wood, *American Gothic*, 1939, oil on wood, 29.2 x 24.8 in., Art Institute, Chicago.

Republic. In his emotionally loaded pictures, Dix depicted the horrors of the First World War, and the glaring night-life of urban bars, those scintillating hotbeds of vice. Dix's and Grosz's portraits are among the most moving of this genre attempted in the 20th century: for one last time before the catastrophe struck, German-Jewish society appears on canvas in their psychologically impressive images [213].

At the same time in the United States, a similar movement toward realistic and critical themes was making itself known. Grant Wood (1892–1942) criticized the puritanical bigotry of American rural life in his double portrait American Gothic [214]. In the unbroken tradition of American Realism, Edward Hopper (1882–1967) depicted the loneliness of urban life [215]. Georgia O'Keeffe (1887–1986) pursued a different path in her gigantic enlargements of natural forms, such as flower calixes, whose size gives them an abstract and almost mystical effect.

[215]
Edward Hopper, *Early Sunday Morning*, 1930, oil on canvas, 35 x 59.8 in., Whitney Museum of American Art, New York.
Hopper's theme is the isolation of the human being in the streets and diners of American cities.

[216]
Max Beckmann, *The Night*, 1918–1919, oil on canvas, 52.3 x 60.6 in., Kunstsammlung Nordrhein-Westfalen, Düsseldorf

Beckmann

The German painter and graphic artist Max Beckmann (1884–1950) cannot be identified with any single style. After Impressionistic beginnings, he moved toward a style heavily determined by lines after the First World War. Like Dix and Grosz, Beckmann reflected the immense violence of the war years

[217]
Giorgio de Chirico, *The Uncertainty of the Poet*, 1913, oil on canvas, 41.7 x 37 in., Tate Gallery, London.

and the corruption of the so-called "golden twenties" in his works [216].

Beckmann increasingly included literary and mystical references in his stringently conceived works in order to express society's smugness and its political dangers. He often preferred a three-panel picture, the triptych, with its associations with Medieval altar pictures. (Later, the British artist Francis Bacon would also call upon this tradition, see p. 197). Beckmann's series of self-portraits convey, more than almost any others of the 20th century, the condition of the artist at the moment of painting, and especially after his emigration in 1937, served to assure him of his own identity.

Pittura Metafisica

Framed in deep perspective, and strewn with the limbs of dolls and other pieces of the urban inventory, the paintings of the Italian Giorgio de Chirico (1888–1974) convey the magic of simple objects and the dream-like melancholoy of emptiness. The pictures have a "surreal," that is, over the real, atmosphere. It is therefore not surprising that the Surrealists of the 1920's placed great value on his work.

[218]
Max Ernst, *The Great Forest*, 1927, oil on canvas, 44.9 x 57.5 in., Kunstmuseum, Basel.

Between 1911 and 1915, while he was in Paris, de Chirico developed his *pittura metafisica* (metaphysical painting) into a realistic alternative to Futurism [217]. At times, Carlo Carrà (1881–1966) and

Giorgio Morandi (1890–1964) also worked in this style. All the artists tended to make strange references to the art of the *Quattrocento* (15th century Italian Renaissance). Carrà and de Chirico especially valued the formal qualities, and complex definitions of surfaces and space found in Uccello and Piero della Francesca. Morandi soon con-

centrated on pale still lifes, whose limited elements he combined in various ways, and used in great formal concentration.

Surrealism

After Abstract Painting and Expressionism, Surrealism became the most successful painting style of the 20th century. As with a number of other movements, a highly respected writer laid the theoretical groundwork. In 1924, André Breton (1896–1966) drew up the *Manifeste du Surréalisme*, and throughout his life he accompanied the movement with his acute essays and commentaries. Whereas Dada attacked the everyday world, with its bourgeois values and norms, and revealed the dangers of its conventional superficiality, Surrealism offered both artistic and social alternatives. Marxism, psychoanalysis, and the supernatural were the springs of Surrealistic creativity. The movement required of its adherents the ability artistically to make real what are unconscious processes, dreams, and fantasies, without the mediation of consciousness. The resulting "Automatism" resulted in a preference for certain artistic techniques, or the invention of new ones. Collage was a popular form of expression, and around 1925, Max Ernst (1891–1976) invented the frottage, in which everyday objects like wood or leaves were rubbed into paper or "printed" on oil paintings [218].

As a political and literary movement, Surrealism spread throughout Europe. Very often, its reference was to works of the past, but it also commented critically on the present without, remarkably, losing the spiritual undertones of its theory.

In concrete realization, Surrealist theory led to characteristically different styles. The dream-images of the Belgian René Magritte (1898–1967), goaded the viewer with irreconcilable combinations of realistic

[219]
Joan Miró, *Woman and Bird in Moonlight*, 1949, oil on canvas, 31.9 x 26 in., Tate Gallery, London.

[220]
Salvador Dalí, *The Burning Giraffe*, 1936–1937, oil on canvas, 13.8 x 10.6 in., Kunstmuseum, Basel.

objects and situations; the Franco-American Yves Tanguy (1900–1955) peopled his nightmarish, poetical deserts with unformed organic shapes; the obsessive, usually sexually-encoded Catalan "soulscapes" of Salvador Dali (1904–1989) painstakingly imitated the style of the old masters, but referred to a different psychological world [220]; the Catalan Joan Mirò (1893–1983) covered his much more playful and accessible broad colored surfaces with the swinging figures and lines of an imaginary world [219].

Classical tendencies—1920 to 1945

Starting in about 1920, 20th century painting entered a transitional phase, with a noticable turning back to a realism whose roots lay in ancient classic or Renaissance models. This neoclassical tendency can be found even in the mechanical figures of Schlemmer or Léger, as well as in Matisse, de Chirico and—under the auspices of Stalin—in the late work of Malevich. One explanation for the phenomenon may lie in a certain withdrawal from the hectic urban world of mass unemployment, inflation, and increasing Fascist terror in Germany, Italy, and Spain. The return to a safe formal world drawn fom the history of art, granted a breathing space in the race of the "isms" and arguments of the time.

[221]
Pablo Picasso, *The Lovers* (detail), 1923, oil on canvas, 51.2 x 38.2 in., National Gallery of Art, Washington, D.C.

Picasso, however, must be named here as the great exemplar of twentith-century art. In *The Lovers* [221], he created a work in the style of antique Mediterranean statuary, and a serene but firmly anchored compositional pattern characterizes the line-oriented painting. A similar consciousness of tradition is evident in his printed graphics, which conjure up Arcadian dreams. And yet, Picasso also continued to paint in the Cubist tradition. The rich excitement of his oeuvre derives from his mastery of various modes of artistic expression, which he applied according to theme, independent of the time or style.

Art under Fascism and Stalinism 1933 to 1945

As soon as Hitler seized power in 1933, all Jewish artists, as well as any not conforming to the banal realism of official Nazi art policy were placed under tremendous pressure. Harsh reactionary criticism had been the fate of all avant-garde artists already

[222]
Emil Nolde, *Hohe Sturzwelle*, ca. 1930, watercolor on rice paper, 13.2 x 17.9 in., Nolde-Stiftung, Seebüll.

in the 19th century. In 1892–1893, in a book entitled *Entartung* ("degeneration"), Max Nordau had polemically attacked both Symbolism and Realism as decadent. The Nazis perfidiously exploited the difficulties that the general public had been having in understanding art developments since 1900, and even before they officially came to power, 70 abstract and Expressionistic paintings were removed from the Weimar Schlossmuseum, and museum directors were forced to resign. After coming to power, the Nazis systematically continued their program, particularly against abstract—supposedly "Bolshevist" or "Jewish"—art, and artists of the New Objectivity and Expressionist movements, who had directed their attention to the conditions ensuing from the First World War.

In 1937, Hitler staged a dual exhibit—one in a shabby warehouse, where 130 works of modern, or "degenerate," art were displayed in polemical and consciously poor groupings and defamed with mocking commentary. The second, called "Great German Art Exhibition" in the newly built House of Art, the official art was displayed—portraits of the Führer and demagogical pictures of Arian heroes, intended to create a warlike spirit. Shortly thereafter, more than 15,000 works of modern art were seized. Some were destroyed, some found their way into Hermann Göring's private collection, and some were sold at a profit in foreign countries to raise war funds. In the Soviet Union, Stalin carried out a similar program. The transition to officially ordained Social

Realism—which paradoxically drew from the Realism of the czarist 19th century—took place in the early 1930's under cover of a "progressive" application of art in the spirit of the October (Bolshevik) Revolution. Only in 1934 did a true purge take place, as in Germany, with destruction of art works and professional disenfranchisement. In Italy, Futurism managed more or less to survive through compromises with Facism, such as the official rededication of content, and the revision of overly abstract tendencies. Artists who remained in Germany, such as Emil Nolde [222] who was under professional ban, tried various means of response to the difficult conditions. The terrible fate of the Jewish artists who did not emigrate is well known: most were killed in Auschwitz, after passing through the perverse intermediate station of the "model" concentration camp at Theresienstadt, which was mainly reserved for intellectuals.

The exodus of artists from Germany and the occupied areas led first to Paris and the Côte d'Azur, the Netherlands, and England, and later in the course of the war, to the United States. The results of the migration had far-reaching effects on the develop-ment of painting. Josef Albers, Piet Mondrian, Max Ernst, the Bauhaus architects Walter Gropius and Mies van der Rohe all carried their European experiences and traditions to America, helping to make New York the successor to Paris as the capital of Western art after 1945.

Picasso's *Guernica*

With *Guernica* [223], Picasso succeeded in creating a work that impressively and movingly brings the catastrophes of the 20th century to art. The work was actually commissioned by the Spanish Republi-can government—in-exile for its pavillion at the Paris World Fair of 1937, and depicts the horror of the first large bombing attack on civilians carried out by the German Condor legion for Franco,

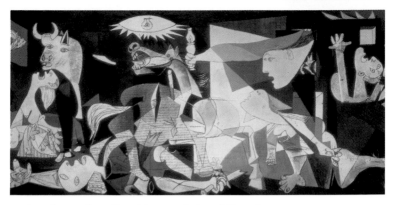

against the northern Spanish coastal city of Guernica on April 26, 1937. Out of hatred for the dictatorial Franco regime, Picasso had already finished eighteen pictures on two etchings for a poem, "Franco's Dream and Lie"—motifs he used again for his great wall painting. The effect of the gigantic painting in Paris must have been unnerving, especially in the vicinity of the scornfully inhuman monumentality of the German pavillion.

In *Guernica*, Picasso on the one hand summarized his own artistic creativity from the beginnings of his Blue Period, through Cubism, to the Classicism of the 1920's. On the other hand, the artist borrowed from the tradition of the 19th century historical picture (Goya, Delacroix), and connected these with the Cubist vocabulary of the Classical Modern style. Picasso accomplished all this with great discipline in a modern pictorial language, which in the fragmented, formally thought-out structure of the picture, oppressively conveys the chaos in the city during the attack. This key work of the Modern stands, in its developed humanistic presence, against the cruelty of the century, the terror of bombings, and genocide, while at the same time, it completely refutes the lies that accuse modern painting of being merely formalistic play.

[223]
Pablo Picasso, *Guernica*, 1937, oil on canvas, 11.5 x 25.6 ft., Centro de Arte Reina Sofía, Madrid, Spain. The shattered pictorial space does not conceal its origin in the box-like room of Renaissance Florentine art. The basic division of the composition into three parts by means of a shallow pyramid made up of figures that form the center of the picture, is also to be found in the central panel of Uccello's well-known *Battle of San Romano*: the elongated prone figures are recognizable in Piero della Francesca.

Art Since 1945

German painting—A new beginning?

The end of the Second World War brought Europe liberation from German National Socialism (Nazism), but the trauma of the Holocaust weighed heavily on the new world. The unspeakable—the largest attempt in human history to eradicate an entire people—had become reality. Psychological shock, the repression of feeling, and silence, were inseparable companions to the activity of reconstruction. At the same time, the cost of the reconstruction of a new world from the ashes of the old was high: Cold War, whose front line ran through the center of Germany until 1989–1990.

In the first years after 1945, artists responded to the cruelty of the Nazi period only on an indiviual basis. Karl Hofer (1878–1955), for example, attempted to recall and capture the horror of the period by means of an expressive realism [224]. Richard Oelze (1900–1980) carried on in his surrealistic style of the prewar years. His depiction of the isolated human being in a dark landscape signified both repression and loneliness.

But the figurative expression of what had been experienced in those years remained the exception in painting, and the famous dictum of the philosopher Theodor Adorno, that poetry was no longer possible after Auschwitz was all too eagerly adopted by the artists—including painters—of the late 1940's and 1950's. In West German universities, the creation of art was explained by a version of art history that in many ways, and without critical question, continued the Nazi tradition of opposition to the Modernism of the 20th century. Even when the Nazi "blood and soil" vocabulary had disappeared, the survival of the tradition had seriously damaging effects on art. It was no accident that the most widely read art history book emerging from Germany after the war was Hans Sedlmayr's reactionary and pessimistic

evaluation of modern art, *Der Verlust der Mitte* ("The Loss of the Center").

Expressionist or abstract artists who had been outlawed by the Nazis, like Emil Nolde and Willi Baumeister (1889–1955), picked up after the war where they had left off. After years of artistic isolation, abstract painting—now established throughout the rest of the world—hit postwar German artists with a culture shock. After his pre-war Expressionist painting, Ernst Wilhelm Nay (1902–1968) accepted the abstract creative framework of the new generation, and found his way to shallow-surfaced abstract paintings, whose design lay in the rhythm of color. A signicant role in conveying cultural memory that had been screened out or extinguished by the Nazis was played by the French-German painter Wols (real name Alfred Otto Wolfgang Schulze, 1913–1951). After training at the Bauhaus, he worked in Paris after 1932, and spent the war in internment camps. After 1945, Wols developed an abstract style consisting of expressively knotted lines in front of a colored background [225]. The artist enriched his abstract approach with both surrealistic elements and the individual movements and postures of his figures. This sense of motion, or "tache," in his pictures gave rise to the term *Tachism*, which is often used synonymously with the word *Informel* to describe this style of painting. Building on Wols, Emil Schumacher (b. 1912) developed his spacious, graffitti-covered canvases.

1964
Nikita Khrushchev forced to resign; Civil Rights legislation in U.S.
1964–1975
Vietnam War
1968
Student unrest in France and Germany; end of Prague Spring; assassination of Martin Luther King
1969
Moon landing
1972
Watergate Affair
1975
Death of Franco—Spain becomes a democracy
1976
Death of Mao Tse-tung
1985
Gorbachev secretary-general of U.S.S.R.
1986
Nuclear catastrophe at Chernobyl
1989
Fall of Berlin Wall; China crushes protests in Tiananmen Square
1992
Maastricht Treaty
1992–1996
Bosnian War

[224]
Karl Hofer, *The Blind*, 1948, oil on canvas, 35.4 x 32.3 in., Nationalgalerie, Berlin.

[225]
Wols, *Composition*, 1947, oil on canvas, 31.9 x 25.6 in., Kunsthalle, Hamburg.

189

[226]
Henri Matisse, *Blue Nude I*, 1952, cut paper on canvas, 41.7 x 30.7 in., Fondation Beyeler, Basel.

In the Soviet area to the east, later the German Democratic Republic, Stalin's official "Socialist Realism," which he had imposed on the Soviet Union in 1934, was now imported, and rigorously applied in Germany. A group of young painters carried out the official cultural policy: Art was to serve the construction of the socialist state, and abstract or surrealistic painting was classified as "formalistic," and was repressed. Returning emigrants like John Heartfeld were unable to reestablish their connections with their earlier art.

French and Spanish painting

The experience of the Second World War had an amazingly small effect on the work of the great 20th century French painters. Before 1939, in his masterpiece *Guernica* and several related works, Pablo Picasso had already movingly portrayed the horrors of the Spanish Civil War, and after the Second World War ended, he painted *War* and *Peace* (1952). But afterwards, he turned his attention again to typical themes of the prewar period: The relation of the artist to the model, or mythological subjects. Until his death in 1973, Picasso never limited himself to a single style, but moved constantly between Cubist and figurative inventions, the brush strokes of his late work becoming ever freer and more generous.

Matisse, on the other hand, limited his expressive forms and lines, and his works increasingly depended on figures formed of sweeping curved lines [226]. Like Fernand Léger (1881–1955), whose clear and assured balance, and calm designs united his early Cubist works with surrealistic effects, or like Marc Chagall (1887–1985), Matisse in this phase of his

work drew drafts for stained glass windows, an art form that corresponded to his preference for line and luminous color.

Surrealism also underwent further development after the war, but with the death of its most important theoretician, André Breton, it fell into a crisis that was made even more acute by the challenge of the literary Existentialism of Jean-Paul Sartre and Albert Camus. The old surrealist masters Max Ernst, Joan Miró, and Salvador Dali once more returned to their themes of the 1930's. Like Matisse, Miró revealed a penchant for large compositions, worked out over broad surfaces.

In a parallel development, there appeared the *Informel* movement, an outgrowth of Wols's work, and underpinned by the art history theoretician Michel Tapié. *Informel* painting was a "tachistic" abstract art of movement and gesture, a kind of European variant of contemporary American Expressionism.

The heavy black and brown beams of Pierre Soulages (b. 1919) are reminiscent of Japanese calligraphy [227]. In a variation of the "drip paintings" of American "Action painter" Jackson Pollock (see p. 193), Georges Mathieu (b. 1921) pressed his paint directly from the tube onto the canvas.

The *Art Brut* of Jean Dubuffet (1901–1985) took impulse from Hans Prinzhorn's book *The Creative Energy of the Mentally Ill* published in 1922. Using sand, plaster, and other unusual materials as a painting ground, the artist scratched or plastered his seemingly naive figures onto the surface. In reality, his figures were intellectually developed, in spite of their charming, ironic childishness.

The Catalan artist Antoni Tàpies (b. 1923) created an impressively various oeuvre from elements of

[227]
Pierre Soulages, *3. April 1954*, 1954, oil on canvas, 76.8 x 51.2 in., Albright-Knox Gallery, Buffalo, New York.

Informel and *Art Brut*. In a complex process, the artist applied layers of earth colors on a ground of sand or cement, and then scraped them away, resanded the surface, and applied the colors again. The result was a poetic style of painting, full of depth and encoded meanings. His painting works as an invitation to meditation, but many of his pieces must also be seen as criticism of Franco's dictatorship.

Painting in the United States—Abstract Expressionism and Action Painting

After the Second World War, the center of innovative painting moved in one fell swoop from Paris to the United States. The collective terms "Abstract Expressionism" and the "New York School" refer to such artists as Jackson Pollock (1912–1956), Barnett Newman (1905–1970), Mark Rothko (1903–1970), Willem de Kooning (1904–1997), and Clyfford Still (1904–1980). Their way had been prepared by European emigrants such as Josef Albers (1888–1976), whose series *Hommage to the Square*, begun in 1949, had an important influence on developments in America, as did his widely translated 1963 book *Interaction of Color*, derived from his lectures at Yale. A closer look at Abstract Expressionism makes it clear that its practitioners were hardly a homogenous group. Rather, the opposite is true: Pollock's style of Action Painting is a world apart from Newman's or Rothko's fields of color. But the desire to overwhelm the senses of the viewer was a goal that united all these artists. To this end, the artists, as well as the increasingly important art critics and gallery directors, struggled to provide a variety of theoretical models for understanding the new art—such as psychoanalysis in the case of Pollock, or religious references in the case of Newman.

The painters succeeded in re-establishing abstract painting as something more than a merely formal experiment; rather, their paintings offered comprehensible patterns or models that were meant to be sen-

sorily grasped by the viewer in the process of looking at the picture. Furthermore, such paintings make room for individual ways of "seeing." This explains the immense popularity of these complex works, which have become the true "classics" of the post-war era. Not until the appearance of Andy Warhol's Pop Art were new icons of the everyday world set up as an alternative to the abstraction of the New York School.

[228]
Jackson Pollock, *Number 32*, 1950, varnish paint on canvas, 8.8 x 15 ft., Kunstsammlung Nordrhein-Westfalen, Düsseldorf. The emotionality of the large canvas carries over to the viewer, who at the same time can follow the artistic process itself. To the viewer, the painting appears to be a part of a continuous circling movement around the form which repeatedly gathers itself in points of concentrated color and then relaxes again.

Pollock and de Kooning

Before the war, Pollock had developed a surrealistic style under the influence of the Mexican painters José Clemente Orozco (1883–1949) and David Alvaro Siqueiros (1896–1974). Pollock expressively enriched his paintings with his own psychoanalytial experiences. The power of the subconscious as it took form in the automatism of his "drip paintings" [228] brought Pollock fame in 1947. The artist spayed and squirted various materials, such as varnish based paints and oils, onto gigantic horizontal canvases: the brush, that traditional handtool of the painter, was thus eliminated. The often extreme rectangularity of his pictures helps reading the "handwriting" which usually flows from left to right, top to bottom.

The "gestural" painting of Willem de Kooning resembles Pollock's "action painting" in many ways, but always makes reference to real objects. In addition, human figures play a large role in de Kooning, and often convey the artist's emotional messages and sensibilities.

[229]
Barnett Newman, *Vir heroicus sublimis*, 1950–1951, oil on canvas, 7.9 x 17.7 ft., private collection. Newman demands that the viewers stand close to his gigantic canvasses. Only so can his paintings produce the desired overpowering effect that casts the viewer into a "sea of color" in which they must seek reorientation. The pictures set emotions free, while the colored fields become meditation sites.

[230]
Barnett Newman, *Visitors in front of "Vir heroicus sublimis"*, 1950–1951, photograph.

Newman and Rothko

During the war, Barnett Newman began painting apocalyptic visions which owed much to Surrealism, but in 1948, the artist altered his style radically. From this point onward, he coated large canvas surfaces with monochrome layers of paint, to produce a vibratingly homogenous impression. He set his glowing surfaces into rhythmical motion by thin vertical bands of color he called "zips" [229].

Newman explained his art in terms of the immediate experience it provides the viewer; his painting refers to the "natural human longing for the sublime" and to "absolute emotions." In his 1948 essay *The Sublime is Now*, he claimed that "[t]he image we produce is the self-evident one of revelation, real and concrete, that can be understood by anyone who will look at it without the nostalgic glasses of history."

Newman's art, requiring the immersion of the viewer [230], is far removed from the perhaps more

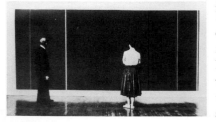

popularly successful work of de Kooning and Pollock, with its clearly formulated forms and movements. In 1956–1957, Newman underwent a crisis in which he produced no work; upon emerging, he devoted himself to the central themes of

Christian painting. Between 1958 and 1966, he worked on the *Stations of the Cross—Lema sabachthani* (National Gallery, Washington), consisting of fourteen variations of white pictures whose black vertical lines and nebulous negative images of his earlier "zips"dominate the structure of these canvases.

With the choice of a classical theme calling up traditional associations in the viewer, Newman thus turned away from the pure abstraction of his earlier paintings. His later pyramid-shaped canvases *Jericho* and *Chartres* in 1968/1969 are the continuation of this course. In these works, Newman drew from the Medieval and Renaissance image of an eye inside a triangle, which had symbolized the omnipresence of God. At the same time, the sculptured corporality of his *Shaped Canvases* is reminiscent of the upwardly striving form of the cathedral. The very shape of Newman's last paintings also gives them the character of objects, thus corresponding to a painting trend of the late 1960's seen in the shaped canvases of Frank Stella (b. 1936).

Like Newman and Pollock, Mark Rothko also had a prewar artistic career before radically breaking away from his figurative style in 1948. He then developed a style of painting based on fields of color, which, however, unlike Newman's, were not sharply delineated from one another by lines or strong color contrasts. Instead, on the surface of a vertically-oriented canvas, Rothko placed two or three hazily defined rectangles which seem to float in a field of color [231]. All components of the picture are subtly related to each other in color. Rothko claimed that his abstract pictures were direct expressions of emotional states: ecstasy, melancholy,

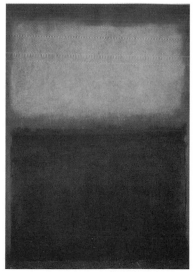

[231]
Mark Rothko, *Orange and Yellow*, oil on canvas, 7.6 x 5.9 ft., Albright-Knox Gallery, Buffalo, New York. Basically, rectangles of the painting have replaced the figures in Rothko's earlier work in order—as the painter himself claimed—to tear down every possible barrier between the painter and the idea, and the idea and the viewer. The intensity of color draws the viewer irresistibly into the painting. As with Newman's work, the process of approach and distancing from the painting conveys meditative impulses to the viewer.

and the terror and pity inspired by tragedy. He vehemently denied a purely aesthetic apprehension of his pictures, in spite of the temptation offered by the decorative quality of their color, and possessed concrete notions of how his pictures were to be displayed (no direct light, no exhibition, either as as single works or in combination, with works of other painters).

He began to paint in series, and received three commisions for cycles. In 1959, Rothko painted a series of works for the Four Seasons restaurant designed by Philip Johnson for Mies van der Rohe's Seagram Building in New York. Typically for him, the location soon seemed unsuited for his paintings, and he bequeathed nine canvases to the Tate Gallery in London. After completing a commission for Harvard University in 1962, Rothko designed an octagonal chapel commissioned by John and Dominique de Menil for St. Thomas University in Houston for whose walls he painted triptychs and single paintings in variations of a black-violet-brown harmony (1964–1967). Both in content and formal compactness, the ensemble is comparable to Newman's *Stations*, though the final arrangement was done after Rothko's death.

Clyfford Still also developed a color-field style of painting in the space between Pollock and Newman: Large, light-colored surfaces covered by darting, waving lines in various colors, a combination of forms which lends tension to his work.

Ad Reinhardt (1913–1967) followed the abstractionist road to its logical end. Proceeding from Malevich and Mondrian, Reinhard reduced color and form to such an extent that his *Black Paintings* achieve a kind of a black-on-black painting that consists only of the deepening of subtle gradations of color. The process of logical reduction and subliminal simplification had great influence on the Concrete Art of the 1960's.

Bacon

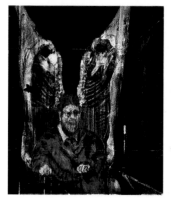

The autodidactic English artist Francis Bacon (1909–1992) came only late to painting. In his first official work, *Three Studies for Figures at the Base of a Crucifixion* (1944, Tate Gallery, London), Bacon already employed many of the elements, particularly the triptych form, that remained in his work into the 1980's. Before a monochromatic background, a scene develops nebulously—shapelessly flowing figures, or even painfully ripped masses of flesh and muscle, form themselves around a defined pictorial space against the contrasting background. Bacon did not varnish his pictures, but enclosed them behind a glass plate, thus keeping the viewer in distance, and set his canvases in heavy gold frames.

One may contend that Bacon brought the great tradition of the medieval and Renaissaince panel and altar-painting to a close, and took up once again the basic aesthetic problems in the history of painting: The opposition of surface and space, the placement of figures in the space, the creation of pictorial depth by means of perspective.

[232]
Francis Bacon, *Head Surrounded by Sides of Beef (Study After Velázquez)*, 1954, oil on canvas, 52 x 48 in., Art Institute, Chicago. Under the brush of the painter, the faces dissolve and run together. Even the reference to a classic work from the history of painting does not grant a sense of identity or security to the picture.

[233]
Francis Bacon, *In Memory of George Dyer*, 1971, oil on canvas, triptych panels, each 78 x 58 in., Fondation Beyeler, Basel.
In the left panel, Dyer appears as a formless and tortured mass of muscle; in the right, the painter creates a memorial portrait of his friend, whose features are already flowing tragically together.

The sovereignty of gesture and pose, combined with a technical mastery of the medium seemed to Bacon to be the only way to effectively fend off the alienation of the human being, and to reconstitute the lost personal identity. Bacon was unable to fulfill his own high goals. Already his early variations of Velásquez's *Portrait of Innocent X* were transformed into the cry of the encapsulated human creature [232]. In the *Triptych* painted after the suicide of his friend and companion George Dyer, Bacon attempted to reconstruct the moment before death in the middle panel, perhaps also to masochistically recall again in visual form his discovery of his friend's body. The personal and the universal unite in this event painting. In the gloomy convergence of form and pictorial statement, the triptych marks a highpoint of figurative painting since 1945 [233].

[234]
Jasper Johns, *Flag*, 1955, wax painting, oil and collage on canvas, 42.2 x 60.6 in. Museum of Modern Art, New York.

Johns and Rauschenberg

With his first *Flag* [234], Jasper Johns (b. 1930) struck a decisive note against Abstract Expressionism. For the first time in the history of painting, artwork and object are unified into a single entity. The crucial question of the art critic Alan R. Solomon, "Is it a Flag, or is it a Painting?" states exactly the new theoretical crisis. Criticism as a whole was caught unaware, in particular because Johns chose the icon of the flag, the holiest object of America's understanding of itself, as the theme of his painting. The German art historian Max Imdahl pursued the issue further by posing the double question, "Is it a flag, or is it a painted flag?" and "Is it a painted flag, or is it a picture?" The irritating uncertainties are clearly visible, and led to a linkage between Johns's revolutionary act of liberation and a theoretical discussion on the meaning of Modern-

ity itself. In fact, since the first "ready-made" of Marcel Duchamp in 1913, no painting had opened such provocative questions. Where Duchamp for his part had declared an object of daily life such as a *Bicycle Wheel* or *Bottle-Rack* to be works of art, Johns took the priciple a step further, for he did not set an actual cloth flag in a frame, but rather painted it in three parts that he then, in an act of artistic creation, set together as a flag. In any case, photographs produce a false image of the work, whose unusual wax-painting technique on snips of newspaper reminds the viewer of the artificial and artistic character of the work, and thus perhaps diminishes the iconographic affront.

Equally radical is the rejection of American tradition found in the early work of Robert Rauschenberg (b. 1925), who is perhaps the most many-sided figure on the American art scene since the war. Staged as a "happening," his erasure of a drawing by Willem de Kooning was a startling gesture. A reflex of this destruction of a work of art is visible also in the overpainting, or painting over an existing painting, of the Austrian artist Arnulf Rainer (b. 1929).

Where Rauschenberg's *Black and White Paintings* still more or less conformed to tendencies in painting since 1955, his "combines"—three-dimensional assemblages of everyday objects—broke new ground in the history of painting. Against the mystique of abstract art, Rauschenberg held up his own commentary on everyday American life and politics, thus breaking through ingrained habits of seeing [235].

According to Rauschenberg, painting refers both to art and life, and the artist's job is to close the gap. Thus, in his written directions—a kind of user's manual—to his *Black Market* (1961), he demands that the viewer open the suitcase, remove the contents, and replace them with new ones. The

[235]
Robert Rauschenberg, *Retroactive II*, 1964, oil and ink screen print on canvas, 82.7 x 59 in., Stefan T. Edlis Collection, Chicago.

new objects must, however, be provided with an "Original Rauschenberg Stamp" and carefully documented in a book before replacement. In this way the artist oversteps all bounds that had earlier separated the viewer from his creative work. The artist becomes a "designer of experience" (Oscar Bätschmann). With this participatory art, Rauschenberg is criticizing Barnett Newman's attempt to eliminate the distance between the viewer and the work by means of the spiritually overpowering character of the work.

Positions in the 1960's—
Klein, Fontana, Kawara, Twombly

Abstract Expressionism exerted a repressive effect on artists both in Europe and America. The inspiration and incentive it provided are clear, but resistence to the trend increased, culminating in exemplary attempts to redefine the meaning of painting. In this process, the significance of galleries played a large role. A gallery owner like the New Yorker Leo Castelli cultivated not only the revolutionary reversal in painting history initiated by Jasper Johns, but also gave the eccentric and extroverted Frenchman Yves Klein (1928–1962) a chance to exhibit and conduct "performances" in New York. Even when the self-assuredness of the European Klein became offensive, and the influence of American artists like Rauschenberg and Rein-

[236]
Yves Klein, *Anthropometry Performance*, Paris, March 3, 1960, photograph.
Musicians provide accompaniment to the performance of two women with blue-painted bodies who roll themselves across a paper-covered floor to create the picture.

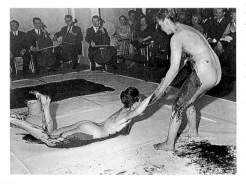

hardt on Klein's work was eagerly pointed out, Klein's monochrome blue pictures nonetheless aroused attention. As a matter of fact, Klein's "invention" *IKB* (or "International Klein Blue"), is theoretically sound, rooted in the artist's reference to the cosmic

universality of the color in nature. His huge *Sponge Pictures* (1958–1959, Foyer of the Opera House, Gelsenkirchen, Germany) pass beyond the boundary from picture to object.

On the other hand, Klein is also representative of the art of the 1960's in his blurring of the border between sculpture and painting. He was also a pioneer in making Action Art into an integral component of his whole artistic oeuvre [236]. Klein's anthropometry performances of 1960 were of great importance to the Fluxus movement, as well as to the work of Joseph Beuys (1921–1986), who made his first appearance with "happenings" in 1962, and also for the Performance Art of the British pair Gilbert & George (*The Singing Sculpture*, 1970, London).

The role of painting as the flagship of the avant-garde—a role that the Classical Modern of the beginning of the 20th century was also able to claim for itself—was more and more lost in the 1960's. Other forms of expression increasingly replaced the traditional painting. This process is exemplarily demonstrated in the development of the Italian Pietro Manzoni (1933–1963). Manzoni's *Achromes* of 1957, white canvases on which various materials or seams had been applied or worked, constituted a rejection of the common understanding of painting as a conveyor of meaning. The artist abandoned painting as a medium entirely in 1960, and turned to the creation of objects whose radical statement and means passed far beyond Duchamp's "ready-mades," shocking as Duchamp's urinal (*Fountain*, 1917) had been. Manzoni declared not only his bodily excretions, his blood and excrement to be works of art, but in 1961 created with his *Socle for*

[237]
Lucio Fontana, *Spatial Concept*, ca. 1962, oil on canvas, 50.8 x 36.6 in., Lucio Fontana Foundation, Milan, Italy. The object of artistically intended destruction still remains as such in existence, but the viewer is now forced into a consciousness of the surface of the painting that up to this point had been a sacred whole.

the World (Herning, Denmark) a conceptual piece which makes everyone who ascends the pedestal into a living work of art.

The Italian Lucio Fontana (1899–1968) integrated painting into his concept of a new comprehensive use of space. He presented his theory of *Spazialismo* in a series of manifestos from 1947 to 1952 which sought the integration of sculpture and painting. Starting in 1949, Fontana pierced the surfaces of his canvas paintings with bullet holes and, after the mid 1950's, with his famous slits, to represent the death of traditional painting. His procedures spurred reflection on the function of a painting in society.

The Japanese artist On Kawara (b. 1933) emerged in 1953–1954 with a series of *Bathroom* drawings in which the isolation of the modern individual is made drastically clear: Amputated figures and pock-marked shapes move about in claustrophobically narrow, tiled rooms. The wounded human being hovers in time and space. Kawara thus processed the traumatic experience of the atom bomb attacks on Hiroshima and Nagasaki in 1945, as well as the Korean War. In order to acertain his own existence, the artist began a long series of *Date Pictures* in 1965. Against a dark background, Kawara painted the given date of a day with painful exactness. In their concept, Kawara's *Date Pictures* stand completely alone in the 1960's, and enrich the classical oil painting with their perspective on temporality, and thus on the mortality of human existence.

Later, the series of installations by the German artist Hanne Darboven (b. 1941) also attempted this important theme of conceptual art in her three-tone modulations, postcards,

[238]
On Kawara, *View into the Studio, with Date Painting of the Same Day*, 1966, photograph. Viewers of Kawara's pictures feel not only the need to think about the given date, but also to see themselves as a part of a time-space continuum from which the paintings have grasped and eternalized a certain moment.

and rows of numbers, and scribbled words. In the work of the American Cy Twombly (b. 1928), still-fresh memories of Abstract Expressionism vie with the influences of early Pop Art.

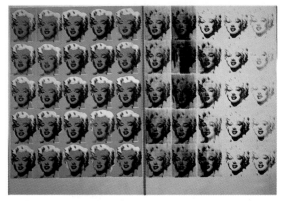

[239]
Andy Warhol, *Marilyn Diptych*, 1962, screen print and acrylic on canvas, each panel 80.3 x 57 in., Tate Gallery, London. On the left panel, Warhol presents a colorful and beaming Marilyn, but to the right, her gray image increasingly dissolves, becomes unclear, and finally disappears. The technique of screen printing conveys the impression of reproduction at will.

Against light backgrounds, he spread his code-like abbreviations and quotations. Twombly's emigration to Italy in 1957 brought him nearer as a painter to the world of European literature and antique mythology. He succeeded in an intellectual balancing act between cultural citations and broad-surfaced pictorial spaces. His development of a graffiti-like pictorial language paved the way for the public success of Keith Haring (1958–1990).

Pop Art—Warhol and Lichtenstein

The first great Duchamp retrospective in Los Angeles in 1963 proved a milestone in the development of Pop Art. It is impossible to rate the effect of the reconstructed "ready-mades" too highly, but it is nonetheless important to note that they neither created nor justified Pop Art, but rather only confirmed it. Jasper Johns with his flag, and Rauschenberg with his "combines" had already taken the important first steps in this direction. Coincidentally, Andy Warhol (1928–1987) also was exhibiting his first paintings of *Campbell's Soup Cans* from 1962 for the first time in Los Angeles in 1963. These events broke the ice for a new generation of artists to elevate everyday artifacts into art.

Early Warhol art is political. He reacted to the protests against the death sentence, which reached a high point after the execution of Caryl Chessman in

[240]
Roy Lichtenstein, *M-Maybe (A Girl's Picture)*, 1965, oil and magna on canvas, 59 x 59 in., Museum Ludwig, Cologne.
Lichtenstein selects individual scenes, enlarges them on a grid, and adapts them to canvas. Such an oversized enlargement of triviality makes the banality of everyday life concretely visible.

1960, with his *Electric Chair* in 1963; he commented darkly on the racial unrest of the same year. Marilyn Monroe's suicide in 1962 spurred him to recreate her icon-like image. This replication, however, combined a completely earnest intention to illustrate the tragedy of the star cult with Warhol's own infatuation with celebrity. In looking at the early *Marilyn Diptych* [239], one must remember that Warhol was not yet the successful "business artist" of the 1970's who earned his money with series of vanity portraits. Warhol's openly-lived homosexuality, as well as his celebration of drug addicts and transvestites, made him at that time into an unsellable *enfant terrible* on the art market. Success came only with the harmless but market-pleasing *Flowers* of 1964, and, most importantly, with his acceptance by the star-making gallery owner Leo Castelli.

However, even with success, Warhol remained unconventional, announcing in 1965 that he wanted in the future only to make films. He exploited his earlier painting inventions, especially the Marilyn portrait. In his factory he arranged concerts for the pop group Velvet Underground, which operated under his auspices and combined light and film presentations into a kind of total work of Pop Art. After surviving an assassination attempt in 1968, Warhol withdrew from his earlier surroundings, and in the 1970's returned to his experimental beginnings. In his *Oxidation Paintings* he aimed at abstract effects by urinating on a copper-colored surface, and in his final and traditionally painted work, *Last Supper* (1986), Warhol took up the great theme of Leonardo's fresco, but covered portions of the canvas

with oversize commercial logos of American firms. The shock of early Pop was unquestionably still alive. Roy Lichtenstein (1923–1997) reinvented the world of the comic strip for art [240]. In a similar fashion, Claes Oldenburg (b. 1929) was enlarging artifacts of everyday life, and creating an alienating effect by changing hard materials to soft, and soft to hard. Thus, in both celebrating and commenting on everyday life, Pop Art found its place in materialist culture. Art itself had become a trivial component of life, the decor of a jaded middle class struggling to be hip. Increasingly, it became merely another commodity to be traded or held as an investment in the booming art market.

[241]
David Hockney, *A Bigger Splash*, 1967, acrylic on canvas, 8 x 8 ft., Tate Gallery, London. This icon of British Pop Art reflects the California world of swimming pools, naked bodies, palms, and cool drinks, yet the human presence is only indicated by the splashing water.

European Pop—Hockney, Richter, Polke, Vostell

Of the European artists, the British David Hockney (b. 1937) is the most "American." He, too, makes no secret of his homosexuality, and his early pictures are full of direct references to it. He achieved an artistic breakthrough during his time in California with his *A Bigger Splash* [241], though his later works are more conventional in their figurativeness. Hockney produces precise portraits, often as double portraits, and has expanded his field of creativity to stage designs and photo collages.

On the continent, the political Pop Art of the early Warhol aided the parallel efforts of German artists to a critical view of the objects of consumer culture. Gerhard Richter (b. 1932) turned to newspaper clippings and photographs which he gathered from photo reports, in his early paintings. He enlarged and painted these materials, in the process hazing

Werner Heyde im November 1959, wie er sich den Behörden stellte.

[242]
Gerhard Richter, *Werner Heyde*, 1965, oil on canvas, 21.6 x 25.6 in., private collection.

[243]
Sigmar Polke, *Higher Beings Commanded: Paint the Right Corner Black!*, 1969, varnish paint on canvas, 59 x 47.2 in., Sammlung Fröhlich, Stuttgart, Germany.

Höhere Wesen befahlen: rechte obere Ecke schwarz malen!

over their contours. Revealing the apparent objectivity of the photographs, he delved into the mechanism of post-war German repression, as in the picture of the arrest of the Nazi doctor *Werner Heyde* [242]. His political interest culminated in 1988 in his series *18. Oktober 1977,* in which he commented pictorially on the deaths of the incarcerated Red Army Faction terrorists in a German high-security prison. Richter continuously searches after new forms for pictures and techniques. After his almost abstract cloud pictures, which emanate a suggestion of Vermeer, Richter turned to abstract colored paintings after 1976. All of his work shares in common a consciousness of the tradition of painting.

Sigmar Polke (b. 1942) is also an artist who offers surprises with new pictorial forms, vehicles (tablecloths, bedsheets), and painting techniques (resin, varnish with acrylic). With his "grid pictures," he ironizes both American Pop Art and the capitalist consumer society of his native Germany. With lightness and technical brilliance, he comments on his environment, its myths and trivialities. In his picture *Higher Beings Commanded: Paint the Right Corner Black!* [243] he mocked the idealistic intellectual/spiritual attitude of Abstract Expressionism, as well as Conceptural Art.

The collages, assemblages, and paintings of Wolf Vostell (b. 1932) are even sharper in tone. He criticized not only the consumerism of West Germany, but also the political situation in America, particularly during the Vietnam War. In contrast to Polke or Richter, he turned increasingly to "happenings" designed to provoke or alienate, as well as to inspire new ways of seeing, hurling lightbulbs at his audience or

filling an automobile with cement—action art with a vengeance.

Painting after Pop Art: A perspective

The accomplishment of the Pop artists was to reconcile everyday culture with the artistic avant-garde. Their aesthetic influence on today's consumer society can hardly be overexaggerated. While they discerned the triviality of daily life, they were themselves accepted as trivial—and became popular in return. The acceptance of Pop Art was doubtless accelerated because of the seemingly comprehensible "simplicity" of their figurative forms, and because the works themselves have the character of objects, that is, goods in a consumer society, and even take on the character of cult objects.

Precisely because Pop plays with the most varied stimuli and references from the real world, Pop Art was bound to respond to the rise of Postmodernism, which made its appearance in all areas of culture starting in the mid-1970's. Postmodernist theory, to define it briefly, assumes that the social, historical, and philosophical framework which had led by various routes to the development of abstract Classical Modern art around 1910, has ceased to exist. Therefore, with reverse reasoning, figurative works full of references borrowed from the history of painting before 1900 are now appropriate, and have in fact become fashionable, as seen in the work of the Italian painting group "Transavanguardia."

But Pop Art is not the only alternative. The painting of Georg Baselitz (b. 1938) places the expressiveness of the picture in the foreground, and prefers an impulsively presented, gestural figurativeness [244]. His point of departure is German Expressionism, especially the *Brücke* (see

[244]
Georg Baselitz, *Red-room (Elke and Georg)*, 1975, oil on canvas, 11.5 x 8.2 ft., Museum Ludwig, Cologne, Germany.
Baselitz painted upside-down figures to emphasize the forms.

p. 168). This new style of expression, influenced the "Junge Wilde," recent young German Neo-expresssionists.

In his large-format paintings, Anselm Kiefer (b. 1945) takes up the themes of Nazi domination and its roots, and transposes the old Germanic myths, as well as classic German landscape, into the present with both critical distance and commentary. Kiefer combines his oil paints with sand, charred wood, and other materials, to make the earthbound weight of the myths physically tangible. To some extent, his work is related to that of Cy Twombly and Joseph Beuys, particularly in the use of writing or letters, which appear on many of Kiefer's canvases.

Another trend of art since the 1950's is a concentration on new solutions for resolving or employing the classic opposites of light, space, and color (found, for example, in the German group Zero). In the 1970's, such reflections, mixed with a good portion of Pop, were picked up in the "Optical Art" of Victor Vasarély (1908–1996). Like Pop Art, Op Art's bright color modulations, distorted colored circles, and color scales have worked their way back into the products of consumer culture.

There is an enormous variety of activity in contemporary art. Noticeable on the one hand is a backward reference to the art of the entire century, particularly to the 1960's, along with the "revivals" of older styles in general. In the work of many artists, the boundaries between painting, sculpture, and video have disappeared. Increasingly, women, Native American, and third world artists are enriching the established art scenes of western metropolises with their new ways of seeing, and defining their own criteria for art. At the same time art

"I never read, I just look at pictures."
Andy Warhol

history is keeping step with these developments, publishing a great number of exhibition catalogues of contemporary art. Since the beginning of the 1990's, computerized reproduction techniques, such as scanning and color copying, make possible an emotionally distanced approach to both figurative and abstract art [245]. Graphic programs allow the precise alteration of digitalized pictorial data, and, combined with the new communication technologies, foster the transfer of old as well as contemporary art into every corner of the earth. What effect the global network of the Internet will have on either conventional or electronic art is impossible to determine as yet.

In spite of all the fears that the new audio-visual age means the end of traditional painting and the end of art history, the tasks of painting outlined in the introduction to this book will still hold true in the future as they have in the past. Even if the works of Malevich, Newman, and Reinhard apparently formulated the end-point of Abstraction, an artist like Robert Ryman (b. 1930), shows how apparently simple alterations of pictorial vehicle, materials, and application of color, provide impressive answers to the basic questions of painting. Artists will always respond to the challenge of filling a two-dimensional surface with color and forms, whether abstract or figurative, and will continue to encourage and provoke their audience to find new ways of seeing.

[245]
Jack Pierson, *Leopoldo One Morning in Capri*, 1996, acrylic and lacquer on canvas, 6 x 6 ft., private collection, Cologne, Germany.
The basis of the picture is a scanned photograph that was electronically altered and printed with an ink-jet printer onto canvas. The attempt of Pop Art to distance itself from trivial objects increases in this picture, until the "pin-up" disappears in the artistic process of double alienation from both body and landscape.

Selected Bibliography

Selected Bibliography

Alexander, Jonathan J.C. *Medieval Illuminators and Their Methods of Work.* New Haven, CT: Yale University Press, 1992.

Alpers, Svetlana. *The Art of Describing: Dutch Art in the 17th Century.* Chicago, IL: University of Chicago Press, 1983.

Arnheim, Rudolph. *Art and Visual Perception.* Berkeley, CA: University of California Press, 1974.

Baldini, Umberto. *Primavera: The Restoration of Botticelli's Masterpiece.* New York: Harry N. Abrams, Inc., 1986.

Beckett, Sr. Wendy. *The Story of Painting.* London: Dorling Kindersley, 1994.

Burckhardt, Jakob. *The Civilization of the Renaissance in Italy.* New York: Harper Torchbooks, 1958.

Camille, Michael. *Gothic Art: Glorious Visions.* New York: Harry N. Abrams, Inc., 1996.

Chipp, Herschel B. *Picasso's Guernica: History, Transformations, Meaning.* Berkeley, CA: University of California Press, 1988.

Duby, Georges. *The Age of the Cathedral: Art and Society 980–1420.* Chicago, IL: University of Chicago Press, 1981.

Eitner, Lorenz. *Géricault's Raft of the Medusa.* New York: Phaidon, 1972.

Ferrier, Jean-Louis (ed.). *Art of Our Century.* New York: Prentice Hall, 1989.

Fried, Michael. *Manet's Modernism.* Chicago, IL: University of Chicago Press, 1996.

Garrard, Mary D. *Artemisia Gentileschi.* Princeton, NJ: Princeton University Press, 1989.

Gombrich, Ernst H. *The Story of Art.* 16th ed. London: Phaidon, 1995.

Hale, Nancy. *Mary Cassatt.* Garden City, NY: Doubleday & Co., 1975.

Haskell, Francis. *History and Its Images.* New Haven, CT: Yale University Press, 1993.

Hauser, Arnold. *The Social History of Art.* New York, NY: Vintage Books, 1985.

Heller, Nancy G. *Women Artists: An Illustrated History.* 3rd ed. New York, NY: Abbeville, 1997.

Higonnet, Anne. *Berthe Morisot.* New York, NY: Harper & Row, 1990.

Holley, Michael Ann. *Panofsky and the Foundations of Art History.* Ithaca, NY: Cornell University Press, 1984.

Hollingsworth, Mary. *Patronage in Renaissance Italy From 1400 to the Early 16th Century.* Baltimore, MD: Johns Hopkins University Press, 1994.

Honour, Hugh. *Neo-Classicism.* New York: Penguin Books, 1979. *Romanticism.* New York: Harper & Row, 1979.

Honour, Hugh and **Fleming,** John. *The Venetian Hours: Henry James, Whistler, and Sargent.* Boston, MA: Little, Brown, 1991.

Hughes, Robert. *American Visions.* New York: Alfred A. Knopf, 1997. *The Shock of the New.* New York: Alfred A. Knopf, 1981.

Huizinga, Johan. *The Waning of the Middle Ages.* New York: St. Martin's Press, 1967.

Kandinsky, Wassily and **Marc,** Franz (eds.). *The Blaue Reiter Almanac.* New edition. New York, NY: Da Capo Press, 1976.

McCabe, Cynthis Jaffee. *The Golden Door: Artist-Immigrants of 1876–1976.* Washington, D.C.: Smithsonian Institution Press, 1976.

Metropolitan Museum of Art. *American Paradise: The World of the Hudson River School.* New York, NY: Metropolitan Museum of Art, 1987.

Panofsky, Erwin. *Albrecht Dürer.* Princeton, NJ: Princeton University Press, 1945. *Meaning in the Visual Arts.* Chicago, IL: University of Chicago Press, 1982. *Renaissance and Renascences in Western Art.* Stockholm: Almqvist and Wiksell, 1960.

Parris, Leslie (ed.). *The Pre-Raphaelites.* London: Tate Gallery, 1994.

Roethel, Hans K. *The Blue Rider.* New York: Praeger, 1971.

Shearman, John. *Mannerism.* New York: Penguin Books, 1967.

Snyder, James. *Medieval Art.* New York: Harry N. Abrams, Inc., 1985. *Northern Renaissance Art.* New York: Harry N. Abrams, Inc., 1985.

Sproccati, Sandro (ed.). *A Guide to Art.* New York: Harry N. Abrams, Inc., 1992.

Tümpel, Christian. *Rembrandt.* New York: Harry N. Abrams, Inc., 1993.

Turner, Jane (ed.). *The Dictionary of Art.* 34 vols. New York: Grove's Dictionaries, Inc., 1996.

Vasari, Giorgio. *The Lives of the Artists.* New York: Oxford University Press, 1991.

Vaughan, William. *German Romantic Painting.* New Haven, CT: Yale University Press, 1980.

Vecchi, Pierluigi and **Colalucci,** Gianluigi. *Michelangelo: The Vatican Frescoes.* New York: Abbeville, 1996.

Willett, John. *Art and Politics in the Weimar Period: The New Sobriety 1917–1933.* New York: Da Capo Press, 1996.

Wind, Edgar. *Pagan Mysteries in the Renaissance.* Revised and enlarged. New York: W.W. Norton, 1968.

Index of Artists and Theoreticians

Index of Artists and Theoreticians

Index of Artists and Theoreticians

Picture credits

The numbers refer to the numbers of the illustrations.

Picture Credits

Museo del Settecento Veneziano, Ca'Rezzonico, Venice 137

Museum der bildenden Künste, Leipzig 159

Museum Folkwang, Essen 197, 199, 211

Museum of Fine Arts, Boston, Isaac Sweetser Fund 80

© The Museum of Modern Art, New York 201 (Acquired through the Lillie P. Bliss Bequest), 204 (The Sidney and Harriet Janis Collection), 234 (Gift of Philip Johnson in honor of Alfred H. Barr, Jr.)

Museum Oskar Reinhart, Winterthur 150

© Nasjonalgalleriet, Oslo (photo J. Lathion) 194

National Gallery of Art, Washington, © 1997 Board of Trustees 5 (Andrew W. Mellon Coll.), 47 (Samuel H. Kress Coll.), 127 (Widener Coll.), 136 (Gift of Mrs. Barbara Hutton), 142 (Andrew W. Mellon Coll.), 177 (Gift of Mr. and Mrs. Cornelius Vanderbilt Whitney), 221 (Chester Dale Coll.)

National Gallery of Ireland, Dublin 141

National Gallery, London 26, 37, 70, 75, 119, 120, 121, 143, 160, 161, 190

National Gallery of Canada, Ottawa 144

Öffentliche Kunstsammlung Basel, Kunstmuseum (photos Martin Bühler) 89, 187, 193, 218, 220

Österreichische Galerie Belvedere, Wien 131 (Fotostudio Otto) 195

Österreichische Nationalbibliothek, Vienna 15

Philadelphia Museum of Art 203

Private collection, New York 229

Private collection, Wolfsburg 242

Marco Rabatti and Serge Domingie 68, 69

Rheinisches Bildarchiv, Köln 114, 179, 202, 244

Rijksmuseum, Amsterdam 126

Sächsische Landesbibliothek, Deutsche Fotothek 53

Scala, Florence 21, 23, 27, 30, 31, 34, 35, 42, 50, 51, 56, 57, 64, 65, 74, 76, 77, 102, 104, 116, 117

Courtesy Aurel Scheibler, Köln (photo Lothar Schnepf, Köln) 245

Marco Schneiders, Lindau 130

Sprengel Museum, Hannover 210

Hermitage, St. Petersburg 198

Staatliche Kunsthalle, Karlsruhe 86

Staatliche Kunstsammlungen, Dresden 135, 155

Staatliche Museen, Kassel 123

Staatsgalerie, Stuttgart 124

Städtische Galerie im Lenbachhaus, Munich 206

Städtische Kunsthalle, Mannheim 213

Stiftsmuseum des Chorherrenstiftes Klosterneuburg (photo Ritter, Wien) 14

Studio Fotografico Quattrone, Florence 32, 45

Tate Gallery, London 169, 170, 217, 219, 239, 241

© Dietmar Thomassin, Trier 10

Victoria & Albert Museum, London 4, 91

Wadsworth Atheneum, Hartford 108 (The Ella Gallup Sumner and Mary Catlin Sumner Collection Fund)

Wallace Collection, London 133

Westfälisches Landesmuseum für Kunst und Kulturgeschichte, Münster 18

Whitney Museum of American Art, New York 215

© VG Bild-Kunst Bonn, 1997: Max Beckmann, Giorgio de Chirico, Salvador Dalí/Demart pro arte B.V., André Derain, Marcel Duchamp, Max Ernst, George Grosz, Jasper Johns, Wassily Kandinsky, Paul Klee, Yves Klein, Roy Lichtenstein, El Lissitzky, Henri Matisse/© Succession H. Matisse, Edvard Munch/© The Munch Museum/The Munch Ellingsen Group, Barnett Newman, Pablo Picasso/© Succession Picasso, Jackson Pollock, Robert Rauschenberg, Marc Rothko, Wolfgang Otto Schulze, Kurt Schwitters, Pierre Soulages, Andy Warhol/ © The Andy Warhol Foundation for the Visual Arts

Copyright Georg Baselitz, Schloss Dernburg

Marianne Feilchenfeldt: Max Liebermann

Nachlass Erich Heckel, 78343 Hemmenhofen

Copyright by Dr. Wolfgang & Ingeborg Henze-Ketterer, Wichtrach/Bern: Ernst Ludwig Kirchner

Gerd Köhrmann, Cologne: Karl Hofer

L & M Services B. V. 970609: Robert Delaunay

Marlborough Fine Art Ltd, London: Francis Bacon

© Nolde-Stiftung, Seebüll 222

Copyright Jack Pierson, New York

Copyright Sigmar Polke, Cologne

Copyright Gerhard Richter

Tradhart Ltd, Slough Berkshire: David Hockney

All rights for illustrations not mentioned here belong to the author, the publisher, or could not be located.